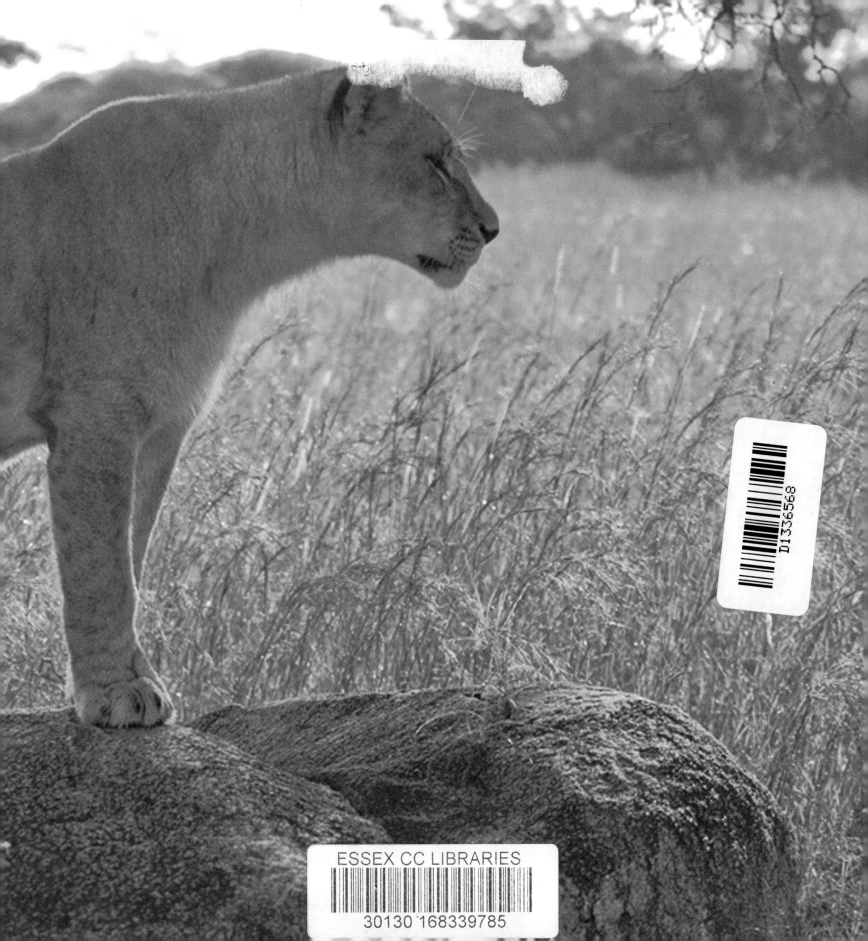

EVANS
MITCHELL
BOOKS

First published in the
United Kingdom in 2011 by
Evans Mitchell Books
54 Baker Street, London W1U 7BU
United Kingdom
www.embooks.co.uk

Design by
Darren Westlake
TU ink Ltd, London
www.tuink.co.uk

Edited by
Caroline Taggart

British Library Cataloguing in Publication Data
A CIP record of this book is available
on request from the British Library.

ISBN: 978-1-901268-59-1

Printed in Germany

itv STUDIOS

LION COUNTRY

Chris Weston

Contents

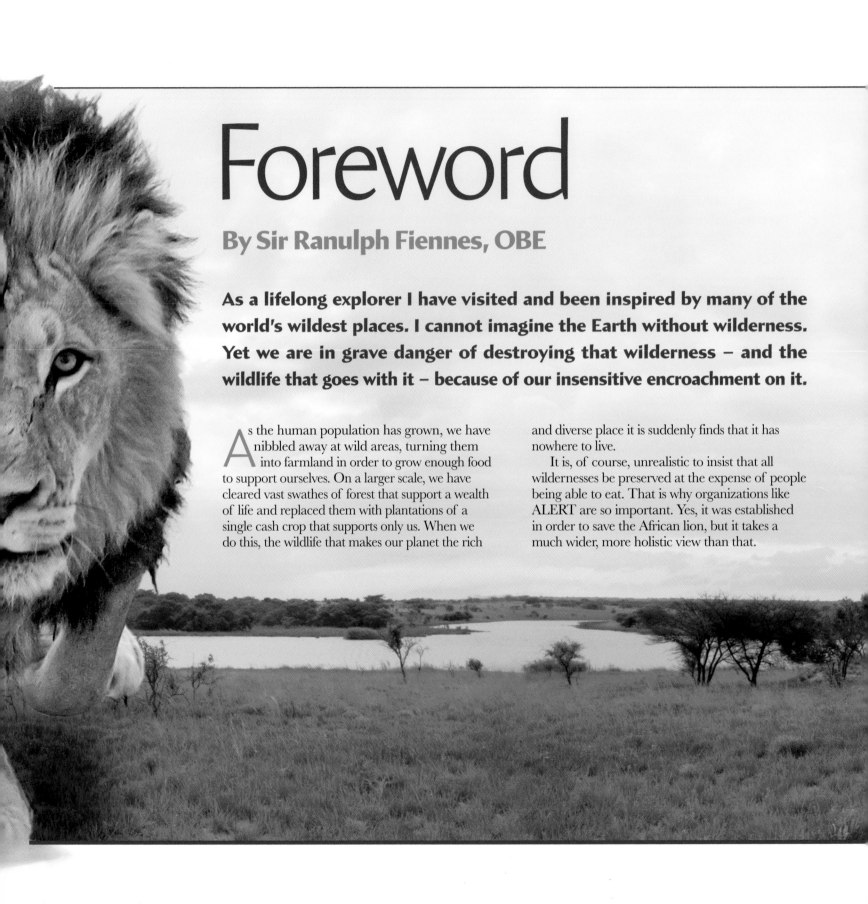

Foreword

By Sir Ranulph Fiennes, OBE

As a lifelong explorer I have visited and been inspired by many of the world's wildest places. I cannot imagine the Earth without wilderness. Yet we are in grave danger of destroying that wilderness – and the wildlife that goes with it – because of our insensitive encroachment on it.

As the human population has grown, we have nibbled away at wild areas, turning them into farmland in order to grow enough food to support ourselves. On a larger scale, we have cleared vast swathes of forest that support a wealth of life and replaced them with plantations of a single cash crop that supports only us. When we do this, the wildlife that makes our planet the rich and diverse place it is suddenly finds that it has nowhere to live.

It is, of course, unrealistic to insist that all wildernesses be preserved at the expense of people being able to eat. That is why organizations like ALERT are so important. Yes, it was established in order to save the African lion, but it takes a much wider, more holistic view than that.

Andrew Conolly and his team are considering the bigger conservation picture, across the whole of the African continent; looking at the entire ecosystem within which the lion lives; seeking ways to develop management plans that will work in the long term and involving and empowering local communities every step of the way.

Refreshingly, they are also willing to work with other organizations, such as their close partnership with the conservation NGO Animals on the Edge, to share ideas and to draw different people together to try to find the best solutions to the problems facing the wildlife and people of Africa. They also understand and support the belief that effective conservation cannot be achieved without the backing of governments, so they work tirelessly to gain the support and commitment of the individual ministers and administrations whose patronage is vital in the battle against extinction.

I have been patron of ALERT since 2007 and remain extremely proud to be part of a project that is so forward-looking, so wide-ranging and such a ray of hope for the king of beasts, its subjects and its kingdom. I have had the privilege of walking with the lions of Antelope Park, the very lions that hold the future of the species in their paws. I am thrilled to be a part of the adventure and I hope that, through the compelling narrative and stunning photographs in *Lion Country*, you too will share my dream for an Africa where the roar of the lion never falls silent.

Opening Statement

From His Honour Francis D. Nhema, Minister for Environment & Tourism, Government of the Republic of Zimbabwe

Man has done damage. We have destroyed. We have destroyed the kingdom that belonged to wildlife. It is time for us to repair the damage we have done and we begin here.

We have been selfish, ignoring the fact that the wilderness where we have built cities was once home to wildlife. We have made these animals run from us whenever they see us. We have instilled fear in them. We want to conquer everything but in doing so we lose something. We have lost our dignity and our love of nature. We have lost our relationship with the wilderness and become incomplete as a planet.

There is no fulfilment without wilderness. There is no fulfilment without wildlife. Wildlife reflects who we are: the love, the care, the understanding. It is only when man walks in the wilderness together with wildlife that he finds fulfilment.

The work that ALERT is doing goes beyond the people of Zimbabwe. It teaches the global community that for this planet to be complete, for us all to reach fulfilment, we must live in harmony with nature. That is the meaning of life.

I want to say thank you to the people working for ALERT and I want to say that the ALERT project must not stop here. We must ensure that the rest of Africa enjoys the proceeds of these ideas and efforts so that our continent will forever be known as Lion Country.

It is time for us to correct our wrongs. I am asking the rest of the world, please take heed. Just think for a moment. When you look at a lion consider its thoughts, its feelings, its expectations for life because, perhaps, they are not much different from yours.

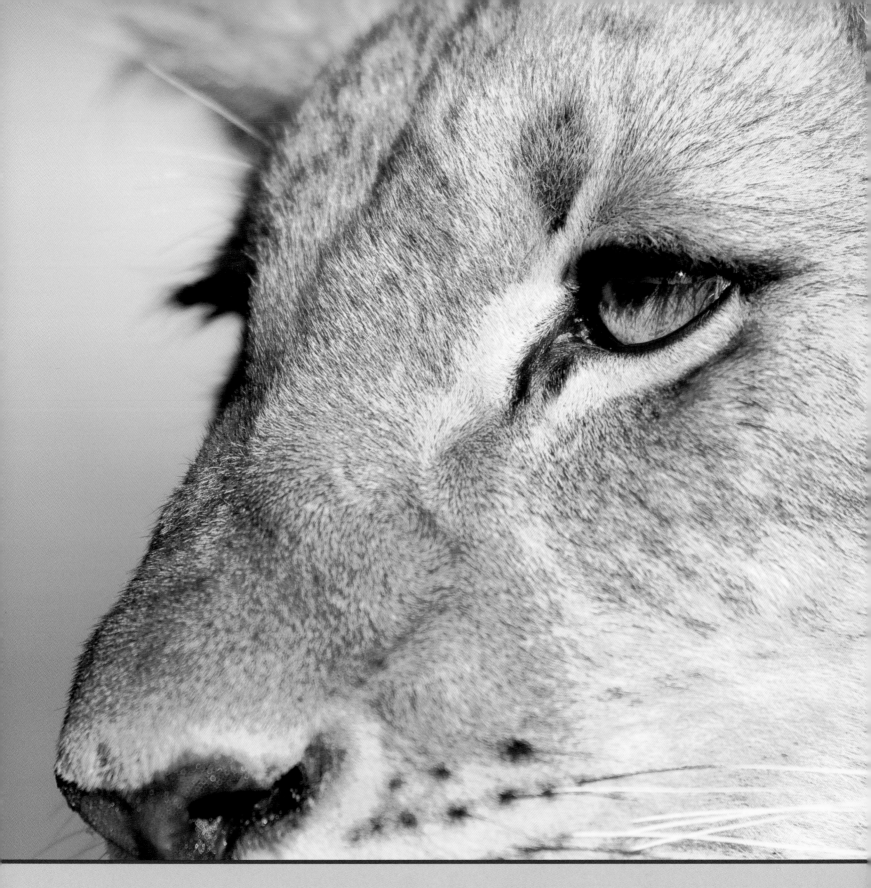

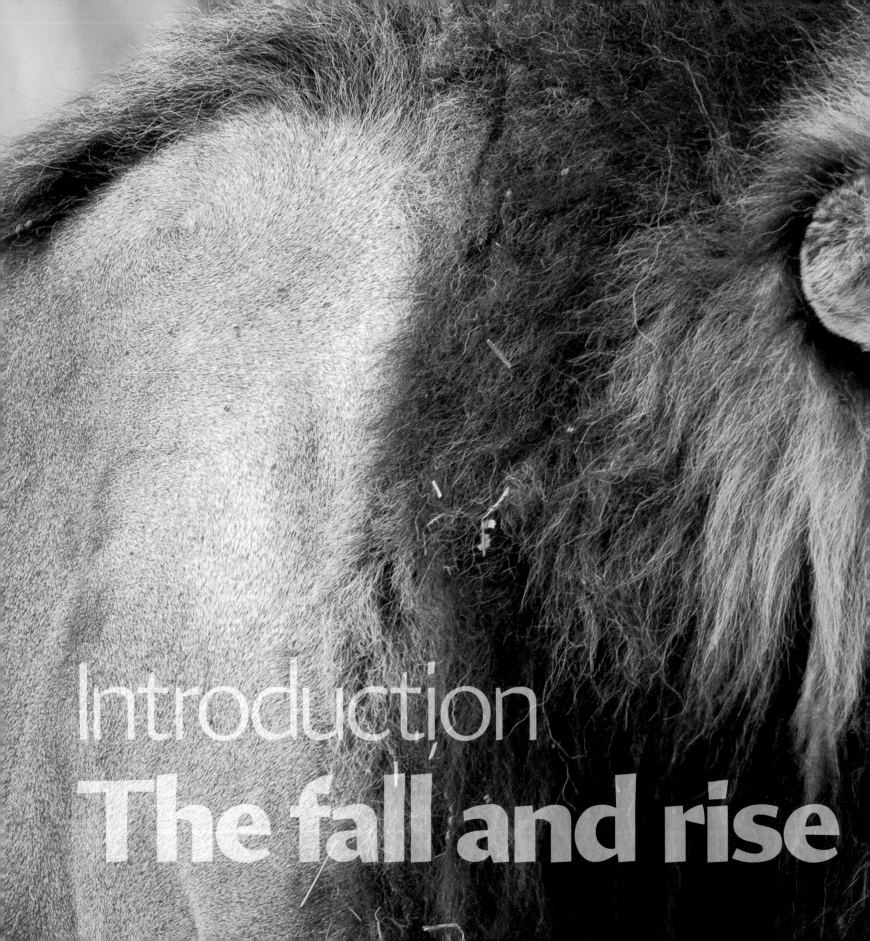

Introduction
The fall and rise

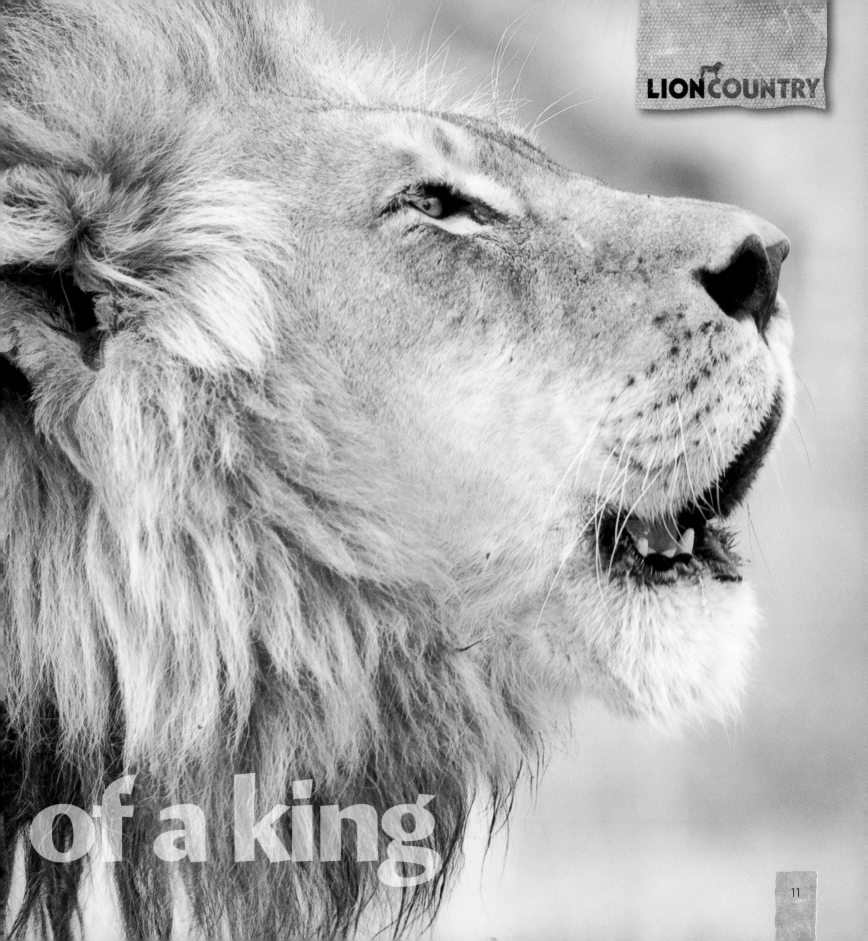

of a king

LION COUNTRY

Introduction

The fall and rise of a king

The lion – rightful king of beasts. No one who has been close to lions can deny their majesty and their magnificence. Their power, strength and vivacity; their bold and regal appearance; the paralysing tremor of their guttural roar all indicate that lions sit very firmly at the top of nature's kingdom. But the lion is losing its crown. Across Africa populations are declining – rapidly. In the last two decades alone lion numbers have dropped by around 40 per cent. From an estimated 400,000 lions roaming west to east, north to south across much of sub-Saharan Africa in the middle of the twentieth century, today there are thought to be fewer than 25,000 individuals surviving in the wild.

In a single generation, over 95 per cent of the world's lions have been lost. And, although the causes of the decline have not always been well understood, over the past 50 years large parts of Africa's wilderness have been developed for agriculture and livestock farming, to supply food for the continent's – and the world's – ever-expanding human population. For lions, this has been a triple whammy. Loss of habitat means less room for both predators and prey. A reduction in prey species means less food for lions. Combined, these two problems have led to increased conflict with humans and to another great threat – indiscriminate retributive and pre-emptive killing.

The lion's relationship with man is complex. For some it is a wonder of the natural world, to be admired and conserved. To others it is an economic resource to be exploited, its value as a trophy far exceeding its financial worth alive.

To others still it is a pest, encroaching on their lands, scaremongering and preying on valuable livestock. At the moment, it's the lion's detractors who seem to be winning.

In the middle of this rhetorical debate is a man who sees all sides of the story – a man with a plan. Andrew Conolly is a fifth-generation Zimbabwean. In some people's eyes he's a visionary, in others a maverick. But Conolly doesn't care about labels, he cares about lions, and in 2005 he established the African Lion & Environmental Research Trust (ALERT) with the aim of solving one of lion conservation's great conundrums: how do you safely release captive-bred and therefore habituated lions back into the wild?

> Across Africa, lions' habitat is being eroded, fragmented and destroyed.

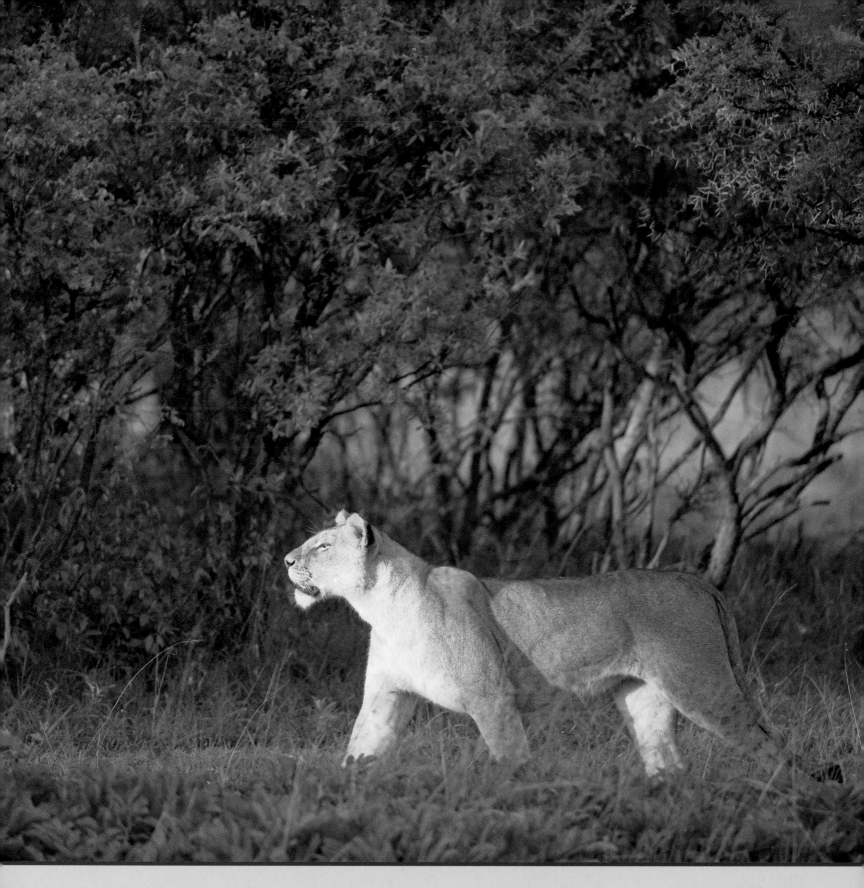

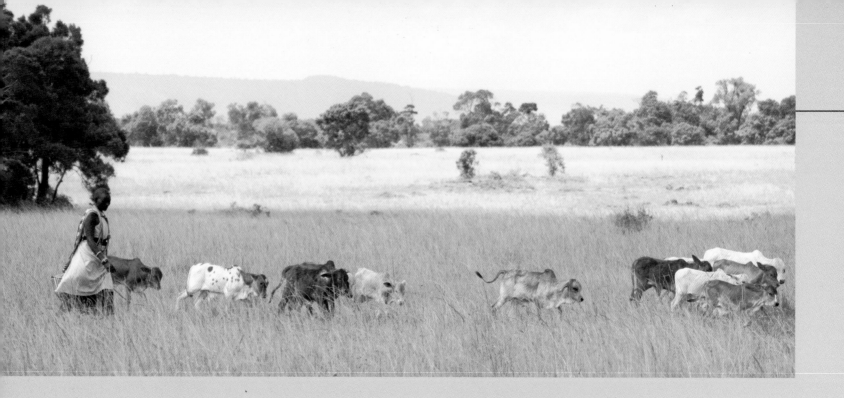

In 1987 Conolly bought a game ranch, Antelope Park, in the Zimbabwean Midlands and inherited six captive lionesses with cubs. To exercise the cubs, he and his wife Wendy used to take them on walks into the bush, where they noticed that, despite having lived their short life entirely within an enclosure, the youngsters were showing the same behaviour and instincts as wild lion cubs. From these observations Conolly started to think about the possibility of rehabilitating captive lions into the wild. More profoundly, he realised that what he had was a large cog in the complex machine to help save Africa's wild lions.

A lot of talking is done under the guise of conservation. Fortunately for the lions of Africa, Andrew Conolly is a man of action. Recognising the many complications and potential dangers inherent in releasing lions into the wild – the fact that captive-bred animals are dependent on humans, their lack of a social structure and their lack of competitive experience with their own species and with others – he set

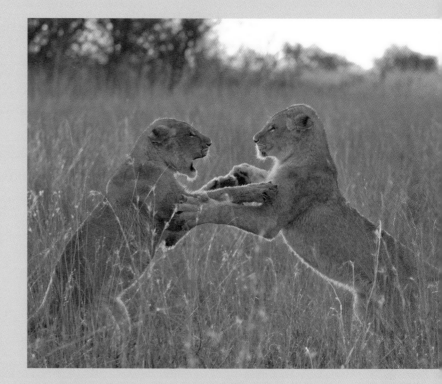

^ Cubs at Antelope Park learn the skills they need to survive in the wild during daily excursions into the bush.
< Andrew Conolly, the founder of and inspiration behind ALERT.

‹ To some communities, the lion is a pest that preys
on livestock and threatens livelihoods.
› A lion cub walks with its handler at Antelope Park.

about developing a programme that would
overcome these historic challenges. The result
was the Lion Rehabilitation and Release into
the Wild programme.

Conolly sees the programme as 'an African
solution to an African problem'. And, although
it has its sceptics – there are many who believe
Conolly's plan simply can't be put into action
and point towards its relatively slow progress as
evidence, while others maintain there are better
ways to spend the money ALERT raises –
Conolly has allies. Dr Pieter Kat, an eminent
ecologist, swam against the tide of scientific
thinking when he said, 'Despite the alarming
statistics, CITES, and the UN and other world
conservation bodies, have remained at best
complacent to the predicament of the African
lion. Despite the drastic decline in continental
lion numbers [they] see no need for increased
levels of protection for lions through
international and local legislation. I therefore
believe the future for lions is in African hands.
If the international community does not offer
considered support, I suggest we come up with
our own solutions.' Kat sees Conolly's
programme as one such solution.

Africa, too, seems appreciative of the idea.
Angola, Mozambique, Zambia, Malawi and
even Ghana, in West Africa, are resurrecting
their protected areas with a diversity of aid
programmes. All have massive areas suitable
for wildlife reintroduction and eco-system
revitalisation, including the eventual
reintroduction of top predators such as the lion.
And all have been in touch with Andrew Conolly
about how he can help. A maverick he may be,
but there are many interested parties in Africa
betting on Conolly's success.

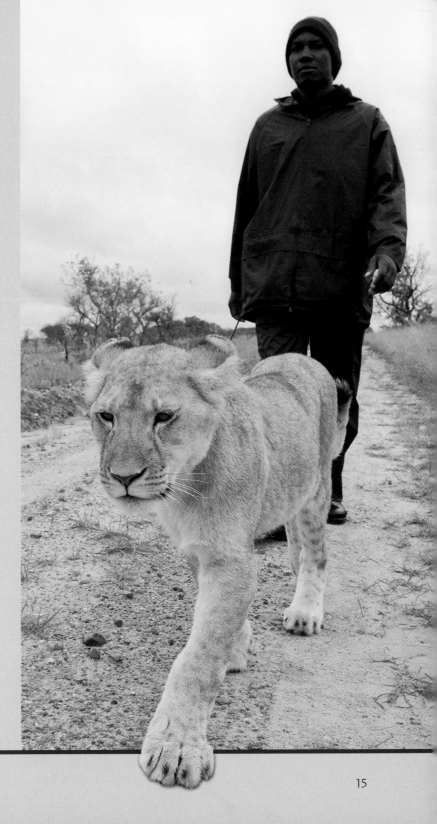

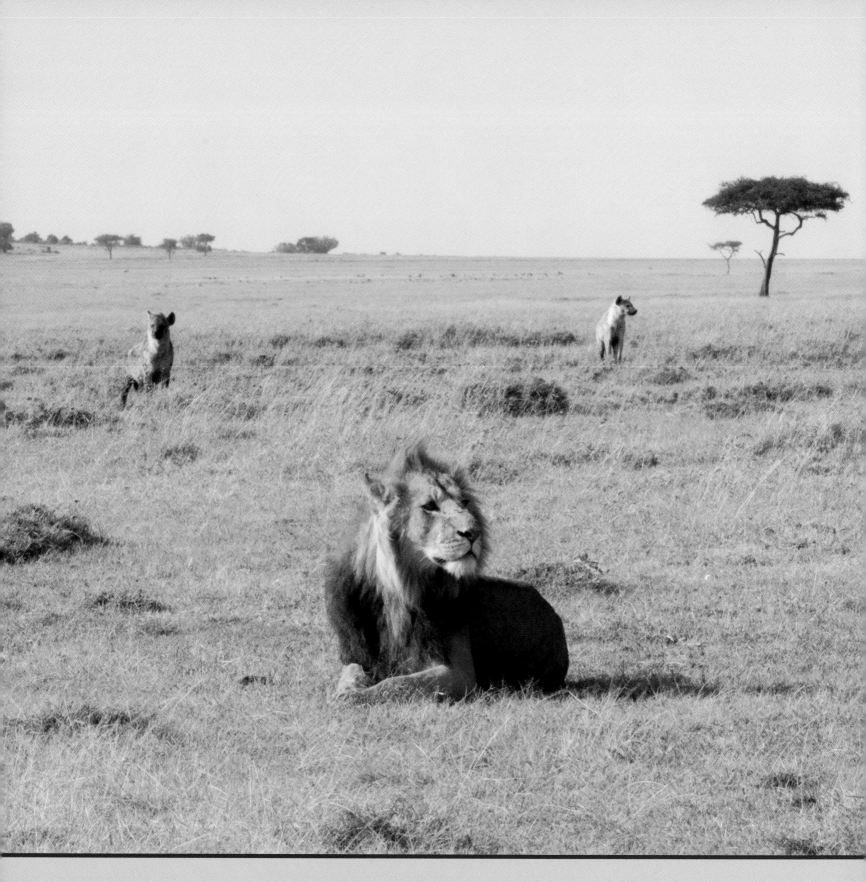

< In the wild, lions have to compete with other carnivores, such as hyenas.
> The Lion Country story is sometimes sad but ultimately it is about triumphing over disaster.

Ultimately, if the programme is successful it will be in no small part due to the efforts of a young British conservationist, David Youldon. As a child, Youldon was mesmerised by the wildlife he discovered in the marshes behind his home in Cambridgeshire. Later, he turned his parents' home into a halfway house for lost pets and, soon after, a makeshift hospital for garden birds. Then, on a school trip to Egypt, he fell in love with Africa.

Youldon discovered ALERT while he was volunteering at Antelope Park in 2004. He stayed for six weeks and found his life's calling. When he left, somewhat reluctantly, he was already forming a plan. Back in the UK, for the next six months he learned all he could about lion ecology and conservation management. He returned to Antelope Park in 2005 and persuaded Andrew Conolly to give him a job. In Youldon

Conolly saw the energy and persistence that was needed to drive the programme forward. His instincts proved right, as the young Brit quickly rose to be Chief Operating Officer of ALERT and started turning a dream into reality.

Lion Country tells the story of one man's fight for the future of Africa's lions. We meet the young pretenders – Phyre, Luke, Jabari, Jelani, Dhakiya and Damisi – who, if Conolly succeeds, will one day be revered as the foot soldiers, the pioneers who paved the way for the return of the king; and we meet the people who have dedicated their time and, in some cases, their lives to ensuring this bold plan becomes reality. The story begins a long time ago. It is often happy but sometimes sad. It is a story about triumph and disaster, about will and conviction in the face of adversity. Most of all, it is a story about hope, faith and aspiration, and a continent's dream to live in a land where a once mighty king reigns free again.

Myths,
legends

and history

LION COUNTRY

Myths, legends and history

How the lion became 'king of beasts'

Around the time of the height of the Roman Empire the lion ranged from western Europe to south-west Asia and in Africa from the northernmost countries to the southern tip. In Europe and Asia in particular it holds an esteemed place in human culture. In Europe it was and remains a prominent symbol depicting strength and nobility, and was foremost in Persia (now Iran) and among the kings of the Achaemenid (Persian) Empire. The island state of Singapore derives its name from the Malay words meaning Lion (*singa*) City (*pura*). The lion is also the basis of the lion dances that form part of the traditional Chinese New Year celebrations, and in India, where it appears on the national emblem, it is considered sacred by all Hindus and is the meaning of the common Punjabi surname Singh.

The lion is also widely depicted in mythology and legend, appearing in at least six of Aesop's fables. In Egypt, the goddess Sekhmet had the head of a lioness and Maahes was the lion god of war. The Babylonian god Nergal was pictured as a lion and the Roman goddesses Cybele and Juno both drove a chariot pulled by lions. In the Bible, Daniel was miraculously saved from a lion's den, Ezekiel encountered four living creatures that had the face of a lion, and John of Patmos saw a creature with a face like a lion in the Book of Revelations. Chimera, manticore and sphinx are all mythical creatures whose form is partly that of a lion.

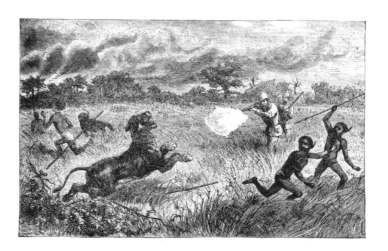

⌐ The advent of firearms resulted in many wild lion populations becoming locally extinct.
›The lion is widely depicted in European coats of arms.

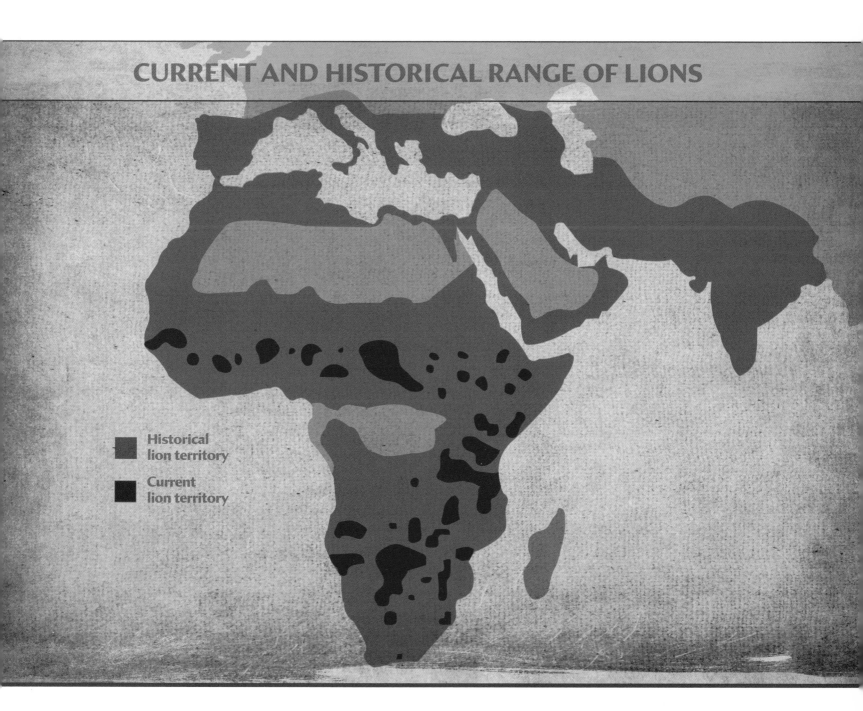

CURRENT AND HISTORICAL RANGE OF LIONS

Historical
lion territory

Current
lion territory

Despite its widespread and widely used symbolism, the European population of lions died out around 2,000 years ago, coinciding with the spread of the Roman Empire. Elsewhere lions fared better for a long time until, in the mid-nineteenth century, the advent of firearms resulted in local extinction over much of its historical range, including most of Asia and the Middle East, and North Africa. Today, lions exist only in sub-Saharan Africa (predominantly in East and southern Africa) and in one specific area of India – Gir National Park.

While the lion's place in history is assured, its status as a symbol of power and majesty has long been balanced by the threat it poses as an apex predator. As humans began to develop areas of wilderness, encounters with lions became more frequent and tales of man-eating lions spread. The most notorious lions in recent history are the two Tsavo man-eaters, considered responsible for the deaths of at least 35 Indian construction workers in a nine-month period during the building of a railway bridge across the Tsavo River in Kenya in 1898. They were immortalised in the 1996 Hollywood film *The Ghost and the Darkness*, starring Michael Douglas and Val Kilmer.

⌐ Lions feature in many Bible stories.

DAVID'S SAY...

'Fossil evidence suggests that the earliest lion-like cats appeared in Tanzania 1.8–5 million years ago. From there they spread into Europe, northern Africa, Asia and America as far south as Peru. 100,000 years ago they were one of the most widespread mammals on Earth.'

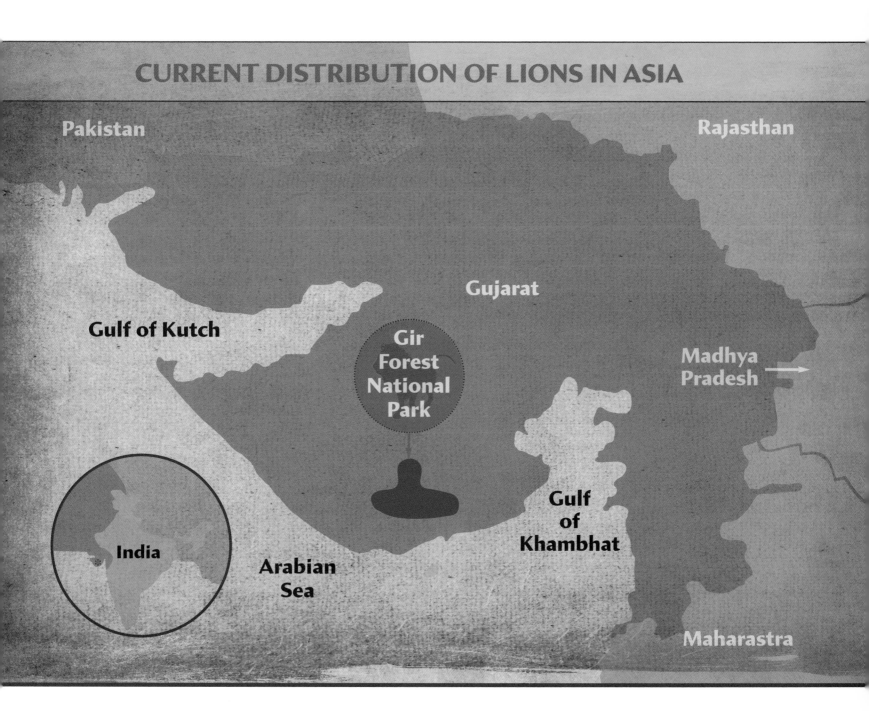

CURRENT DISTRIBUTION OF LIONS IN ASIA

Pakistan

Rajasthan

Gulf of Kutch

Gujarat

Gir
Forest
National
Park

Madhya
Pradesh

India

Gulf
of
Khambhat

Arabian
Sea

Maharastra

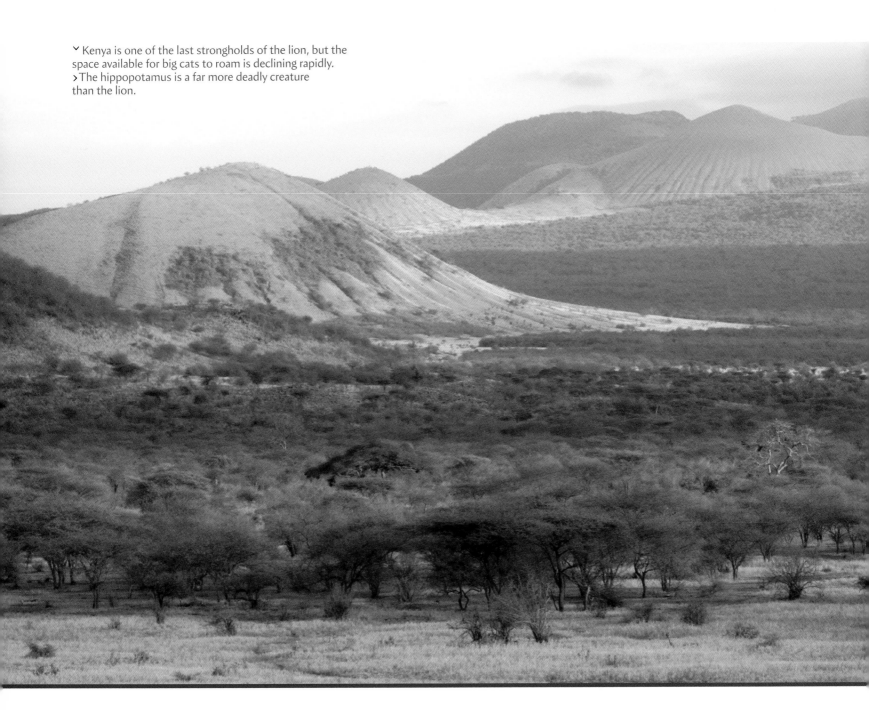

∨ Kenya is one of the last strongholds of the lion, but the space available for big cats to roam is declining rapidly.
> The hippopotamus is a far more deadly creature than the lion.

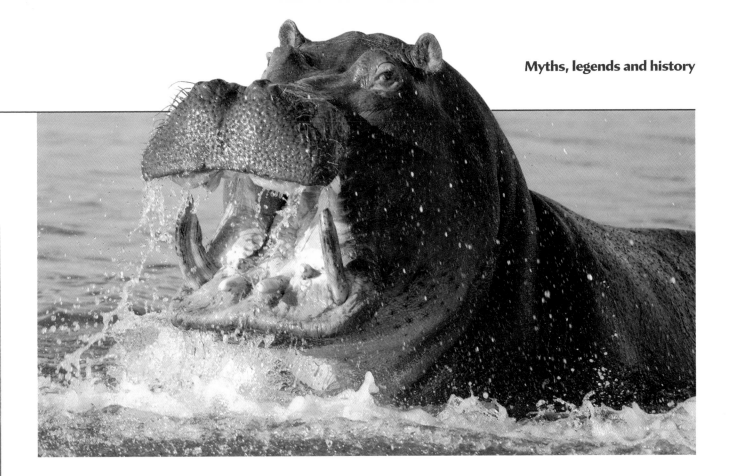

The film and, likely, the original accounts of Lt. Col. John Henry Patterson, who led the construction project, exaggerated the events in Tsavo; there is also a reasonable explanation for the habits of these lions. They may have been used to finding dead bodies in the area, either drowned slaves whose caravans crossed the river here or partially cremated Hindu railway workers, both an invitation to scavengers. It is nevertheless undeniable that some lions, perhaps through desperation or opportunity, develop a predilection for human meat. However, in general, lions will avoid encounters with humans whenever possible. By far the greater wildlife-related threats to humans in Africa are the hippopotamus, crocodile, buffalo and elephant.

In more recent times, loss of habitat and the subsequent increased conflict with man have continued to take their toll on lion populations. Diminishing space and a reduction in available prey have led to attacks on livestock and, in some cases, people. Retaliatory and pre-emptive killing to protect livestock has had a direct affect on lion numbers, while the assumed mantle of 'man-eater' has understandably but unfortunately brought changes in attitude within indigenous human communities, hampering conservation efforts. In the west, where the title 'king of beasts' still resonates, the lion remains a much sought-after trophy for hunters.

From its once undisputed position as king of beasts, the lion is now on the brink, listed as vulnerable on the IUCN (International Union for the Conservation of Nature) Red List of Threatened Species, with its numbers continuing to diminish. That we need to do something to protect the last remaining populations of wild lions and recover their numbers is obvious. The only doubt hangs over what specific actions are required. What is certain is that, if we do nothing, the king of beasts will die and there will be no heir to take its place.

Lion evolution, ecology and behaviour

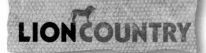

Lion evolution, ecology and behaviour

Where it comes from and how it lives

In evolutionary terms, the lion is a relatively modern king, fossil records showing that it appeared on the scene far more recently than its three close relatives, the tiger, leopard and jaguar. The lion we know today, *Panthera leo*, almost certainly evolved in Africa, most likely in western Africa, around a million years ago, before dispersing across all the planet's northern continents. At one point in history, the lion was the most widespread land mammal after humans, its distribution reaching across Europe and Asia (*Panthera leo fossilis* and, later, *Panthera leo spelaea*) and both North and South America (*Panthera leo atrox*), as well as the whole of the African continent.

However, by the end of the last glaciations, around 10,000 years ago, the lion had disappeared completely from northern Eurasia and the Americas and was restricted to the warmer climates of Africa and southern Asia, where eight recognised subspecies existed: the Asiatic lion (*P. l. persica*), ranging from Turkey across south-west Asia as far as Bangladesh; the Barbary lion (*P. l. leo*), found from Morocco to Egypt; the West African lion (*P. l. senegalensis*), from Senegal to Nigeria; the North-East Congo lion (*P. l. azandica*), found only in the north-eastern region of the Congo; the Masai (or East African or Tsavo) lion (*P. l. nubica*), ranging from Ethiopia through Kenya to Tanzania and Mozambique; the Katanga (or South-West African) lion (*P. l. bleyenberghi*), found in the western and northern states of southern Africa; the Transvaal (or South-East African) lion (*P. l. krugeri*), found in South Africa; and the Cape lion (*P. l. melanochaita*), found in the southernmost regions of South Africa.

> The lion has been around for a much shorter period than its close relatives the leopard (shown opposite), tiger and jaguar.

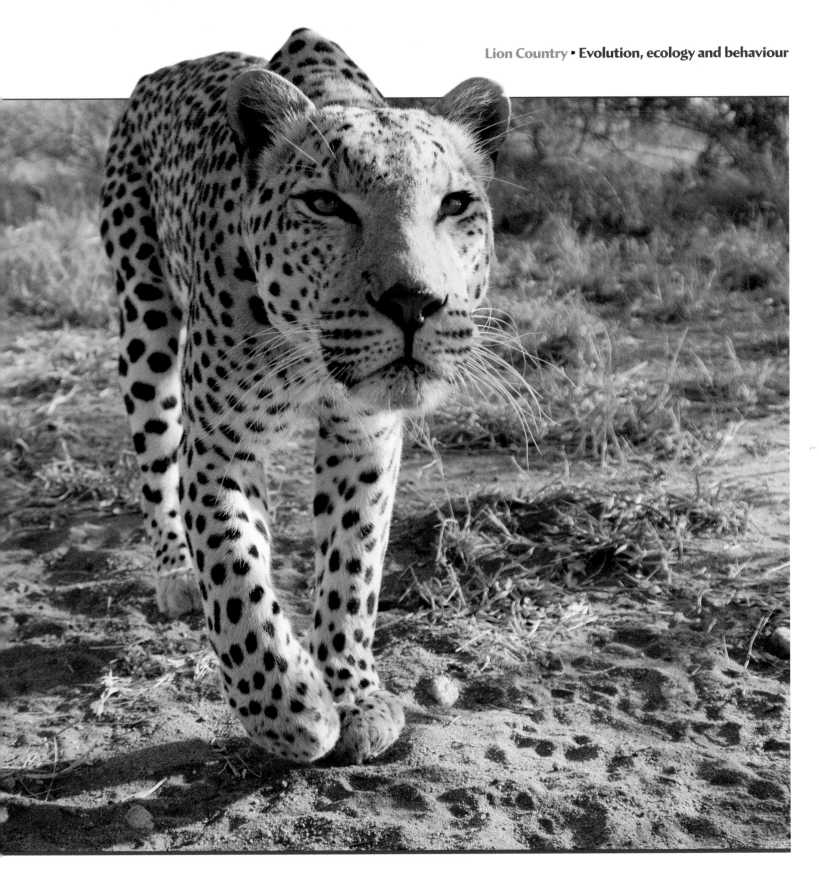

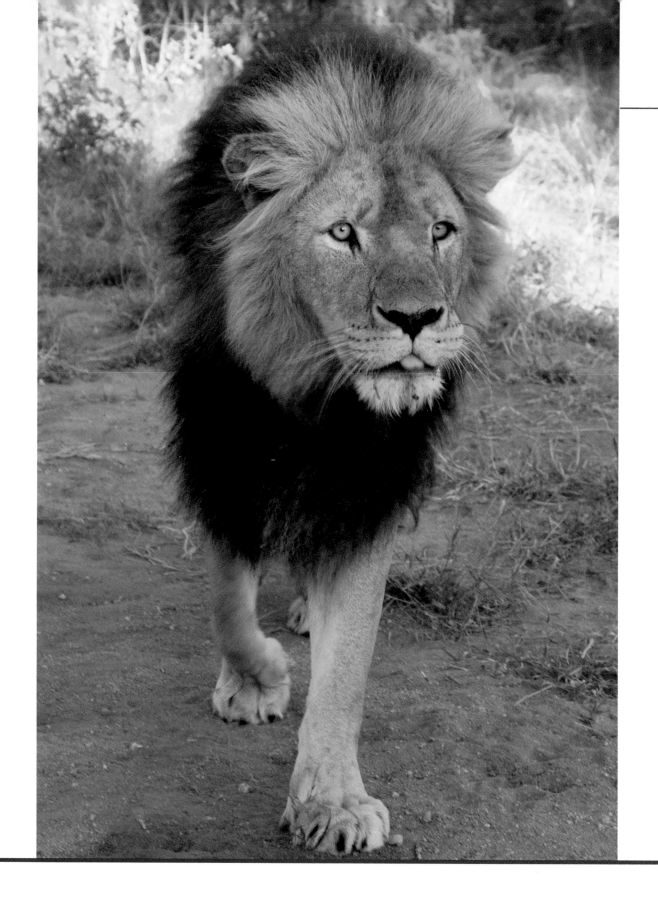

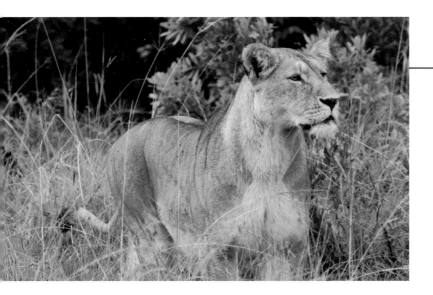

<< The Transvaal lion, found in the south-east region of South Africa, is one of the most abundant.
< Lionesses are around 20 per cent smaller than males, but the lion remains the tallest of the big cats.

tallest at the shoulder (from around 107 cm for a female to 123 cm for a male). Its overall length varies depending on its environment (lions in southern Africa are typically larger than those in East Africa) and ranges from around 170 cm to 250 cm in males and 140 cm to 175 cm in females. In terms of weight, adult males are usually between 150 kg and 250 kg, females 120–182 kg. The heaviest lion ever recorded goes back to 1936 and weighed in at 313 kg. It was found in the eastern Transvaal in South Africa.

Lions have lower bone mass than other animals of a comparable size; much of their weight is composed of muscle. The chest and shoulders are powerfully built, enabling a lion to deliver a debilitating blow with its forepaws, heavy enough to break the back of an animal the size of a zebra.

In more recent times, many of these geographic populations died out and, today, the IUCN, which produces the international standard for species at the risk of extinction – commonly known as the Red List – recognises only two classifications of lion: the African (*Panthera leo leo*) and the Asiatic (*Panthera leo persica*).

Although not the heaviest of the big cats – that distinction goes to the tiger – the lion is the

IUCN RED LIST DATA

Kingdom	Phylum	Class	Order	Family
Animalia	Chordata	Mammalia	Carnivora	Felidae

Scientific name
Panthera leo

Species authority
Linnaeus, 1758

Common name/s
English: Lion, African lion
French: Lion d'Afrique
Spanish: León

Taxonomic notes
Based on generic analysis (O'Brien *et al.* 1987, Dubach et al. 2005), two subspecies are recognised:

African lion *Panthera leo leo* (Linnaeus, 1758)
Asiatic lion *Panthere leo persca* (Meyer, 1826)

In their review in *Mammalian Species*, Haas *et al.* (2005) recognised six African subspecies, although these were not subject to analysis.

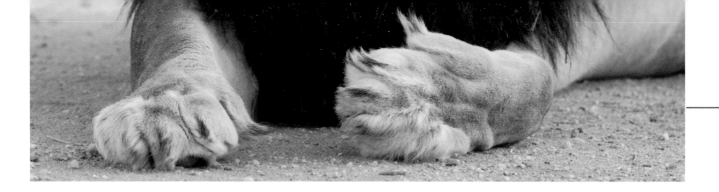

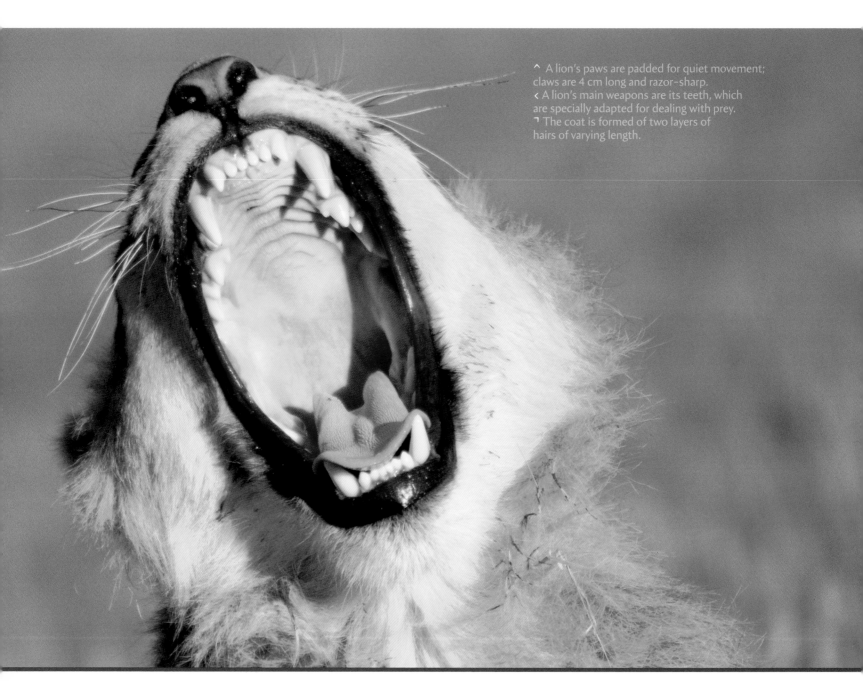

^ A lion's paws are padded for quiet movement; claws are 4 cm long and razor-sharp.
< A lion's main weapons are its teeth, which are specially adapted for dealing with prey.
⌐ The coat is formed of two layers of hairs of varying length.

Each paw is padded, the pads giving protection and enabling stealthy movement. The retractable claws, which are around 4 cm long, grow in layers, which helps to maintain sharpness, as layers are shed when they become worn. The lion's other main weapons, its teeth, are typical of a carnivore and adapted to its prey. The large canines are spaced so that they slip between the cervical vertebrae of zebra-sized prey, enabling them to sever the spinal cord. The carnassials (back teeth) operate like scissors and are used for cutting meat (lions don't chew meat but swallow whole chunks) and the mid-teeth are conical, designed for tearing.

The lion's coat has a layer of relatively sparse, fine under-fur made up of hairs 6–8 mm long and a layer of sub-bristles with hairs 10–14 mm long. There is also a large patch of reverse hair growing forwards, starting above the lumbar vertebrae and continuing up to the mid-dorsal region, where it forms a small transverse crest and extends about one-third of the way down the side of the body. Colouring varies between regions and even within prides, and can range from light buff to a yellowy, reddish or dark ochre/brown. The underbelly is generally lighter. Cubs are born with distinctive rosettes all over the body; these fade with age and aren't usually present in adults.

∟ The space between the canines and the front teeth enables a lion to sever its prey's spinal cord.
˅ Cubs are born with distinctive rosettes that diminish over time.

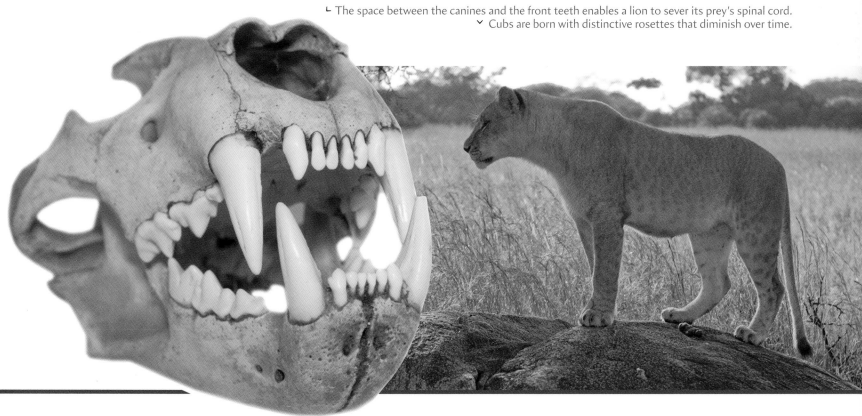

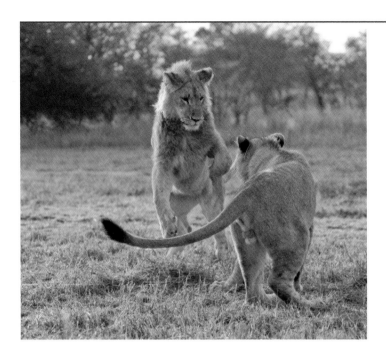

A common factor in lions of both sexes and unique within the cat family is the tufted tail. Nobody is sure of the purpose of the tuft, which is absent at birth and develops when the cub reaches around five to six months of age. In some lions, but not all, the tuft conceals a spur that is formed of fused sections of the tailbones.

Another aspect of the lion's appearance that is unique among cats is that the male and female look decidedly different. From a distance, it's almost impossible to tell a male tiger or leopard from a female, but with lions the mane – in itself a unique feature within the felid family – makes the distinction obvious.

The male lion's mane is the most distinctive characteristic of the species. A lot of research has been done in an endeavour to understand its purpose and make-up (some would argue to the detriment of more urgent work) and it is now believed to fulfil both a sexual and, to a lesser extent, a defensive role. Females have been seen to select mates on the basis of the density and colour of the mane, while research done in

Lions are the only big cats to have a tufted tail. The male lion's mane – also unique among big cats – is the species' most distinctive feature.

Tanzania has recorded that mane length correlates with success rates in male-on-male fights – another consideration in sexual attractiveness. During encounters with competing species such as hyenas, male lions will use their mane to intimidate and to deter an attack, while in confrontations with other lions the mane helps to protect the vulnerable areas around the neck. While the mane plays a role in defence it is a hindrance in attack and is one reason that males within a pride system typically play only a minor role in hunting.

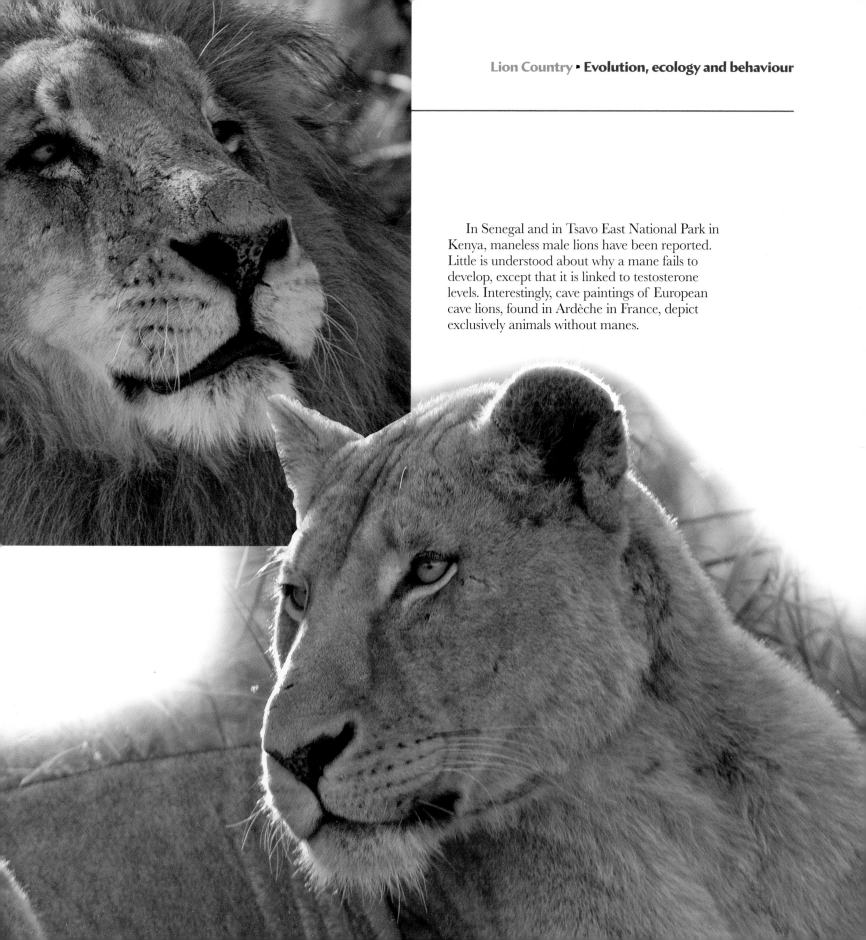

In Senegal and in Tsavo East National Park in Kenya, maneless male lions have been reported. Little is understood about why a mane fails to develop, except that it is linked to testosterone levels. Interestingly, cave paintings of European cave lions, found in Ardèche in France, depict exclusively animals without manes.

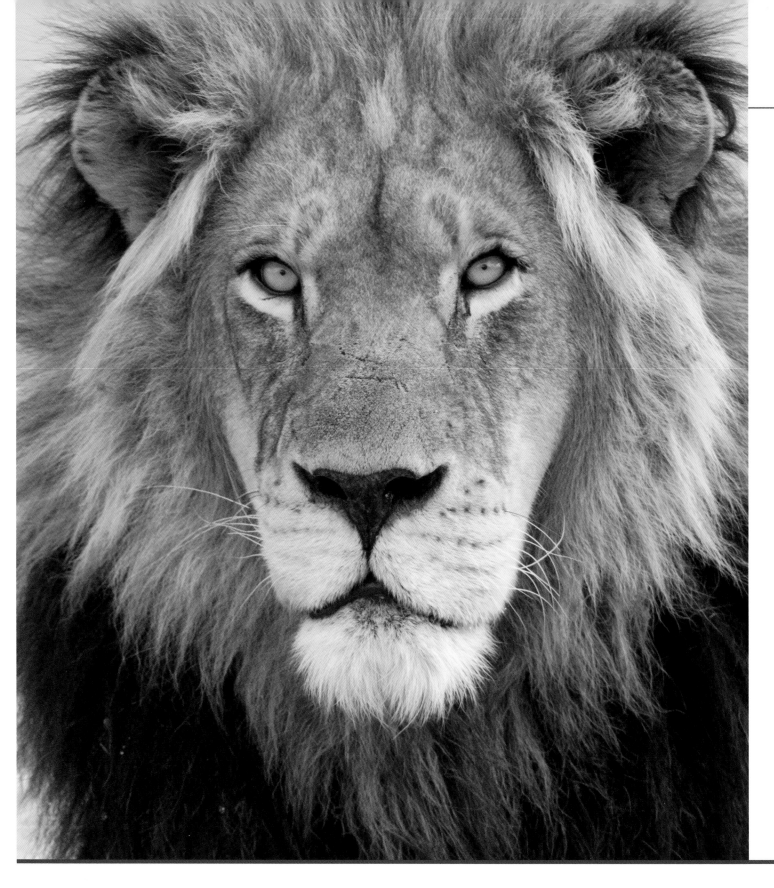

‹ The true purpose of the mane is unknown but it probably has multiple uses, including defence, attack and sexual attraction.

Distribution

The lion is found, although rarely in large numbers, in most countries in sub-Saharan Africa. However, until very recently, there was little factual, up-to-date knowledge about its distribution. So, between 2005 and 2006, the Wildlife Conservation Society (WCS) and the IUCN SSC Cat Specialist Group undertook an extensive collaborative exercise to map and assess current lion range. In its conclusion, the study estimated that lions were present over an area totalling 4.5 million km^2, which may sound a lot but represents less than a quarter of the lion's historical range in a continent with a land mass of over 30 million km^2; it also reckoned that over three-quarters of all lions were found in eastern and southern Africa. Worryingly, despite the extent of the survey, the lion's current status over huge swathes of Africa is still unknown. In Asia, the only remaining population of lions is found in the Gir Forest National Park and Wildlife Sanctuary in western India. The table overleaf shows the WCS/IUCN assessment of the lion's status in the 58 countries of its historic range.

As a part of its research in lion conservation, ALERT has been assessing lions in key regions of Africa. What follows is a synopsis of its findings in four of those countries.

Image courtesy of Tom Svensson

WHITE LIONS

White lions are not albino, neither are they a subspecies. The pale coloration is caused by a condition known as leucism which, in turn, is due to a recessive gene. Leucism is similar to melanism, which causes very dark coloration in, for example, black panthers. White lions are mostly found in captivity, where they are bred for their novelty value, but sometimes occur in the wild in South Africa.

TABLE OF DISTRIBUTION

Afghanistan **Regionally extinct**

Algeria **Regionally extinct**

Angola **Native**

Benin **Native**

Botswana **Native**

Burkina Faso **Native**

Burundi **Presence uncertain**

Cameroon **Native**

Central African Republic **Native**

Chad **Native**

Congo **Presence uncertain**

Côte d'Ivoire **Native**

Democratic Republic of Congo **Native**

Djibouti **Regionally extinct**

Egypt **Regionally extinct**

Eritrea **Regionally extinct**

Ethiopia **Native**

Gabon **Possibly extinct**

Gambia **Regionally extinct**

Ghana **Native**

Guinea **Native**

Guinea-Bissau **Native**

India **Native**

Iran **Regionally extinct**

Iraq **Regionally extinct**

Israel **Regionally extinct**

Jordan **Regionally extinct**

Kenya **Native**

Kuwait **Regionally extinct**

Lebanon **Regionally extinct**

Lesotho **Regionally extinct**

Libya **Regionally extinct**

Malawi **Native**

Mali **Native**

Mozambique **Native**

Mauritania **Regionally extinct**

Morocco **Regionally extinct**

Namibia **Native**

Niger **Native**

Nigeria **Native**

Pakistan **Regionally extinct**

Rwanda **Native**

Saudi Arabia **Regionally extinct**

Senegal **Native**

Sierra Leone **Regionally extinct**

Somalia **Native**

South Africa **Native**

Sudan **Native**

Swaziland **Native**

Syria **Regionally extinct**

Tanzania **Native**

Togo **Presence uncertain**

Tunisia **Regionally extinct**

Turkey **Regionally extinct**

Uganda **Native**

Western Sahara **Regionally extinct**

Zambia **Native**

Zimbabwe **Native**

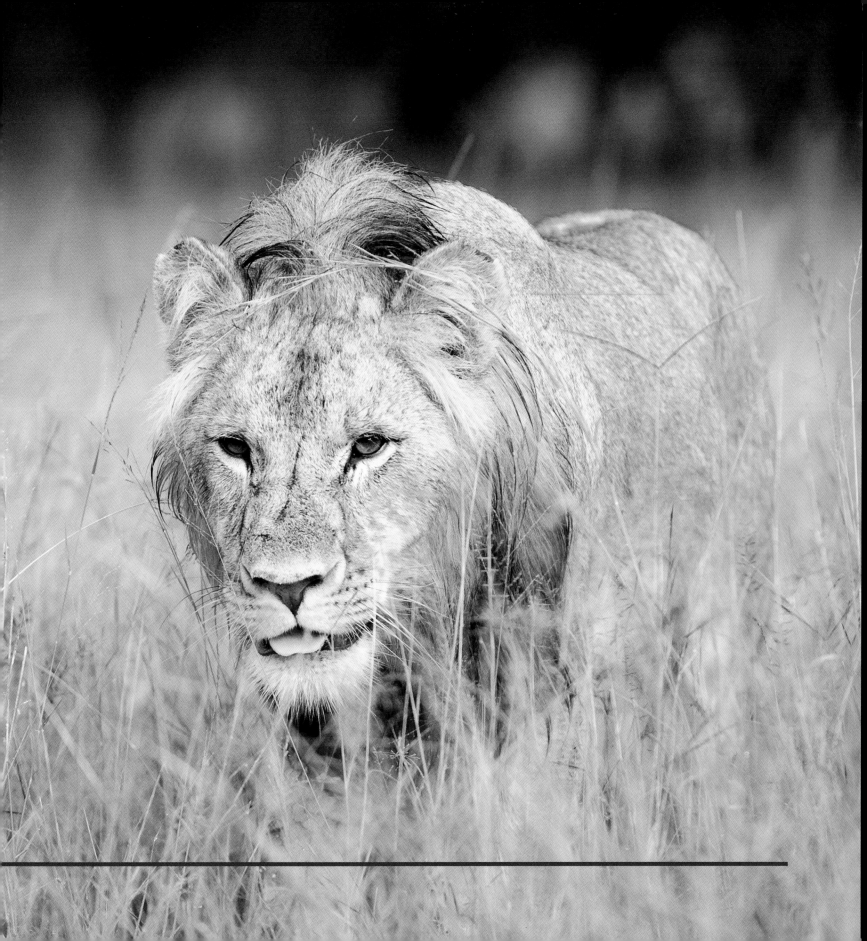

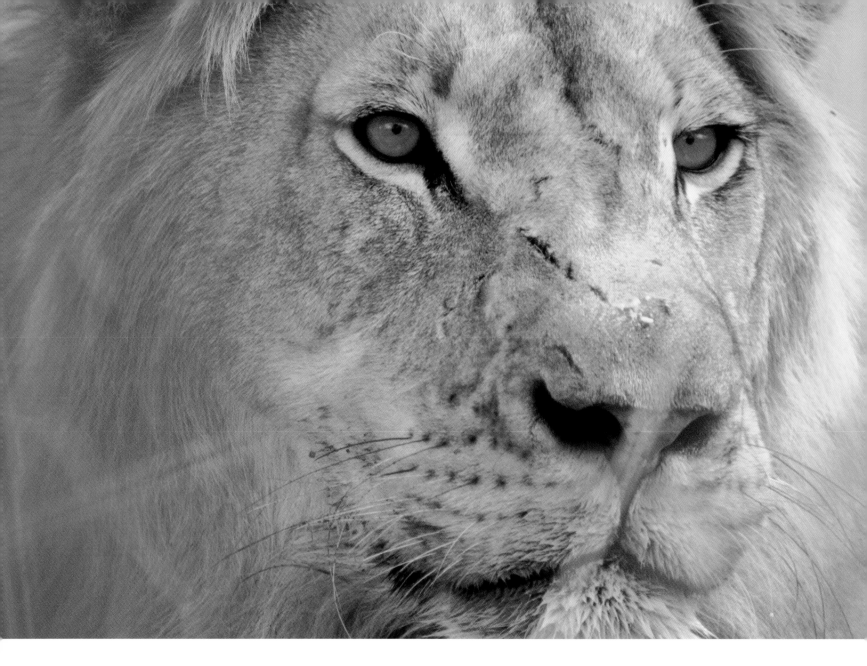

Focus on: Zambia

Zambia is one of the few countries where lions are still widespread and regularly encountered close to human settlements. However, their distribution outside the national parks and game-managed areas has dwindled significantly as a result of persecution and habitat degradation. Today, lions are found more or less throughout the country, mainly in the larger, more remote protected areas, such as North and South Luangwa, and the Lower Zambezi. Even where lions are no longer resident, it's thought they may occur sporadically as transient individuals or groups.

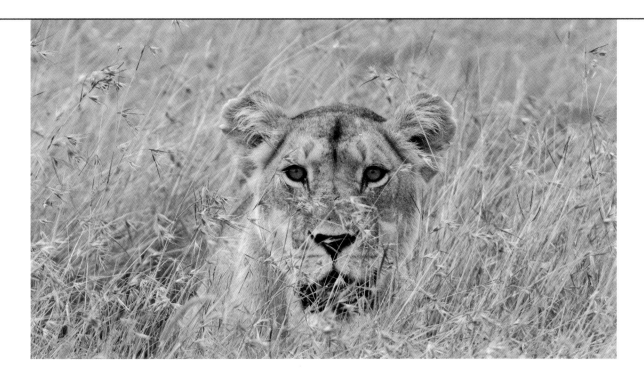

Little contemporary density or population data is available for these or any other areas, although it may be assumed that densities decrease with distance from the major rivers and floodplains, except in the areas immediately surrounding permanent water. This reflects the relationship between the number and size of prides, density of resident concentrations of prey species, and availability of water. In some areas it may well be that lion numbers are also affected by the predatory success of competing carnivores, such as hyenas.

The Luangwa complex may be considered as one of the lion's main strongholds in all of Africa, with a population estimated at close to 1,500 individuals. In the early 1990s detailed studies were carried out in the Nsefu Sector of South Luangwa National Park and the adjoining riverine region of the Upper Lupande Game Management Area, in total an area covering 355 km². These studies concluded that, 'the number of lions in the Hunting Block was estimated at 410 (+/-48), with 205 adults including 40 (+/-5) adult males'.

There are no lions resident in Kasanka National Park, nor it seems in Lavushi Mande National Park. The last sighting in Kasanka was of three animals in 1996, and they are thought to have come from the nearby Democratic Republic of Congo. The Mweru Wantipa and Sumbu National Parks have few lions, as game populations have been massively reduced due to poaching.

There is considerable variation throughout the Protected Areas system in Zambia. These populations occur in some 80,000 km² of suitable habitat, comprising approximately 25,000 km² of national parks and 55,000 km² of reserves or hunting areas. Kafue National Park has a high density of lions, particularly around the river valleys where prey species are still plentiful. Elsewhere, densities are much lower in the West Lunga National Park, Lochinvar and Blue Lagoon National Parks.

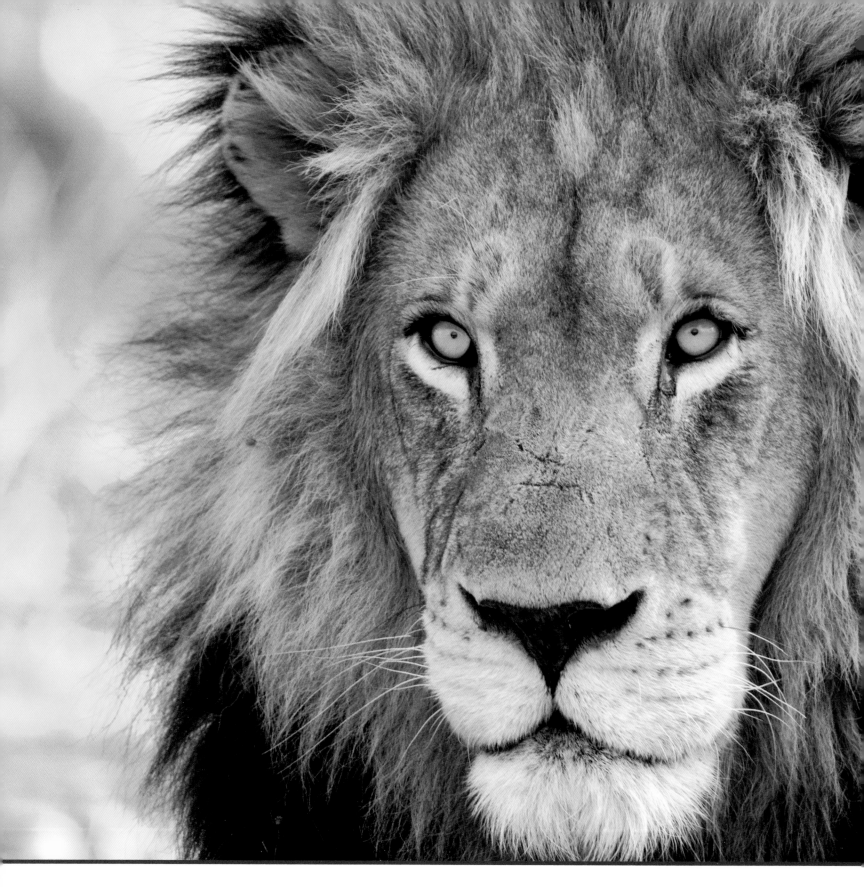

Focus on: **Uganda**

The lion population in Uganda continues to be fairly strong and well distributed. However, it is under increased threat because of high levels of lion/human conflict, either directly (lion on human) or indirectly (lion on livestock).

Between 1923 and 1994, 275 people in Uganda were attacked by lions, of which 206 died. Many of these attacks have been attributed to the lion defending a kill against human scavengers, a fairly common occurrence in this country. In the area near northern Queen Elizabeth National Park (QENP), losses from lion predation on livestock between 1990 and 2000 were estimated to have a value of US$6,400, a significant amount in such a poor area.

Despite this, people's attitudes towards lions remain relatively positive. In a survey conducted in the region of QENP, as few as just over a third of respondents believed that problem lions should be killed. Two-thirds of those questioned felt that non-lethal remedies, such as fences to protect livestock and better education on how to behave around lions, were the most appropriate solutions.

Focus on: Côte d'Ivoire

According to a report from the workshop Lion Conservation Strategy for West and Central Africa, bushmeat, including lion meat, is of considerable importance to people's diet in West and Central Africa and accounts for two-fifths of the diet in Côte d'Ivoire. The hunting of the lion's prey base has contributed to the decline of the lion population, as well as increasing the likelihood of conflict with humans when lions seek to replace lost natural prey with livestock, often leading to the retributive killing of lions by angry farmers.

Although it is impossible to be certain, it is reasonable to assume that lions are now extinct in Côte d'Ivoire. Lion populations within neighbouring countries, which could form the basis for natural re-colonisation, are also small or non-existent: lions in Ghana have been extirpated in recent years; they were never present in Liberia; Guinea and Mali are believed to have only 21 each; and any remaining within Burkina Faso are in the eastern side of the country, away from the border with Côte d'Ivoire. Therefore, any effort to re-establish lions in Côte d'Ivoire at this stage would rely on translocation of populations from non-West African countries, a point of theoretical conflict among some conservationists.

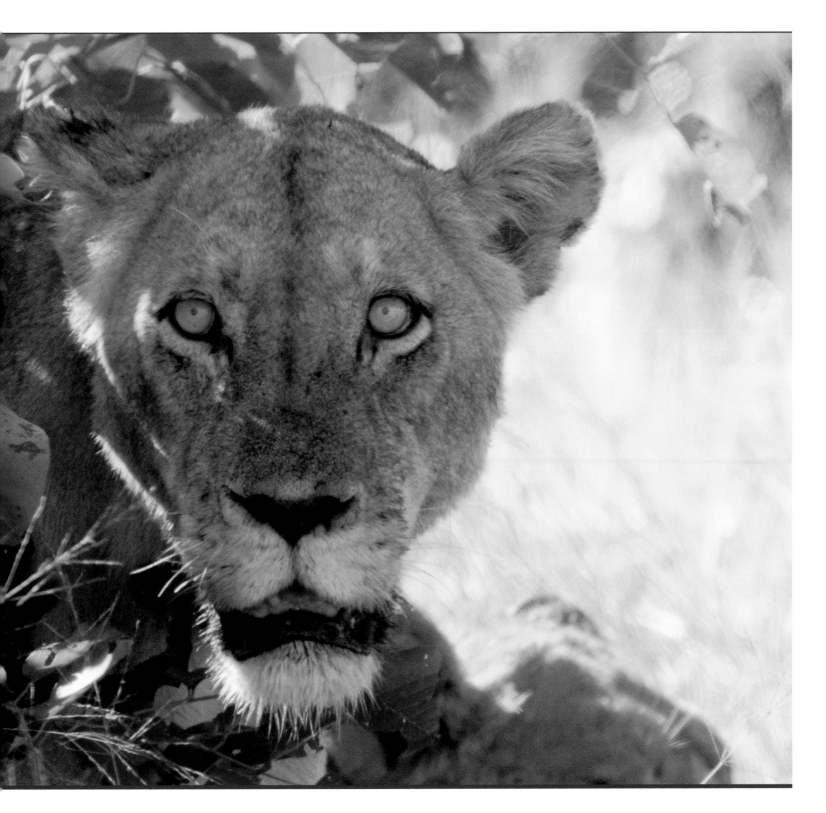

Focus on: Ghana

At the conclusion of a national workshop on carnivore conservation, held in January 2009, none of the participants was able to confirm the presence of lions in Ghana. A possible sighting in Digya National Park, west of Lake Volta, was made in October 2008, the first credible report of lion presence in nine years, and an instance of human/lion conflict was reported from near Kalakpa Resource Reserve in south-eastern Ghana, near the border with Togo, in February 2009. But that has been about it.

A 2010 report further concluded that the picture in Ghana was 'grim'. It suggested a need to restore lions through natural re-colonisation, following a successful programme of habitat protection measures. However, given the apparent loss of lions from neighbouring protected areas, the chances for local re-colonisation are deemed remote, at best.

Another report written in 2010 concluded that lack of prey in Ghana's Mole National Park, previously considered to be plentiful enough to maintain a viable breeding population, was less likely to be the cause of the loss of the region's lion population. The study noted that instances of fatal persecution as a result of human/lion conflict pose a significant threat in the area, with almost half of villagers stating they had encountered problems with lions threatening or attacking livestock. The study also discovered the sale of lion skins and claws in a market in Tamale, the regional capital near Mole, and noted that over half of villagers believed that lions were used for traditional ceremonial and medicinal purposes.

In light of these reports, any attempt to reintroduce lions must take into account broader strategies to reduce human/lion conflict in Ghana, as well as ensuring connectivity between reintroduced lions and remnant populations, to ensure a natural gene flow.

DAVID'S SAY...

'The focus of the ALERT programme is to work with governments to restore lions into areas where they have become locally extinct.'

AFRICAN LION & ENVIRONMENTAL RESEARCH TRUST

ALERT
www.lionalert.org

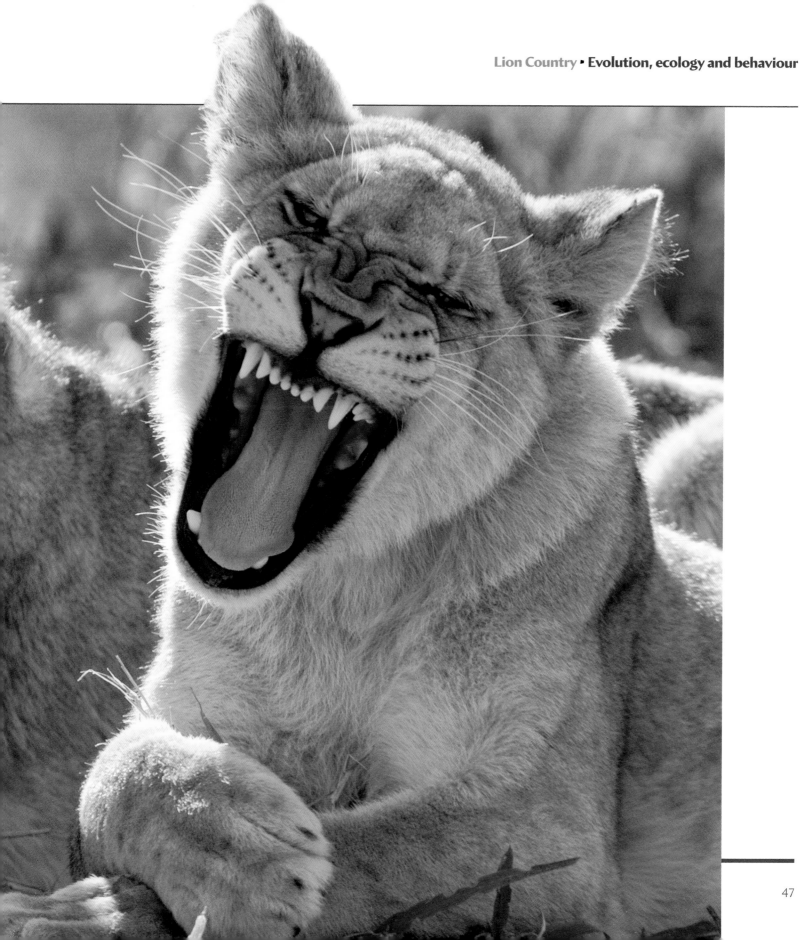

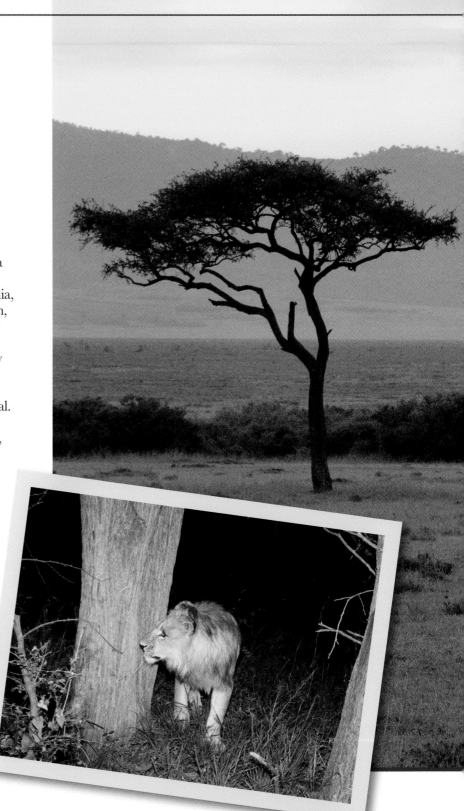

Habitat

Our perception of lion habitat has largely been influenced by television programmes and films, which almost invariably portray the wide-open savannas of East Africa. However, the lion is a supremely adaptable creature, able to survive in most types of habitat with the exception of tropical rainforest and the interior of the Sahara Desert. In the Bale Mountains of Ethiopia, for example, and on Mount Kilimanjaro in Tanzania, lions have been seen at elevations above 4,000 m, while in central southern Africa the lion's ability to obtain sufficient moisture from its prey to quench thirst also enables it to exist in extremely arid environments, such as the Kalahari Desert.

Namibia's so-called desert lions are a prime example of the adaptability of the lion in general. Living along the Skeleton Coast in the west of Namibia, they have developed a unique lifestyle, acquiring habits and survival techniques that contrast significantly with those of the plains lions of East Africa and the lions that thrive in the mixed habitats of Kruger National Park in South Africa.

Optimal lion habitat, however, typically consists of thick brush, scrub and grass complexes, such as those found in the Serengeti/Masai Mara/Ngorongoro

HABITAT LOSS

Across the lion's range, habitat loss and conversion of habitat for mainly agricultural use have had a huge impact on lion numbers, restricting territories and fragmenting dispersed populations.

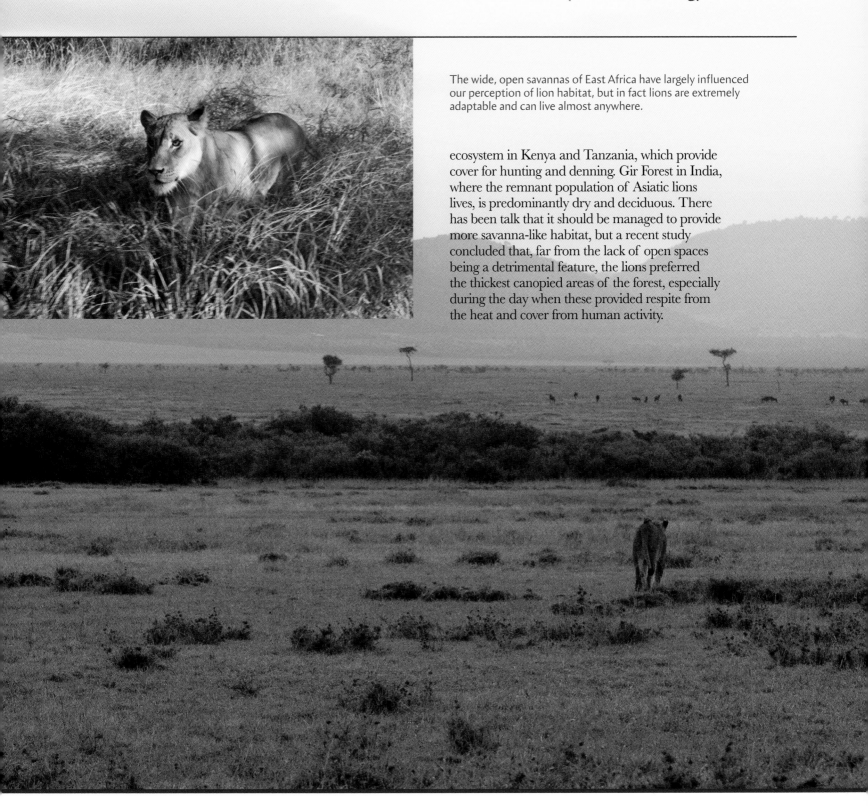

The wide, open savannas of East Africa have largely influenced our perception of lion habitat, but in fact lions are extremely adaptable and can live almost anywhere.

ecosystem in Kenya and Tanzania, which provide cover for hunting and denning. Gir Forest in India, where the remnant population of Asiatic lions lives, is predominantly dry and deciduous. There has been talk that it should be managed to provide more savanna-like habitat, but a recent study concluded that, far from the lack of open spaces being a detrimental feature, the lions preferred the thickest canopied areas of the forest, especially during the day when these provided respite from the heat and cover from human activity.

DAVID'S SAY...

'Lions tolerate a wide range of habitats, preferring open woodlands, thick bush, scrub and grasslands, but penetrating deep into deserts along watercourses.'

Pride structure

The lion is the only social big cat; it lives within an organised social structure known as a pride. The reason for this is the subject of much debate. Increased hunting success must be balanced against reduced per capita food intake when kills have to be shared. Shared responsibility also has its advantages. Some lionesses in a pride take a role in raising cubs, which can often be left alone for extended periods. Other benefits include possible kin selection (favouring the reproductive success of a relative), protection of offspring, defence of the territory and individual insurance against injury and hunger.

Typically, a pride consists of related females and their cubs and occupies a hunting territory large enough to sustain it during times of scarcity. The quality of the habitat – its suitability and the abundance of prey – will determine lion density, home territory size and social group size. Generally, prides are larger in moist grassland regions, where game is plentiful, and smaller in dry bush that has fewer prey animals.

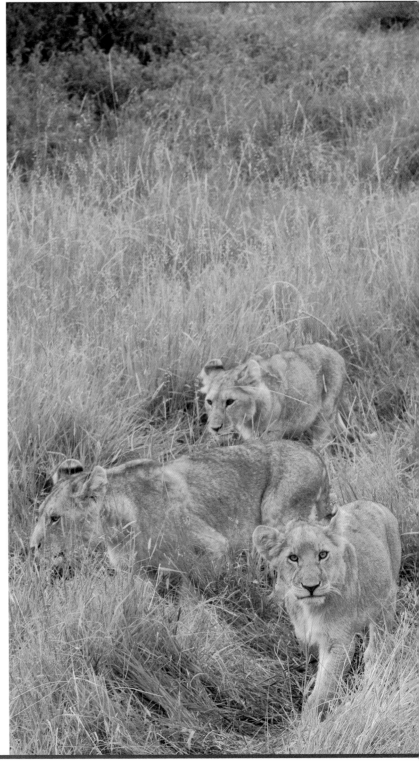

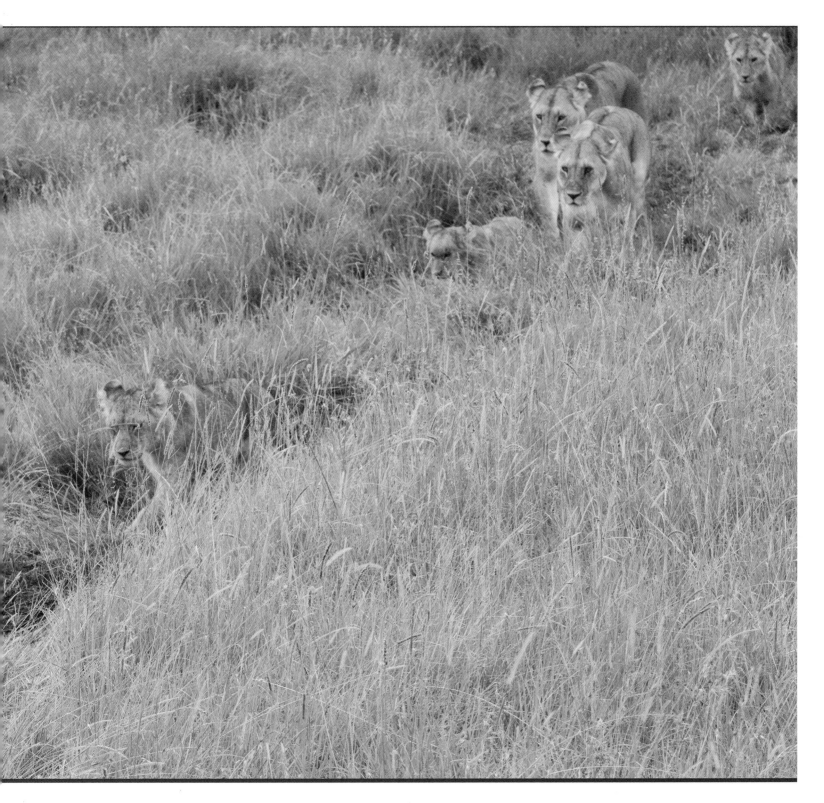

^ Lions are the only big cats to live in a family group, known as a pride.

> After being evicted from the pride, young male lions become nomadic, living alone or in small groups until they are strong enough to take over a territory.

Home territories range from 20 km² in the best habitats to more than 500 km² in regions where prey is scarcer. It's not unusual for pride ranges and territories to overlap, but each pride maintains a core zone within which most of their activities are undertaken, with little interaction with other lion groups. Territories are stable except in periods of hardship and if an area becomes devoid of lions – as a result of disease, for example – there will be a quick influx of competitors battling it out to claim it as their own.

Prides may have as many as 40 members or even more, but are usually smaller: prides within Serengeti and Kruger National Parks, both primary strongholds of the lion, average 13 and 14 members respectively. Females always outnumber males. In larger prides it is rare for the whole pride to spend all their time together; individuals or small groups, typically of three to five members, will scatter throughout the territory for days or even weeks at a time, especially in arid environments or when prey is scarce.

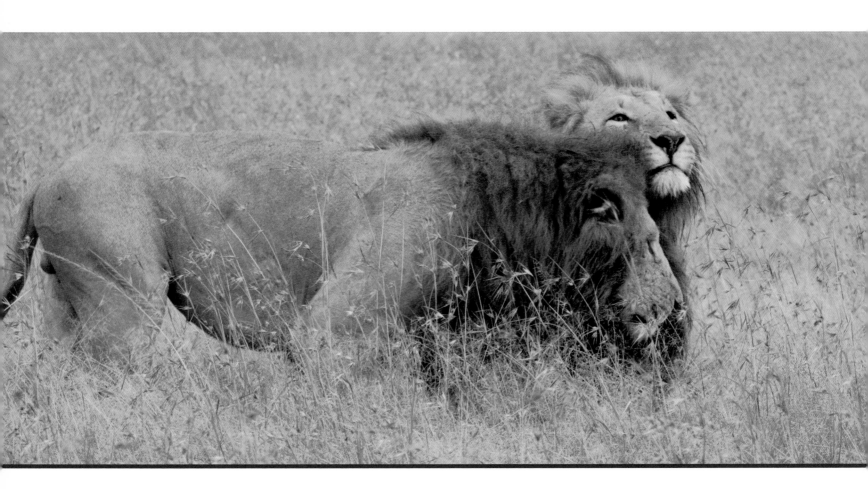

^ Two males greet each other with an amicable ceremony.

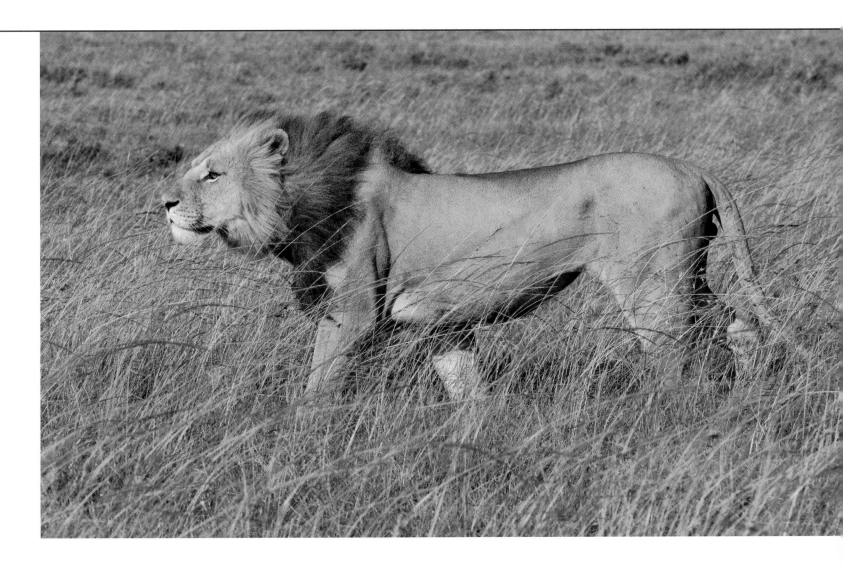

There is no hierarchy among females, and no particular bonding between any pride members, although the adult females in a pride are usually related and stay within their natal range throughout their lives. An exception arises if there is a shortage of food, in which case two-year-old females will be forced to leave. Research indicates that each pride has an apparent maximum number of females. In Kruger National Park, for example, the number of lionesses in six neighbouring prides remained constant for two and a half years, even though the actual membership of the prides changed. If the number falls below the capacity for the home range, subadult immigrants may be allowed to join.

Presence within a pride's territory is not a sign of membership of the pride, as some lions will simply be passing through. Membership of a pride can be distinguished only by an amicable greeting ceremony; anyone lacking the confidence to perform the ceremony will be treated as an outsider.

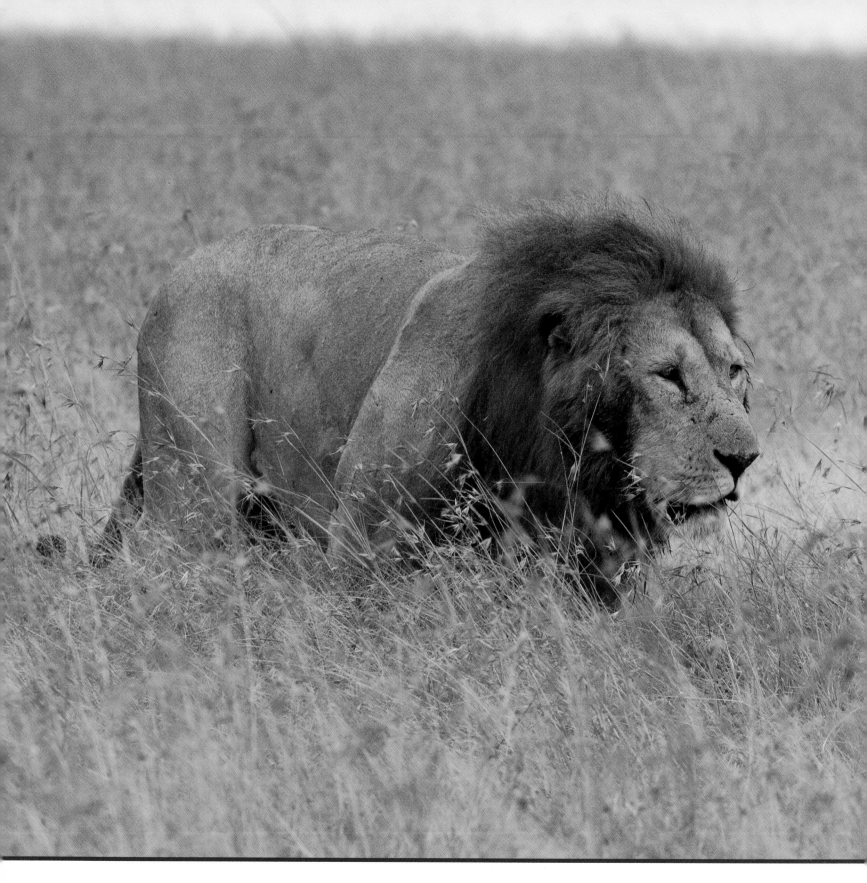

< An old male lion shows the scars of battle on his nose, war wounds gained when defending his territory from insurgents.

Adult males are transient members of a pride, normally in charge of a territory for about two years. On reaching maturity, young males are ejected from the maternal pride because they pose a threat to the sitting dominant male and can disrupt the social group. They then become nomadic, ranging widely and moving about sporadically, either singly or in small groups, typically pairs, known as coalitions. Pairs are most frequent among related males who have been evicted from their birth pride.

This nomadic lifestyle, which resembles a human 'rite of passage', is endured until such time as the males are powerful enough to take over a pride area, usually when they are about five years old. Territorial battles between males are ferocious. If the invading lion or coalition is successful, the resident male or males will be ejected and are liable to die within a short period, either of their injuries or of starvation.

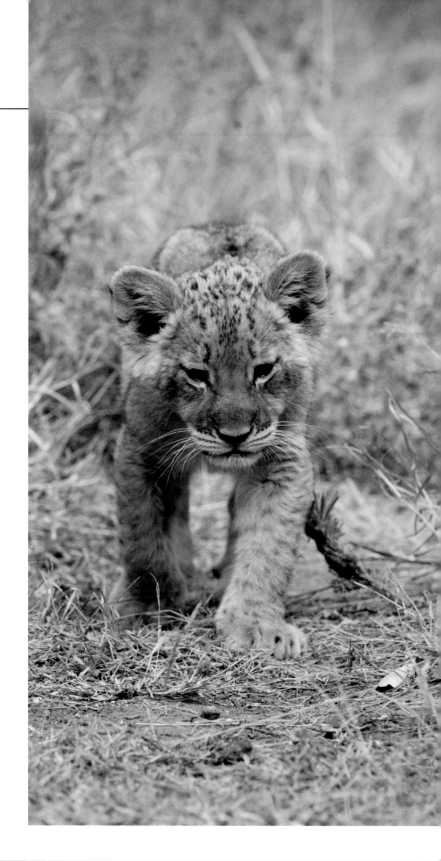

On taking over a pride area, the new ruler or rulers will immediately attempt to kill all the resident cubs under the age of a year. Some females may try to defend their cubs and will sometimes leave the pride in order to protect them. But infanticide is a necessary part of the lion's reproductive cycle. The average interval between the birth of a litter and the female's next oestrus is 530 days – not far short of the average tenure of a pride male. However, the loss of her cubs will bring a lioness into oestrus immediately and she will mate within a few days or weeks. So, by killing any progeny within the conquered territory, the new male gives himself the opportunity to reproduce and pass on his genes during his reign.

Following the successful takeover of a pride area by a new male or coalition, and the loss of any cubs, females enter a period of heightened sexual activity, mating frequently. However, for the first four months or so, they rarely conceive. This period of infertility is probably designed to ensure that the new dominant males are strong enough to hold the territory against other immigrant males and to increase their bond with the females, reducing the chance that they will desert the pride.

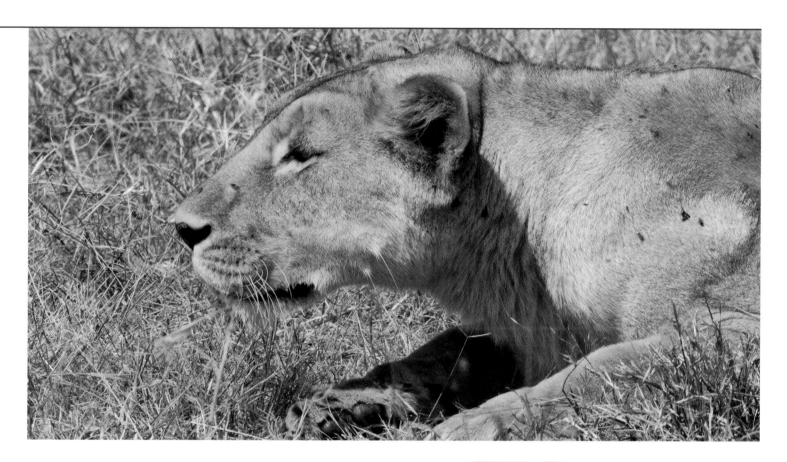

‹ When a male takes over a territory, resident cubs are in grave danger from the new 'king'.
^ Lionesses will sometimes fight to protect their cubs from the new territorial ruler.

Both males and females will defend the pride area against intruders of the same sex. Females don't normally allow outside females to join the closely knit social unit, while males must defend their relationship with the pride against outside males who attempt to take over. In any confrontation, pride members assume specific roles. Some will be assigned to lead the defence, while others lag behind to provide other valuable services to the group.

DAVID'S SAY...

'One of the most fascinating observations from the ALERT programme is how the behaviour of our lions so closely resembles that of wild lions.'

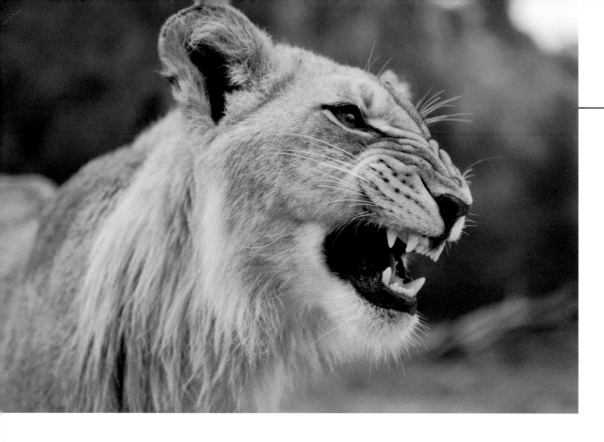

< Snarling is a common
form of lion communication.
> A young cub hisses at
a perceived threat.
˅ A lion's roar starts in its stomach
and is a deep, guttural sound
characteristic of the species.

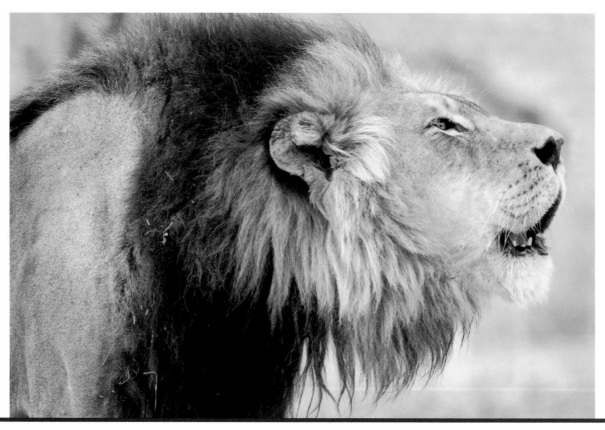

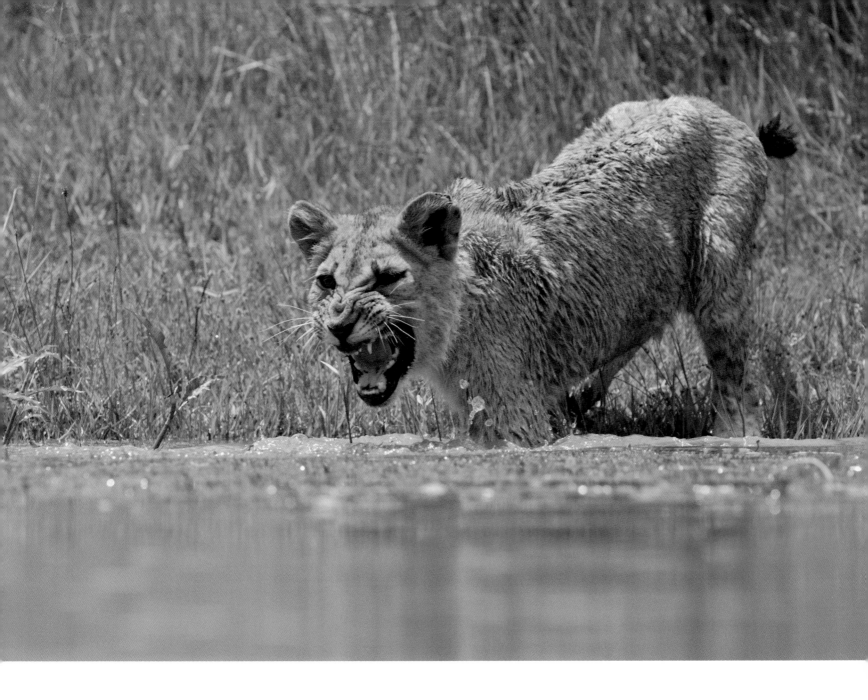

Communication

The lion has the loudest roar of any of the big cats but roaring isn't its only form of communication. The most common purpose of the roar is to signal a lion's presence. It's a characteristic behaviour, starting deep in the stomach and emitted first in a long guttural sound that can be heard over several kilometres before tailing off into shorter, less intense roars. This variation in intensity and pitch, rather than discrete signals, appears central to lion communication. In addition, their vocal repertoire includes snarling, purring and hissing, and cubs in particular make a meowing sound very similar to that of a domestic cat.

Social licking is common between pride members and is comparable to grooming among primates.

Like most mammals, lions also use an array of facial expressions and body language for the purposes of communication. The most common non-threatening tactile gestures are head rubbing and social licking, which have been compared to grooming in primates. Head rubbing (nuzzling the forehead, face and neck against another lion) is a form of greeting, often displayed when a lion has been apart from the pride, or after a fight or confrontation.

Rubbing typically occurs between adult members of the same sex or between cubs and adult females. Social licking often occurs in tandem with head rubbing and is generally mutual. The head and neck are the most common parts of the body to be licked, which may have arisen out of necessity, as a lion cannot lick these areas of its own body.

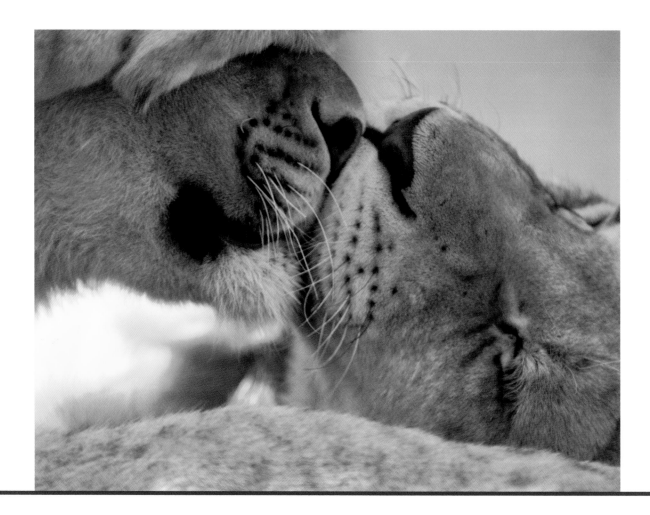

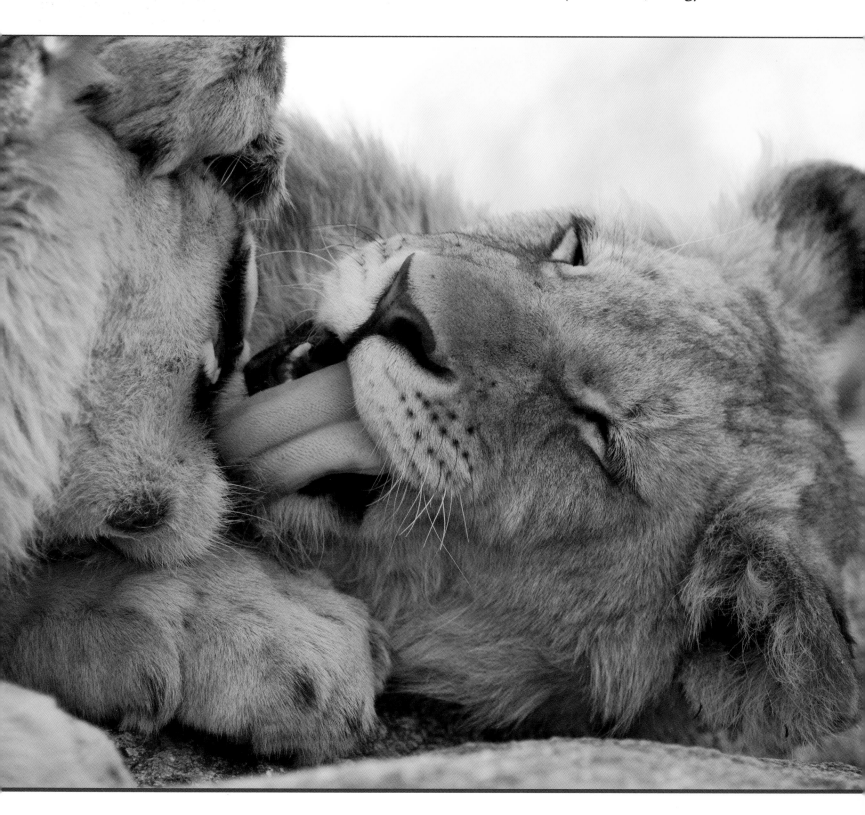

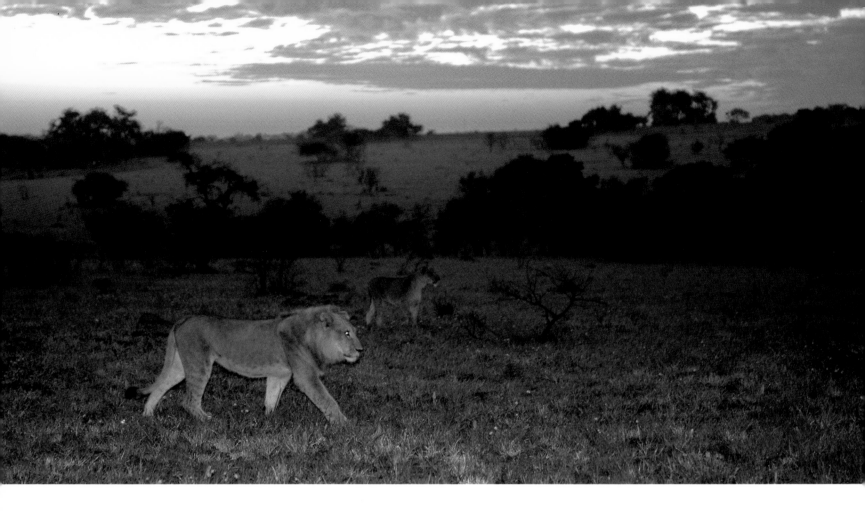

Hunting and predation

Hunting usually takes place in open spaces, making it easier for prey to see the potential threat. To overcome this disadvantage, the lionesses of a pride operate as a team (males are rarely involved when a pride hunts unless the prey is particularly large, such as a buffalo or elephant). Each has a favoured position or a specific task to perform, which may involve flanking the prey to create a diversion, stalking prey on the wing of the herd, or making the actual attack. Because lions lack stamina (they have relatively small hearts) the lionesses will stalk their prey to within 30 m or less, using natural or geographic features, such as trees, termite mounds or hillocks, or the cover of darkness to reduce their visibility. For such large animals, lions are surprisingly stealthy. One night at Antelope Park, I watched a two-and-a-half-year-old male sneak to within a metre of a duiker (a small antelope) without being detected.

During a typical hunt, several lionesses working together encircle a herd of prey from different points. Once they have closed the gap between themselves and the herd, they attempt to isolate an individual animal, often the weakest or oldest. The attack, when it comes, is short but powerful, involving a fast rush and a final leap, with the lion using all its upper body strength to inflict a debilitating and, ultimately, fatal injury.

The force of the initial attack may instantly kill smaller prey, such as small antelope or calves. With larger animals such as zebra and wildebeest, the prey is usually immobilised first and then killed by strangulation or suffocation before being consumed. However, it is not uncommon for lions to begin eating before the prey is dead, starting from the underbelly.

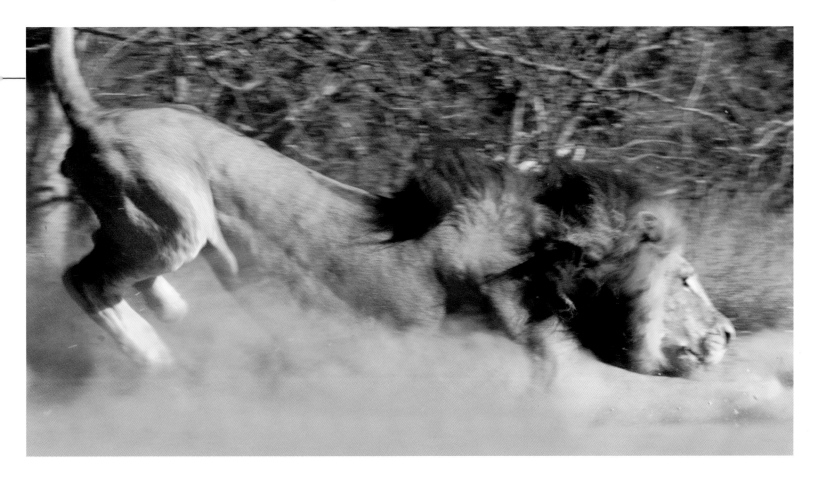

⌐ Lions typically hunt during times of low light –
at dawn and dusk – and at night.
∧ The force of the initial attack can kill
smaller prey instantly.
‹ Once a kill is made, lions gorge
themselves in a feeding frenzy.

Once a kill is made, the lions gorge
themselves in a feeding frenzy, consuming up to
30 kg of meat in a single sitting. When they're
full, if there's any meat left, they will rest nearby
and return to the carcass later. If the pride male
appears, the females will make way and allow
him to take over the kill, seeking his permission
to approach if they want to feed again. With
large prey, where there is an abundance of meat
even for a large pride, the lions will drag the
victim to a sheltered position.

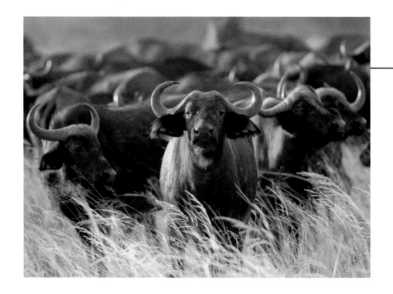

A lion's choice of prey is dictated by habitat and health. In general, lions prey on ungulates of a certain size (between 190 kg and 550 kg), which includes wildebeest, zebra, impala and buffalo. Studies in the Serengeti have identified wildebeest as the primary prey species, followed by zebra. In Kruger giraffes are a popular prey; in Manyara National Park in Tanzania buffaloes form nearly two-thirds of the lions' diet. The Asiatic lion normally feeds on nilgai (a large antelope), wild boar or any of the numerous deer species.

In Tanzania's Manyara National Park buffalo are the lions' preferred prey, while in the Serengeti wildebeest predominate. Throughout the lion's African range, zebras and other ungulates of a certain size also feature prominently in the diet. Along the Savuti River in Botswana, there is a pride that specialises in hunting elephants.

WHY STRIPES?

On the face of it, black and white stripes may not seem the most appropriate camouflage for an animal that lives in a yellow savanna. But zebra camouflage is one of the most effective in Africa. In a herd, zebras are constantly moving, never still. As they move, those stripes mingle and merge to create a pattern which makes it impossible for a lion to tell one end of a zebra from another. Without a specific target point no lion will attack, as it is liable to be killed by a forceful kick. Instead, the lions will wait to isolate a single zebra, at which point black and white stripes become a distinct disadvantage.

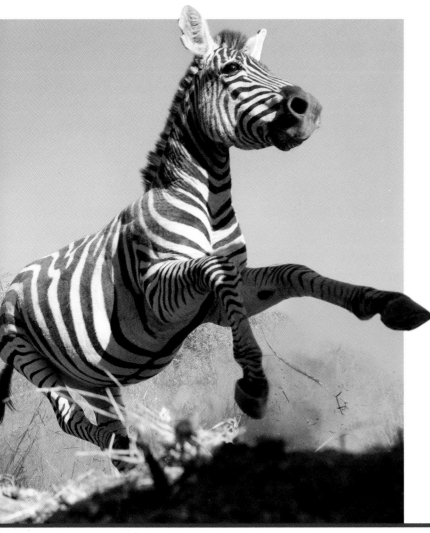

However, lions are unfussy and opportunistic predators and will take both larger and smaller animals in a variety of circumstances: when there is a scarcity of large prey, when hunger drives them or simply when the chance presents itself. Warthogs in particular, but also kudu, hartebeest, gemsbok and eland are among the many species on which lions will prey. Larger animals such as the hippopotamus may also be attacked (although rhinoceroses are usually left alone), as may some of the smaller deer and antelope, such as Thomson's gazelles and springboks.

When lions are hunting in groups, few animals are invulnerable. Along the Savuti River in Botswana, for example, one pride of lions has begun to specialise in preying on elephants. Initially, it is believed that extreme hunger drove them to attack calves. Over time, however, they progressed first to adolescents and then to full-grown adults. The attacks usually take place at night, when the darkness provides cover for the lions and the elephants' vision is poor. Such adaptation and specialised feeding is not uncommon in areas where there is a lack of prey variety.

Although lions are highly skilled predators, they are also adept at scavenging, feeding off animals that have died of natural causes or stealing a kill from another predator, such as a cheetah or a pack of hyenas. Lions are acutely aware of the role of vultures and keep a constant look-out for circling birds, knowing that this indicates a dead or dying animal. Scavenging can lead lions into trouble, however: unlike vultures, they aren't immune to the diseases that cause the death of some wild animals and can pick up an illness by consuming diseased meat.

Where natural prey is scarce, lions, like all predators, will resort to other sources of food, which often means domestic livestock. Across Africa and in India, livestock is of significant value to impoverished communities and the financial loss incurred when lions strike is large.

This is the most common cause of human/lion conflict in both regions and is perhaps the greatest threat to the long-term future of lions. Lions are also known to kill competing species, such as leopards, cheetahs, wild dogs (also known as hunting or painted dogs) and hyenas. Such attacks, however, are driven by a desire to reduce competition for prey rather than to quell hunger, as the lion will rarely consume its victim.

Cubs first display stalking behaviour around the age of three months, although they do not participate in hunting until they are almost a year old and cannot hunt effectively until they are nearly two. Lion cubs in the Rehabilitation and Release into the Wild programme have displayed exactly the same predatory behaviour as wild lion cubs and developed their hunting skills within the same period.

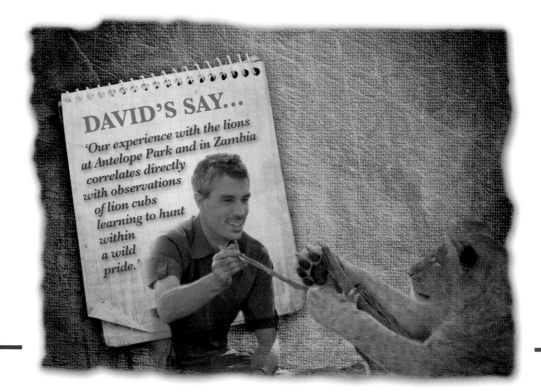

DAVID'S SAY...

'Our experience with the lions at Antelope Park and in Zambia correlates directly with observations of lion cubs learning to hunt within a wild pride.'

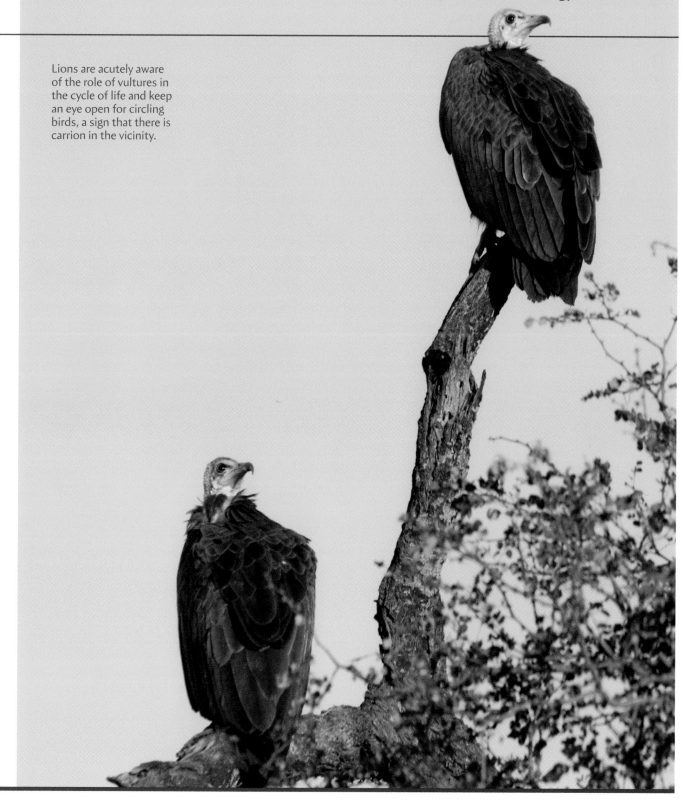

Lions are acutely aware
of the role of vultures in
the cycle of life and keep
an eye open for circling
birds, a sign that there is
carrion in the vicinity.

Reproduction

When lions mate it is not a short affair. There is no mating season and females will ovulate more than once every year. In some cases, however, synchronised breeding patterns have been observed, notably in Kruger (with birth peaks between February and April) and in Serengeti (March–July). This behaviour may be related to seasonal weather patterns and prey availability.

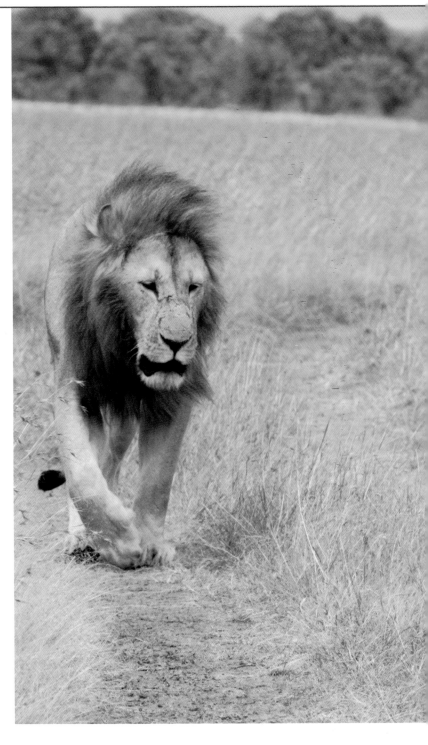

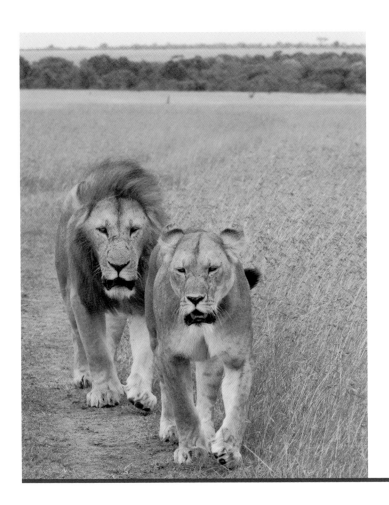

^ Mating between lions isn't a short affair and begins with the male following the lioness around for days on end – like a feline stalker.

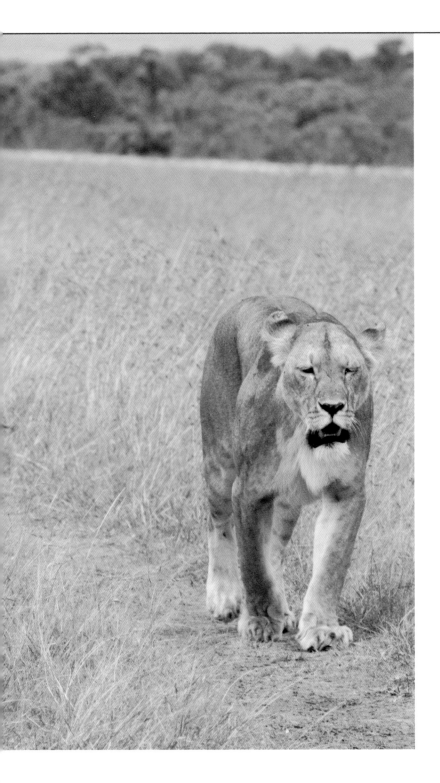

Male lions become sexually mature at around 26 months but are unlikely to breed before the age of four or five years, due primarily to a lack of opportunity. Often they must wait until they are large enough and strong enough to take over a pride area, thereby acquiring breeding rights over the pride. That said, males as young as 27 months have sired cubs at the Phinda Private Game Reserve in South Africa, and males as old as 16 years are able to produce viable sperm (although at this age, they are unlikely to father any more cubs, because they will almost certainly have lost control of a pride area).

Females mature between the ages of two and a half and three years; most lionesses will have given birth by the time they are four. Their reproductive capacity starts to decline when they are about 11 years old, but births in older lionesses are not impossible: one lioness in the Kgalagadi Trans-frontier Park is known to have given birth at the age of 19.

Females usually come into oestrus in response to influences within the pride, such as oestrus in other females, or because they have lost their cubs. Either the male or the female may initiate courtship, the pair then remaining close during the whole oestrus period of four to seven days. As soon as oestrus starts, a male will follow a female very closely. Other males keep their distance, unless there is a clear size difference, in which case a larger male may fight a smaller one. This lack of sexual competition works in lions because the oestrus period is long and the pair copulate many times. Males have been known to lose interest before the end of an oestrus period, giving patient rivals a chance to take over.

When the courting couple is ready to mate, the female usually invites copulation by inwardly arching her back. The male will then climb on top and enter her. Each mating lasts only around 20 seconds, but the pair may copulate up to 100 times in a day. Before dismounting, the male will take the scruff of the female's neck between his teeth. Once he has a firm grip, he will dismount and move quickly out of range. This behaviour is a form of self-defence. As with other cats, the male lion's penis is barbed with backward-pointing spurs. When the penis is withdrawn, the spines rake the walls of the female's vagina, stimulating ovulation but at the same time causing her sufficient pain to make her attempt to bite the male.

˅ Mating lasts for a short time, usually around 20 seconds, but can take place up to 100 times in a day. When the male dismounts, he bites down on the scruff of the lioness's neck. This is because his penis is barbed and causes her pain when he pulls out, in response to which she is liable to bite him.

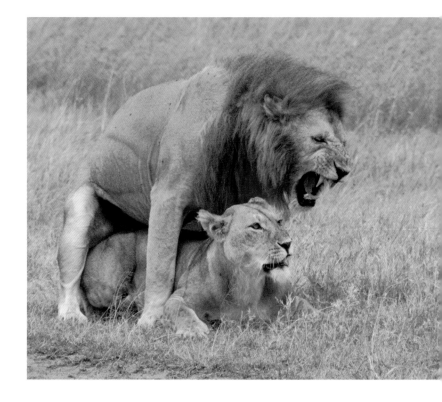

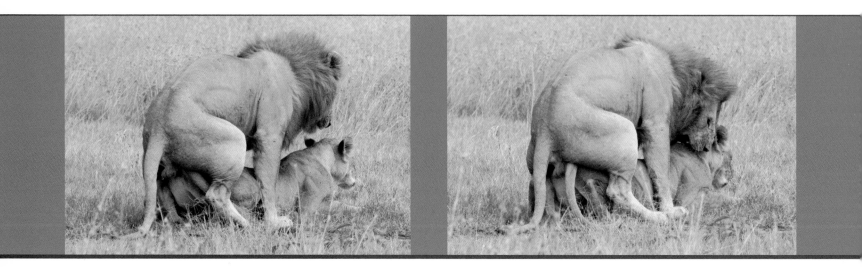

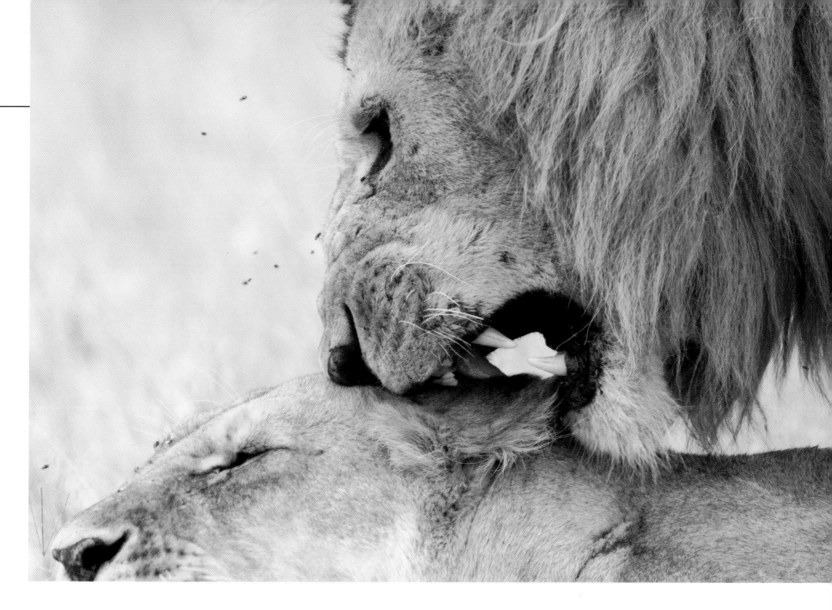

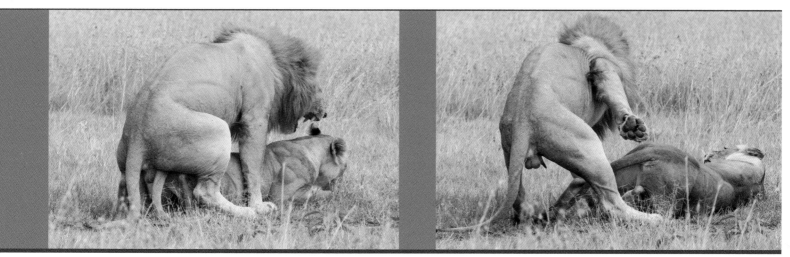

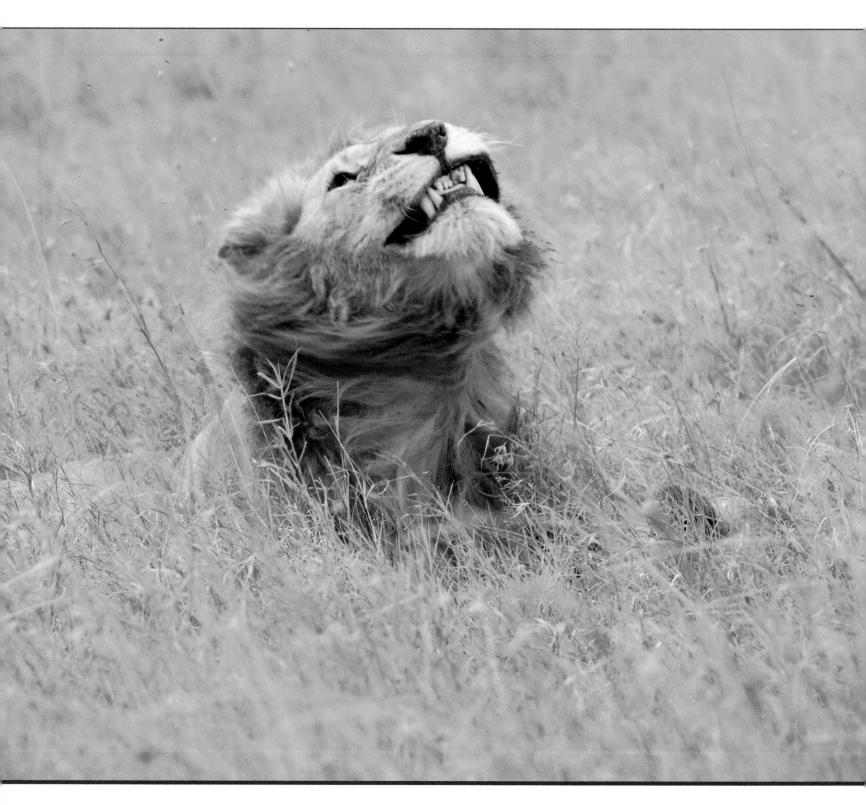

Immediately after copulation, the male grimaces with what looks like a 'cat that got the cream' smirk, while the female may roll on her back in a display of fulfilment and contentment. During the breaks between copulations, the pair may lie together or a short distance apart. A new bout is initiated when the female nuzzles the male or the male gently licks the female on the shoulder, neck or back.

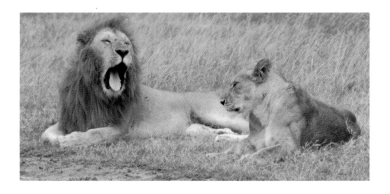

Giving birth

Conception occurs on the fourth day of oestrus and gestation lasts 100–120 days. Shortly before giving birth the female will move away from the pride to a well-hidden den, where the cubs are born. A typical litter contains three cubs but may have as few as one or as many as six. At birth, the cubs weigh around 1.5 kg and will gain around 100 g per day for the next four weeks.

The new mother and her cubs will rejoin the main pride only if any cubs already established in the pride are younger than three months old. Otherwise they will stay apart until the newborns are big enough to compete or until the older cubs are weaned. The reason for this is that lactating females suckle cubs indiscriminately, showing only limited favouritism towards their own offspring. Young cubs, therefore, are liable to suffer if they have to compete with cubs older than three months. This collaborative behaviour probably stems from the fact that all the females in a pride are closely related, so each is increasing her own genes' chances of success by helping raise her sister's offspring. Cubs suckle regularly for the first six months, less frequently thereafter. They remain with their mother until around the age of 30 months.

Cub mortality is high, at around 50 per cent. Cubs may die for a number of reasons, including disease, abandonment, infanticide, predation and ill health in the mother. In total, as many as eight out of ten cubs will die before they reach the age of two years.

Immediately after copulation, a male lion grimaces (left) while the female rolls on her back, seemingly satisfied. The pair then lie together or close to each other while they regain their energy for another bout.

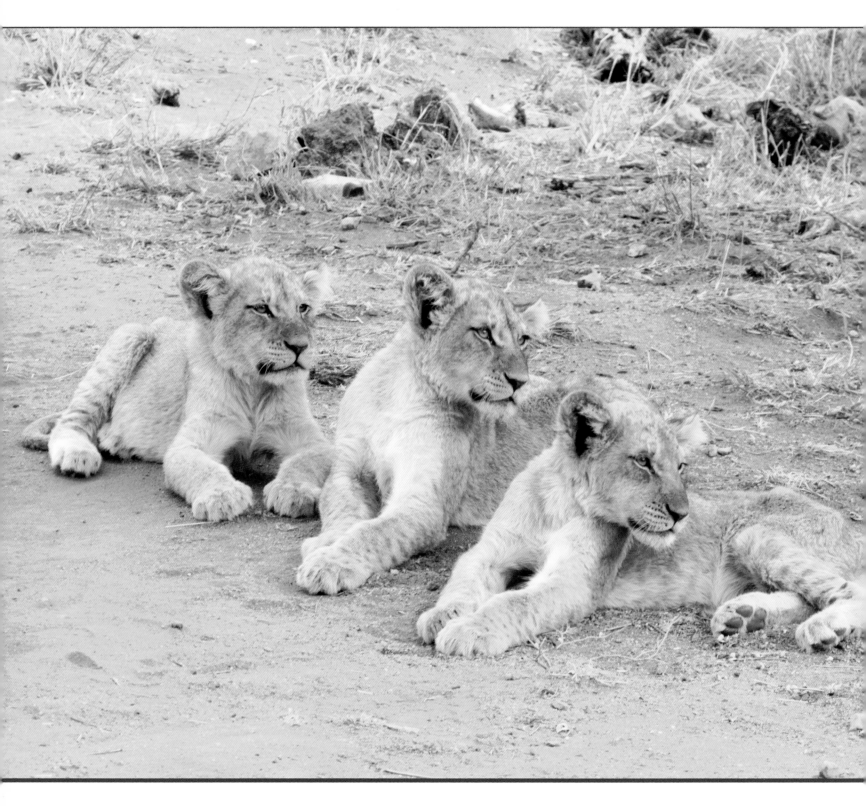

LIFE CYCLE OF LIONS

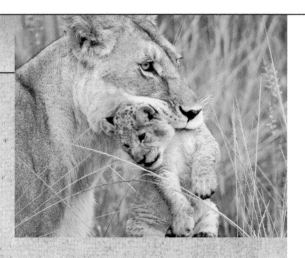

Day 1
Cubs are born weighing 1–2 kg. They are blind and helpless.

Days 3–10
Cubs open their eyes but their eyesight is poor for another week.

Days 11–15
Cubs start to walk for the first time.

Days 21–25
The milk teeth erupt. The canines show first, followed by the back teeth a few weeks later.

Days 26–30
Cubs are able to run.

Months 1–2
Cubs leave the den and are capable of the full range of vocalisations, except roaring.

Months 2–3
Cubs are capable of keeping up with the pride and begin to observe prey movement. Weaning starts.

Months 6–9
The cubs are weaned but remain dependent on their mother.

Months 10–12
The permanent teeth erupt, although it may be several months before they are all present. Cubs take part in hunts.

Months 12–24
Cubs make their first kills, usually involving small or injured animals.

Months 24–27
Cubs reach sexual maturity.

Years 2–3
Young males are pushed out of the pride. Young females may suffer the same fate if the optimum number of females has been reached.

Years 3–4
Both sexes are now fully grown.

Year 4
Females give birth to their first litter.

Year 5
Males take over the tenure of a pride area.

Year 7
Weight peaks and the male's mane attains its optimum quality.

Year 10
Males are ousted from the pride area by younger, fitter males. They typically die soon afterwards, but may survive for up to another six years.

Year 11
Female breeding success rate reduces.

From year 11
Females may die of old age, though some survive up to about 18.

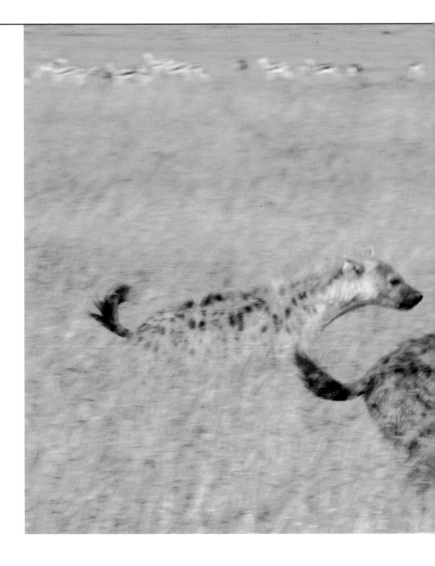

> Lions and hyenas have been described, fittingly, as 'eternal enemies'. In Africa, lions also have to compete with many other predators, including leopards, cheetahs and hunting (wild) dogs.

Health and mortality

The lion is an apex predator, meaning that it sits at the top of the food chain with no natural predators of its own. Without natural predators, most lions die either at the hands of man, as a result of disputes with other lions or through disease. Lions often inflict serious injuries on one another, either when members of different prides encounter each other in territorial disputes, or when members of the same pride fight at a kill. Nomadic lions, especially lone individuals who are unable to kill sufficient prey to keep themselves in peak condition, often weaken and fall prey to other predators.

Disease is a significant cause of mortality in lions. In 1962, almost the entire population in the Ngorongoro Crater in Tanzania was wiped out by an outbreak of stable fly, which returned in 2001 and resulted in the death of six more lions. They are also vulnerable to the canine distemper virus (CDV), which is spread through domestic dogs and other carnivores, especially wild dogs. In Serengeti, an outbreak of CDV in 1994 left many lions with neurological symptoms, such as seizures, and resulted in deaths due to pneumonia and encephalitis. It is believed that over half the lions in Kruger are infected with bovine tuberculosis, passed on by buffaloes, and the feline immunodeficiency virus (FIV), similar to HIV in humans, is close to endemic among lions in most of Africa, with the exception of Namibia.

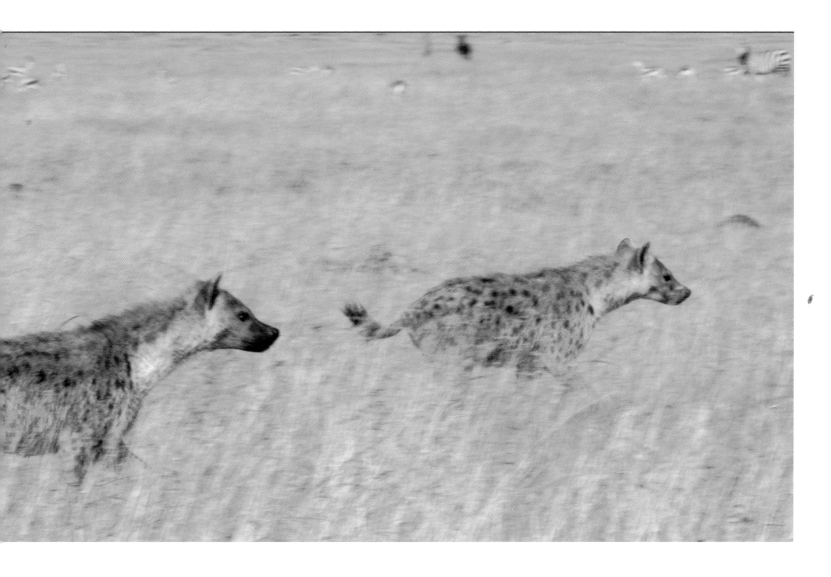

Relationships with other predators

In Africa, lions compete with other predators for prey: their relationship with the hyena is particularly hostile. The species have been described as 'eternal enemies' and it's an apt description for the two adversaries, who sometimes find themselves, quite literally, at war. In a recent conflict over territory in the Gobele Desert, Ethiopia, two weeks of ferocious battling ended with the violent death of 35 hyenas and six lions.

While the extent of this campaign isn't typical, when lions and hyenas meet – which is often, as they occupy the same ecological niche – the outcome is nearly always confrontational. With their larger size and greater power, lions typically react less aggressively towards the mere presence of hyenas but will scent-mark to affirm their territory (an unusual behaviour around other species). Hyenas, however, tend to react visibly when lions are around, irrespective of any immediate threat.

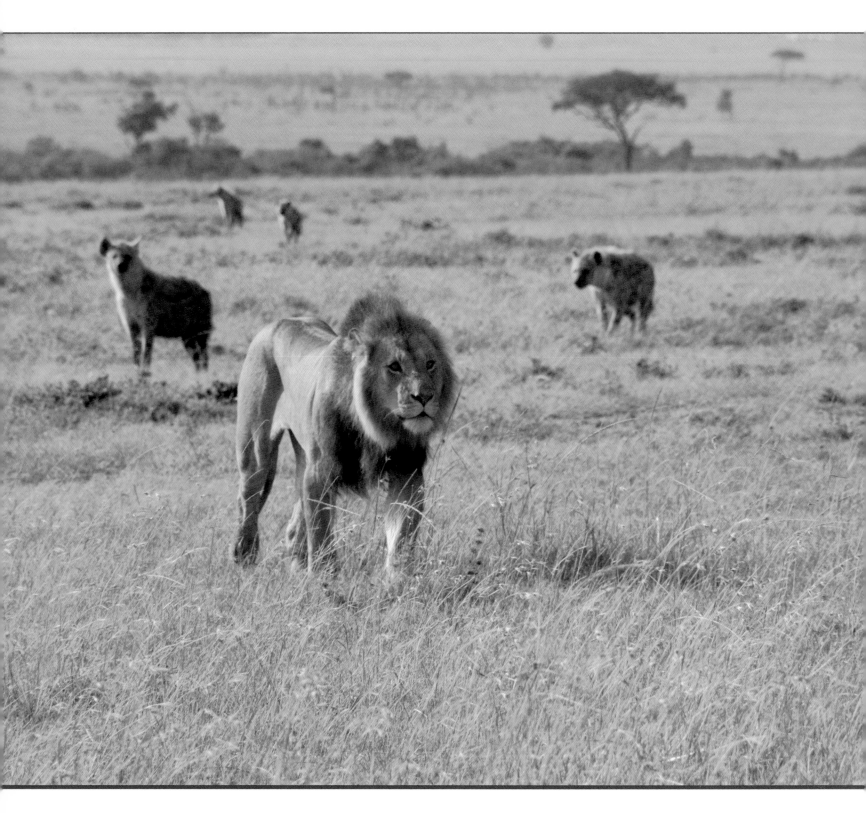

‹ Lions are adept scavengers and often steal prey from hyenas and other predators.
˅ Where they share habitat, lions tend to dominate other predators, such as cheetahs.

Being adept scavengers, lions regularly attempt to steal hyenas' kills and have been seen purposefully following the calls of hyenas feeding. If a marauding pride is large enough it will force hyenas off a kill. For their part, the ousted hyenas will either leave altogether or wait patiently and hopefully around 100 m away. Lone lions and small coalitions fare less well when confronting a pack of hyenas. Hyenas are successful predators in their own right and have the most powerful bite of any mammal in Africa, strong enough to crunch through elephant bones. A large pack is a match for a lion with little support.

Of the other predators, lions tend to dominate smaller cats, such as cheetahs and leopards, in areas where they share habitat. Lions may either scavenge kills, depriving the smaller cat of a necessary meal, or kill cubs and even adults in what appears to be anti-competitive behaviour.

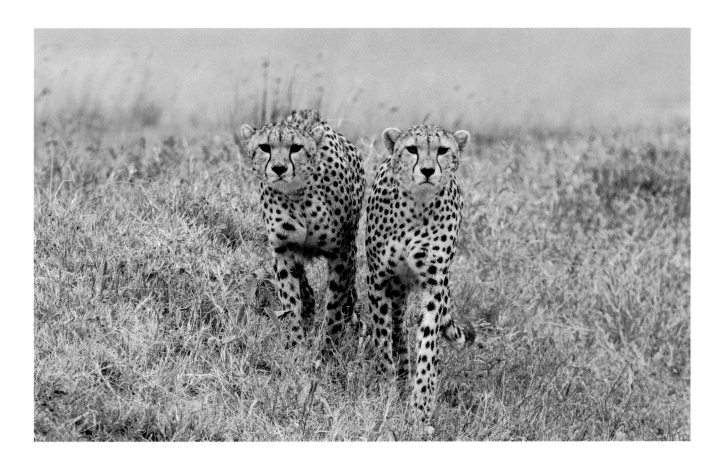

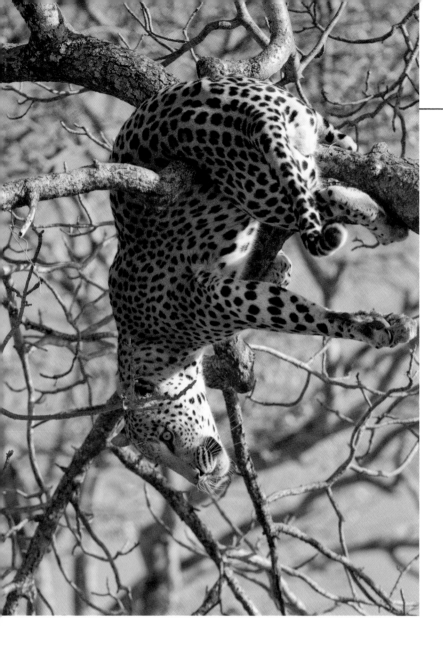

Both cheetahs and leopards have evolved ways of avoiding confrontations with lions. Cheetahs typically hunt during the middle of the day, when lions are almost always resting. When they make a kill, they drag the prey into the bush, where it is well hidden, and gorge themselves until full. They then leave the area and whatever is left of the kill. Leopards carry their prey up into the branches of a tree, out of the reach of lions (and most other predators). Neither is a foolproof strategy but they are largely effective.

Lions similarly dominate wild dogs, not only taking their kills but also preying on both young and, very occasionally, adult dogs.

Of all the predators with which lions share habitat the Nile crocodile is the only one that can individually threaten the lion. Lions have been known to kill crocodiles venturing onto land, while the reverse is true for lions entering waterways, as evidenced by the occasional lion claws found in crocodile stomachs.

Perhaps the most compelling footage ever filmed of lions is the now-famous video posted on You Tube, entitled 'The Battle of Kruger'. In it, a pride of lions is seen stalking a young buffalo.

^ To protect their kill from lions, leopards will carry carrion into a tree.
> The crocodile is the only natural predator that can individually threaten a lion.

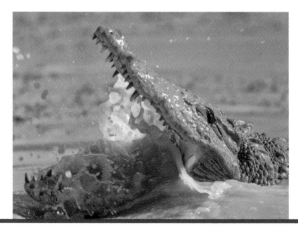

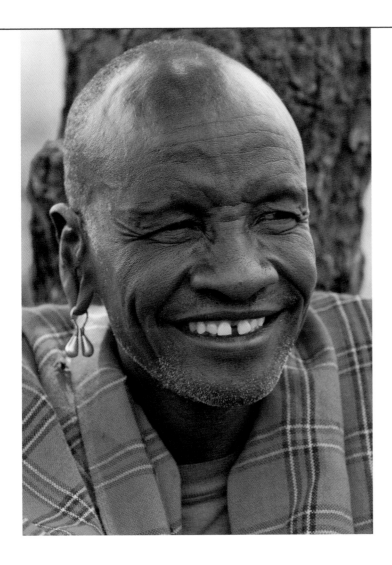

‹ The Masai tribe has a long, often turbulent history with lions.

Lions and humans

While lions do not typically hunt people, there are well-documented instances of, usually, males seeking human prey. One example occurred in 1991 when, in a series of incidents resembling the 1898 Tsavo attacks referred to earlier in the book, a lion dubbed the Mfuwe Man-eater killed six people in the Luangwa River Valley in Zambia. In both this and the Tsavo case, the hunters who killed the lions wrote books detailing the animals' predatory behaviour, from which similarities can be drawn: the lions in both incidents were larger than normal, were maneless and appeared to suffer from tooth decay.

Ill health is almost certainly a reason for lions to attack humans, but other factors, such as prey depletion in human-dominated areas, is a more common cause. Sick or injured animals may be more prone to man-eating but that the behaviour is 'not unusual, nor necessarily aberrant'. If inducements such as access to livestock or human corpses are present, lions (and most other big cats) will regularly prey on human beings.

As human encroachment on wild habitat increases, incidents of man-eating become more frequent. For example, in rural areas of Tanzania – near Selous National Park in Rufiji District and in Lindi Province near the Mozambique border – lions are reported to have attacked 563 villagers in the 15 years between 1990 and 2005. Many of the victims died. Such cases hamper conservation efforts, as the lion is seen as a clear and present danger to human life. It is therefore important that conservation policy mitigates the risk and is the principal reason that ALERT specifically identifies the removal of any human imprinting as an integral part of its release programme.

Undetected by the herd, the lions get within striking distance and the lead lioness lunges for the kill. Her momentum takes her and the buffalo into a waterhole. As the lionesses attempt to drag their prey from the water, a crocodile explodes from the hidden depths, snatching the buffalo's leg. A tug-of-war ensues. The lions win but, in the meantime, the buffalo herd has regrouped and returned. They attack the lions, horning one a couple of metres into the air, and retrieve their calf, which, miraculously, has survived the attack largely unscathed.

Lions
on the edge
Lion conservation

in Africa

LION COUNTRY

Lions on the edge

Lion conservation in Africa

In all respects the numbers are staggering. The world's population of lions has dropped by around 95 per cent in the last hundred years or so, with a suspected decline of one third in the past two decades alone. Today there are thought to be fewer than 25,000 lions alive in the wild. According to the IUCN (International Union for the Conservation of Nature), the principal causes of the lion's decline – indiscriminate killing in defence of life and livestock, coupled with prey-base depletion – are 'unlikely to have ceased', which means that while lion numbers are yet to reach critical mass the species is fast approaching critical status.

Counting lions is no easy task, due to the number of unavoidable uncertainties. In the past 15 years, there have been three main attempts, all using different methods. The African Lion Working Group compiled individual population estimates, mostly from protected areas, which resulted in a figure of 23,000. Another count resulted in a (likely) underestimate of 18,600. The third produced a total closer to 39,000. Whichever figure is accepted, the news is bad and, taking even the most positive of the three, comparisons with earlier counts indicate a decline of nearly half in three generations of lions, with the majority of losses occurring outside protected areas such as national parks and preserves. In West and Central Africa the numbers are even more critical, with the population of mature (breeding) individuals dropping well below half the 2,500 'endangered' criterion.

Indiscriminate killing, mostly to protect livestock, is considered ubiquitous in Africa.

The economic impact of stock raiding can be significant to indigenous farming communities. One detailed report estimated that livestock losses cost ranchers living alongside Tsavo East National Park in Kenya US$290 per year for every lion. Another study estimated annual losses of cattle in areas adjacent to Waza National Park in Cameroon at about US$370 per owner.

As a result, lions are persecuted intensely in livestock areas across Africa and the fact that they are adept scavengers makes them particularly vulnerable to poisoned carcasses put out by livestock owners to eliminate predators. Poisons are indiscriminate. Until very recently even the Kenya Wildlife Service and the Kenya Veterinary Department used them on a wide scale to control hyenas, inadvertently causing the deaths of many lions, including whole prides at once.

> When lions prey on livestock, the financial cost to farming communities is astronomical: as much as a year's wages for every animal lost.

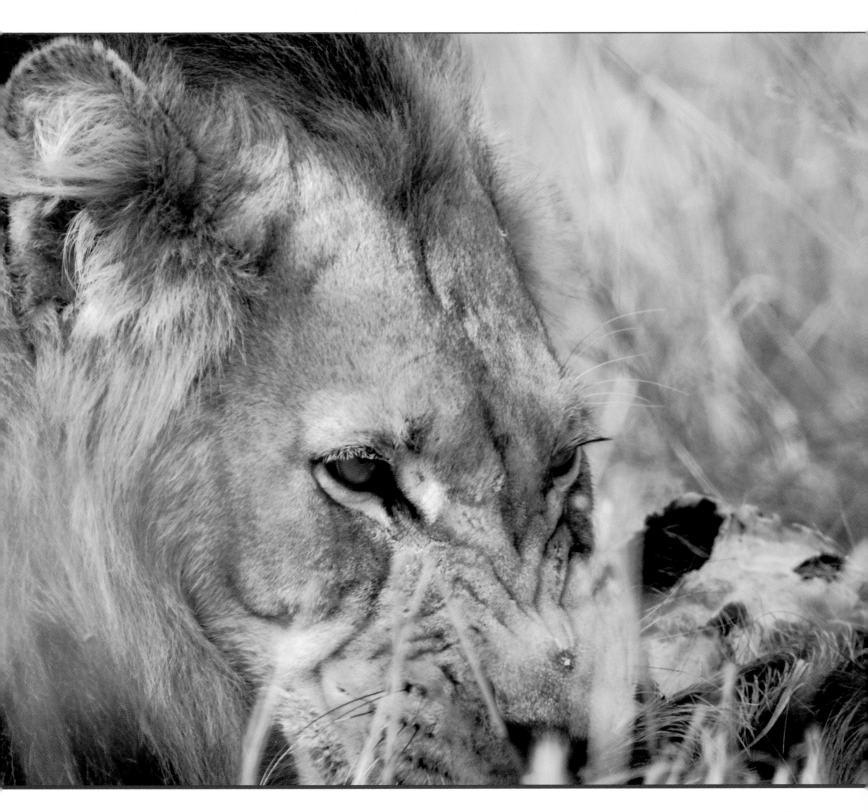

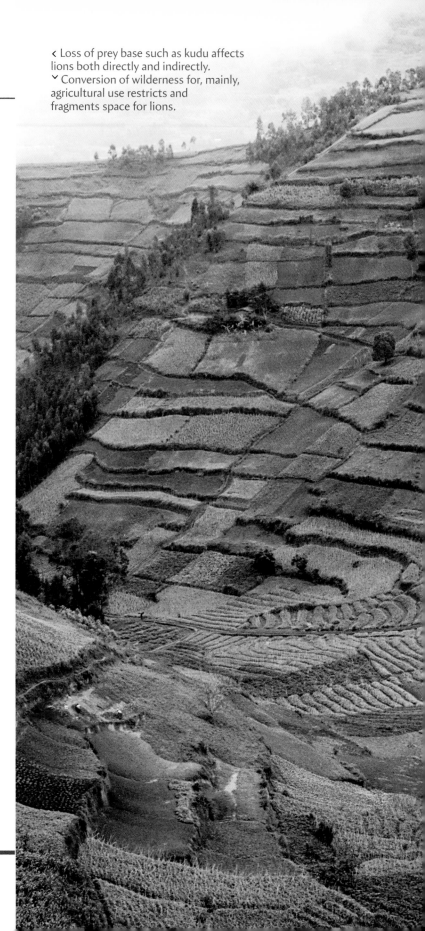

< Loss of prey base such as kudu affects lions both directly and indirectly.
ⵠ Conversion of wilderness for, mainly, agricultural use restricts and fragments space for lions.

The principal reason for the increased level of lion/human conflict is the loss of habitat and its subsequent effect on the lion's prey. As Africa's human population has grown, more and more areas of wilderness have been transformed for agriculture and livestock rearing. This has not only squeezed the amount of space available for lions, but also drastically reduced their natural prey base – zebra, kudu, buffalo, etc. – especially outside protected areas. With less food, less land and the closer proximity of people and domestic livestock, conflict with humans has been an unavoidable consequence.

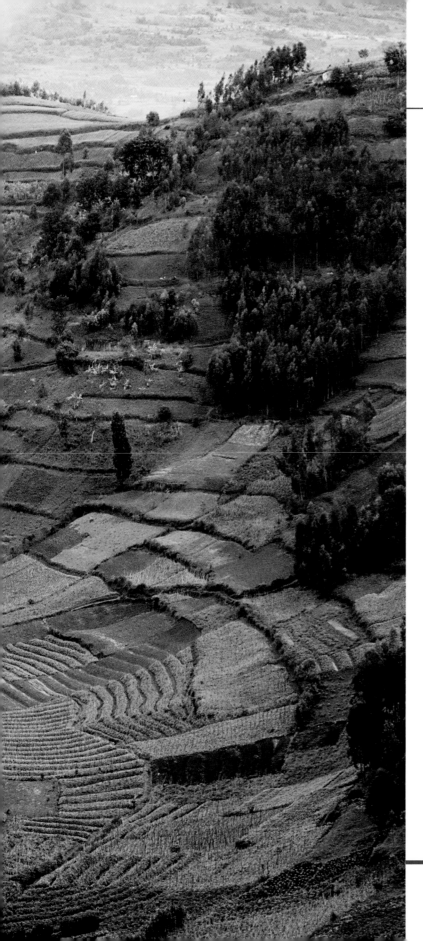

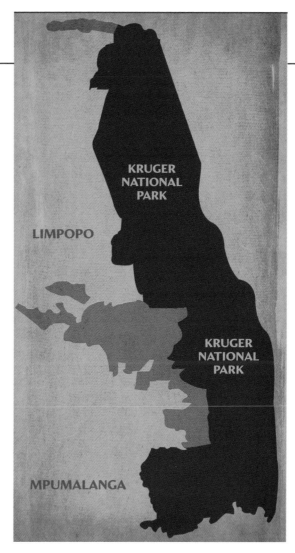

< Kruger National Park is a stronghold of the African lion, but a worrying level of bovine TB is threatening its population.

KRUGER NATIONAL PARK

LIMPOPO

KRUGER NATIONAL PARK

MPUMALANGA

*Ethical and sustainable hunting excludes the practice of canned hunting. A canned hunt is essentially a trophy hunt in which the animal is kept in a more confined area, such as a fenced-in one, increasing the likelihood of the hunter obtaining a kill. Many people and groups object to this practice, either because of its cruelty to the animals involved or because it takes away what is known as fair chase. Some hunting groups, especially those that focus on hunters' ethics, also object to canned hunting on the grounds of fair chase.

Disease poses another major threat to lions. Canine distemper, possibly passed on by hyenas, has resulted in many lion deaths over a number of years in areas such as the Ngorongoro Crater and Serengeti National Park, both in Tanzania. And in Kruger National Park (KNP), South Africa, considered one of the last strongholds of the lion with a population of around 2,000 individuals, tuberculosis passed on by buffalo and kudu is a prominent threat. In a recent statement, vets working in KNP voiced their concerns that, unless appropriate action was taken, 80 per cent of the park's lions would be lost within 20 years.

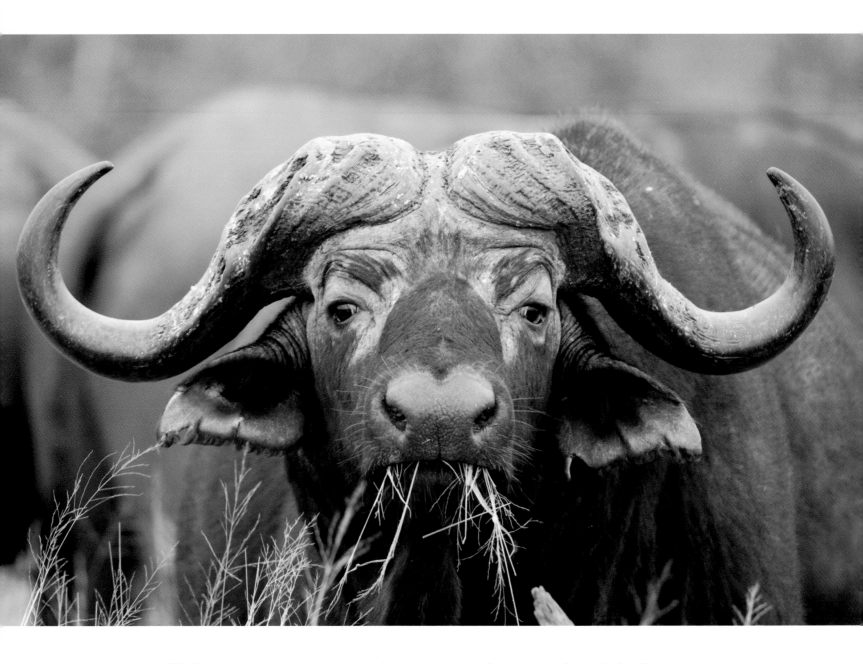

Of all the threats, hunting is perhaps the most emotive and controversial. Hunting lions for sport or social reasons has been going on for centuries. It is believed that the Egyptian pharaoh Amenhotep III participated in the sport, as did the French king known as Saint Louis, during the Crusades. In eastern Africa, killing a lion was a rite of passage for Masai warriors. The term 'Big Five', used extensively by safari operators in marketing literature written to sell holidays, originates from the hunting industry and refers to the five species that are most dangerous to hunt – buffalo, elephant, leopard, lion and black rhinoceros. Although of the five the buffalo is by far the most deadly, the lion, as king of beasts, remains the most sought-after trophy.

For wild populations of lions to survive,

‹ Bovine TB, passed on via prey species, has killed many lions, particularly in Kruger National Park.
˅ In the Laikipia district of Kenya, a multi-faceted approach to lion conservation has generally been successful.

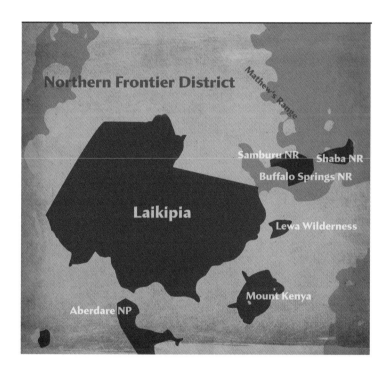

all of the threats facing them need to be addressed. Where livestock management measures have been taken, the results have proved positive. The Laikipia District in Kenya is one such success, with abundant wildlife, including top predators, living alongside humans on commercial livestock ranches. Using traditional African animal-husbandry techniques, where men and dogs guard livestock during daily grazing and then herd the animals into bomas for protection through the night, has meant that in some cases lion predation on domestic livestock has halved.

The role of hunting within the context of conservation is much harder to address and elicits a range of views. There are extremists who argue that hunting is wrong under any circumstances. A more considered view is that hunting for subsistence is acceptable and that, in the case of megafauna such as lions, hunting undertaken to protect threatened ecosystems is justifiable. Others accept hunting as part of cultural tradition. Trophy hunting, the category into which hunting lions invariably falls, is a more emotive topic but there are people – not just hunters – who will argue the benefits of ethical and sustainable trophy hunting.*

One consideration in the debate on hunting that is often ignored is economics. The majority of countries where lions exist are poor and underdeveloped; many people in these countries survive day-to-day on less than a dollar. And, when your primary consideration is not what you're going to eat but whether you'll have any food to eat at all, conservation becomes a luxury. It is hard to convince a starving man that the well-being of a lion should take precedence over the lives of his family and children.

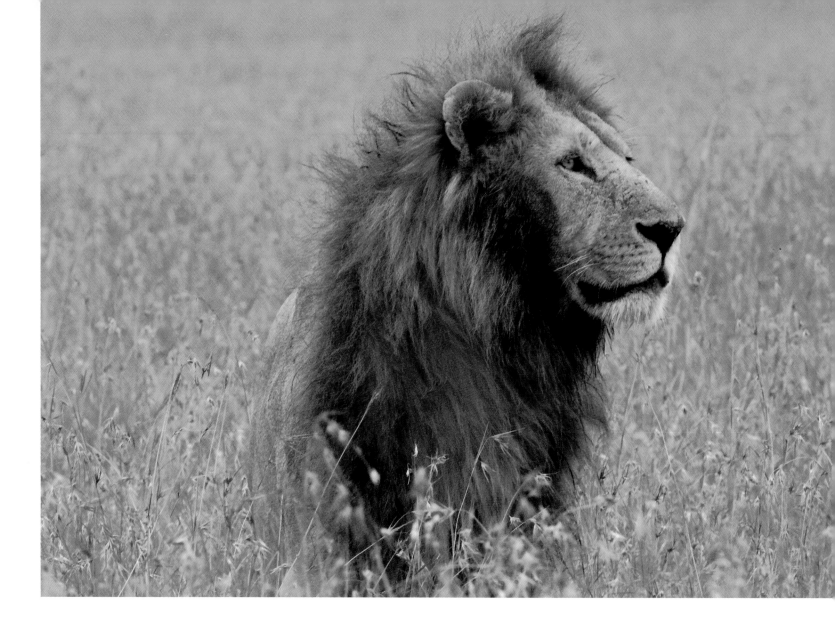

Wild resources are vital to the survival of millions of Africans and those in favour of ethical and sustainable trophy hunting justify it purely on economic grounds. For example, in the 1960s, before trophy hunting became commonplace, the buffalo – one of the 'Big Five' – had an economic value of around $100. It was a disease carrier and was slaughtered to make way for more valuable cattle. As hunting became popular, the value of buffalo increased above that of cattle. Cattle ranches converted to wildlife reserves, and buffalo populations – as well as other wild species –

recovered. In South Africa, between 1980 and 2005, of all the land designated for agriculture, 2 per cent was given over to wildlife. Today, 20 per cent of that land is used for wildlife – more than all the national parks in the country.

In Tanzania, one study estimated that hunting licences yielded around $5 million a year. Additionally, trophy seekers in Tanzania are required to pay for a stay of a minimum of 21 days and on average spend $35,000. Before Kenya imposed a ban on hunting, the revenue contributed about 6.5 per cent of the total foreign

DAVID'S SAY...

'We think that almost half of wild lions live in just four populations in three countries in Africa. In the rest of Africa, lions in any one area total fewer than 70 individuals – a number that makes those populations unsustainable without human intervention.'

‹ For many hunters, the lion remains the most prized trophy.

exchange from tourism. This money, it is argued, makes it viable and prudent for governments to invest in conservation. The counter-argument is that the profits from hunting are rarely ploughed back into conservation projects.

However, when they are, the statistics lend some credence to the hunting lobby's argument. CAMPFIRE (Communal Areas Management Program for Indigenous Resources) was set up in the 1980s by the Zimbabwean Department of National Parks and Wildlife Management with the support of WWF, USAID and the Centre for Applied Social Sciences at the University of Zimbabwe. Its objectives were based on the belief that communities will invest in environmental conservation if they can benefit financially from it.

Ten years after its inception, CAMPFIRE was generating $2.5 million a year, with around 90 per cent coming from the sale of big-game hunting licences. Of this money, a quarter was invested in wildlife management and over half was devolved to the participating communities, who spent it on social development projects, including building schools and clinics and providing clean water. In the same period, while the wildlife populations in much of Africa were declining, in Zimbabwe, before the recent political and economic strife took hold, they were growing.

The argument for including hunting within a conservation strategy must be balanced with the argument against it, namely that the funds accrued from trophy hunting or ivory are said to be small in comparison to the value of these animals as tourist-drawing cards. For example, the $35,000 spent by one hunter to kill a single adult male lion is outweighed by the estimated $500,000 that that lion, over the course of its life, will attract from many thousands of tourists. Advocates of hunting, however, will argue that if the sport was banned outright, there would be insufficient tourists to fill the economic gap, the value of wildlife would again drop below that of domestic livestock and land currently utilised for nature would revert to agricultural use.

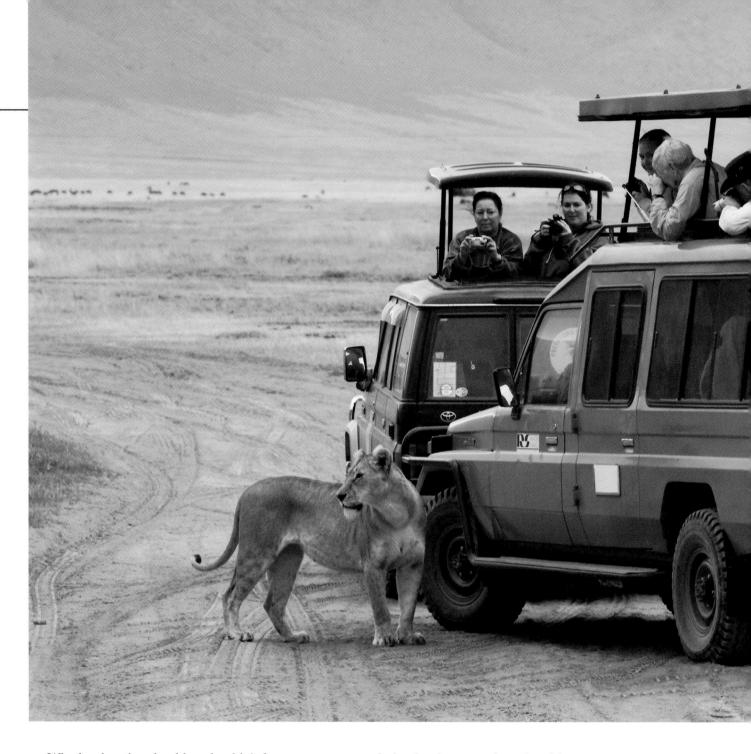

Whether hunting should or shouldn't form part of a collective conservation plan will always be hotly debated. What is unquestionable is that, despite the money invested in lion conservation projects in recent times and the huge amount of research that has been conducted on big cats, Africa's lion population continues to decline at an alarming rate. Andrew Conolly's argument is that Africa should be investing some of its time and money into planning for the unthinkable:

Proponents of hunting argue that tourism has a limited capacity to replace the funds that would be lost if hunting lions was banned outright.

what happens if we find a solution to the problems facing lions, only to discover that there are no wild lions left to protect? It was the need to answer this question that led to the creation of ALERT.

IUCN RED LIST STATUS

Scientific name(s)
Panthera leo leo (African lion)
Panthera leo persica (Asiatic lion)

Red list category & criteria
Vulnerable A2abcd

Year of assessment
2008

Assessment history
2004: Vulnerable. 2002: Vulnerable. 1996: Vulnerable

Justification
A species population reduction of approximately 30 per cent is suspected over the past two decades (approximately three lion generations). The causes of this reduction (primarily indiscriminate killing in defence of life and livestock, coupled with prey-base depletion) are unlikely to have ceased. This suspected reduction is based on direct observation; appropriate indices of abundance; a decline in area of occupation; extent of occupation and habitat quality; and actual and potential levels of exploitation.

Major threats
The main threats to lions are indiscriminate killing (primarily as a result of retaliatory or pre-emptive killing to protect life and livestock) and prey-base depletion. Habitat loss and conversion has led to a number of populations becoming small and isolated.

Conservation actions
Regional conservation strategies have been developed for lions in west and central Africa (IUCN 2006a) and eastern and southern Africa (IUCN 2006b). The west and central African strategy focuses on three primary objectives: to address threats that directly impact lions; to reduce human/lion conflict; and to conserve and increase lion habitat and wild prey base. The objectives of the eastern and southern African lion conservation strategy are articulated around the root issues in lion conservation, including policy and land use, socio-economics, trade and conservation politics. For the Asiatic lion, resolving human/lion conflict is a high priority, as well as establishing a second wild population.

A new way

The African Lion and

forward

Environmental Research Trust

A new way forward

The African Lion and Environmental Research Trust

Imagine Africa without lions. It is a simple enough statement, but one that resonates when you give it more than a moment's reflection. And it was this thought that drove Andrew Conolly to establish the African Lion and Environmental Research Trust (ALERT).

Explaining the ethos of ALERT Conolly states:

'Across the greatest of it savannas, into the depths of its darkest forests, within its vast lakes and rivers and on its towering mountains, Africa's wild heritage is under threat. Wildlife populations are tumbling across every habitat as the footprint of humanity spreads across the continent's fragile ecosystems. And, as habitats are over-utilised or destroyed, the natural processes that offer a vital resource to communities are being denuded. The lack of economic benefits people can derive from such eroded habitats leads only to the need to convert more natural areas to other uses to try to maintain what we have lost – and it is Africa's wildlife that is paying the price.

'But simply halting social and economic development in order to save what is left of Africa's wild areas is unrealistic and unsustainable. Instead we need to look into the future and deliver development that is compatible with life-support systems, ecosystems and natural services. Decision-making cannot be a trade-off between economic development and environmental planning. This is a false choice. Decisions have to take into account both people and wildlife. This change in thinking will not happen overnight. Even if we begin now to integrate theories on holistic management into policy-making for Africa's resources, it will already be too late for many of Africa's species.

'Faced with these huge challenges it is incumbent on our generation to act. We can immediately start a variety of programmes not just to protect what we have left but importantly to establish the means to restore areas to their natural state when protection of those areas is possible.'

It is this vision that continues to drive Conolly today...

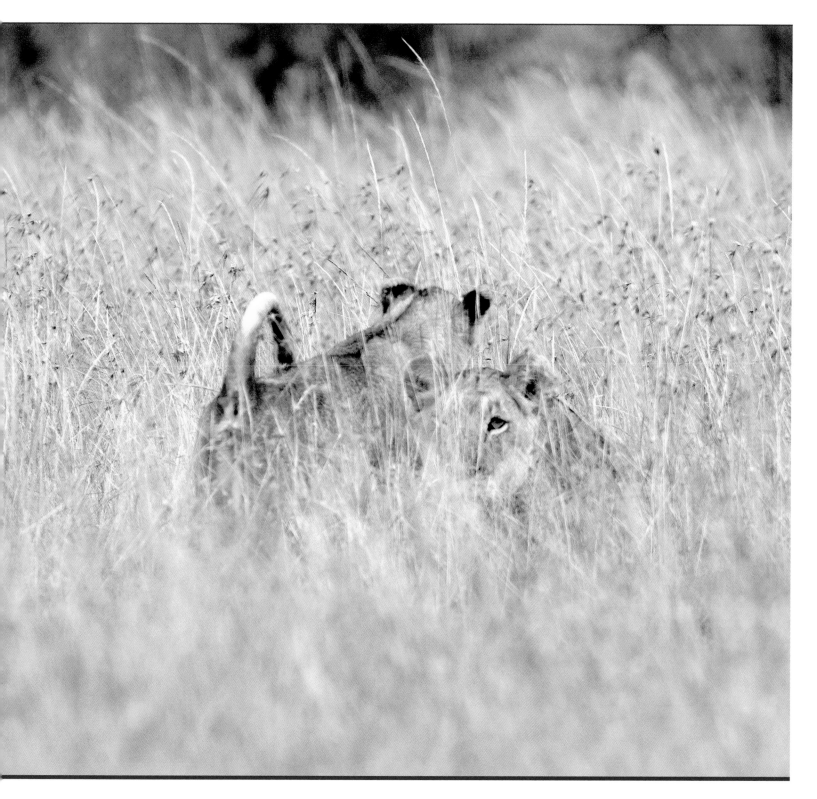

^ Across Africa, wildlife populations are diminishing as human populations grow.

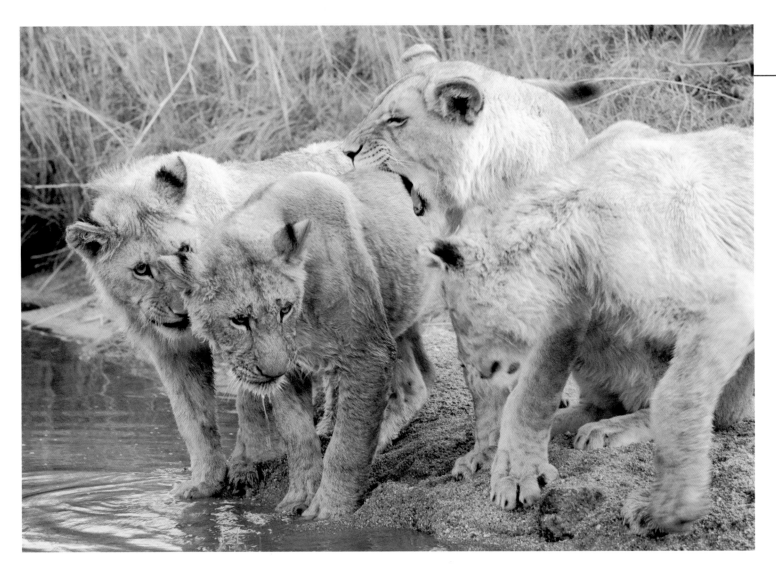

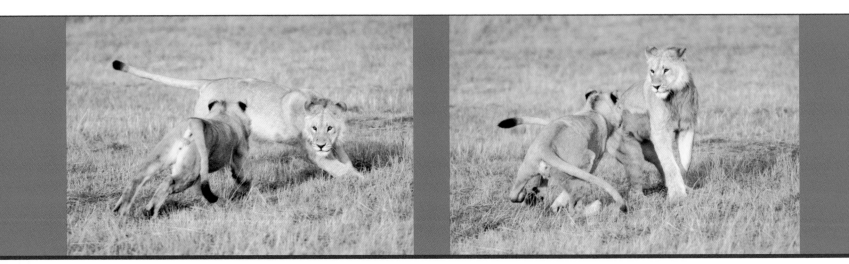

The beginning – putting meat on the bone

In 1987 Andrew and Wendy Conolly bought Antelope Park, which at the time any estate agent would have described as 'a renovation project'. Along with the land, some ramshackle buildings and the odd dilapidated barn, the Conollys acquired six captive lions and some young cubs. To exercise the cubs the new owners took them on walks into the bush. There, they started to notice the lions displaying the same behaviour as cubs born in the wild, something they were unable to do within their enclosures. The more frequently the Conollys walked the lions the more this behaviour developed. It was from these observations, in particular watching the maturing of the cubs' hunting instincts, that Andrew Conolly started to think about the possibility of returning the cubs to the wild.

Over the coming years, as alarming headlines about the decline in the number of African lions appeared in the global media, Conolly did more intensive research into the notion of 're-wilding' captive-bred lions. He began to develop the idea of a release programme and by 1999 he had received encouragement from a number of experts endorsing the view that, given the right set of circumstances and local support, this was an achievable goal, albeit one with some significant challenges.

‹ When the Conolly family bought Antelope Park they inherited six lionesses and some cubs.
˅ When they took the cubs for walks in the bush, they noticed the cubs behaving exactly as they would in the wild.

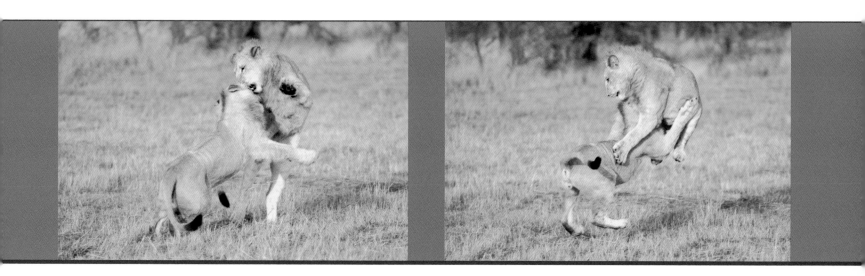

< Conolly realized that cubs born in captivity had to learn how to avoid human obstacles.
> David Youldon joined ALERT as a volunteer and quickly took on greater responsibilities.

Conolly understood that simply releasing lions in order to rebuild populations that were being eradicated through habitat encroachment, loss of prey species, illegal hunting and disease would never be a long-term solution. For a re-introduction programme to endure, he had to consider its wider implications. And so, in 2005, he founded ALERT with a remit to instigate research programmes covering multiple aspects of conservation, including the impact of disease, improved habitat protection methods and measures to mitigate the conflict between wildlife and people.

This last point is of paramount importance to ALERT. The organisation believes that true community participation is fundamental to any effective conservation programme in Africa. Currently few communities receive any benefit from the wild habitats around them and many over-utilise the resources those habitats provide. But if the African people are helped to develop financial and social opportunities that will improve their livelihood through sustainable use of natural resources, they will have reasons to make rational decisions in favour of conservation.

It is this holistic approach that has earned ALERT the backing of conservation organisations such as Animals on the Edge (AOTE), which supports the view that for conservation to be effective 'we must find ways of making trees worth more standing than felled and animals more valuable alive than dead'. And it is from this research that the Lion Rehabilitation and Release into the Wild programme started.

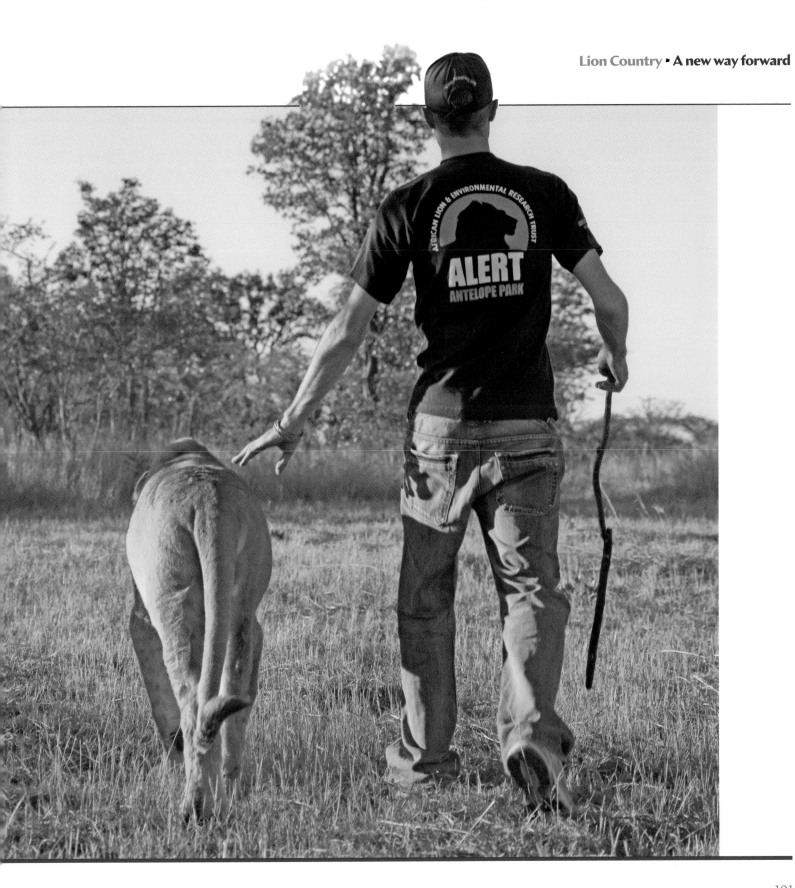

Lion Rehabilitation and Release into the Wild (LRRW)

There are many complications and potential dangers inherent in reintroducing lions into truly wild environments, most notably the likelihood of ensuing conflicts with humans and attacks on domestic livestock. This is especially true of captive-bred lions that have lost or never developed a fear of man and so may lack the human-avoidance characteristics present in wild lions. If Conolly's plan was to work, therefore, it had to overcome the failings and limitations of previous predator-release schemes, which research has shown to be:

- the animals were given no pre-release training
- their dependence on humans was not curtailed
- they were released as individuals with no natural social system
- they had no experience of predatory or competitive species

To overcome these errors and to provide the lions with the very best chance of surviving in the wild, Conolly developed a four-stage programme.

> There are many dangers involved in re-wilding captive lions, all of which Conolly and the ALERT team have to overcome.

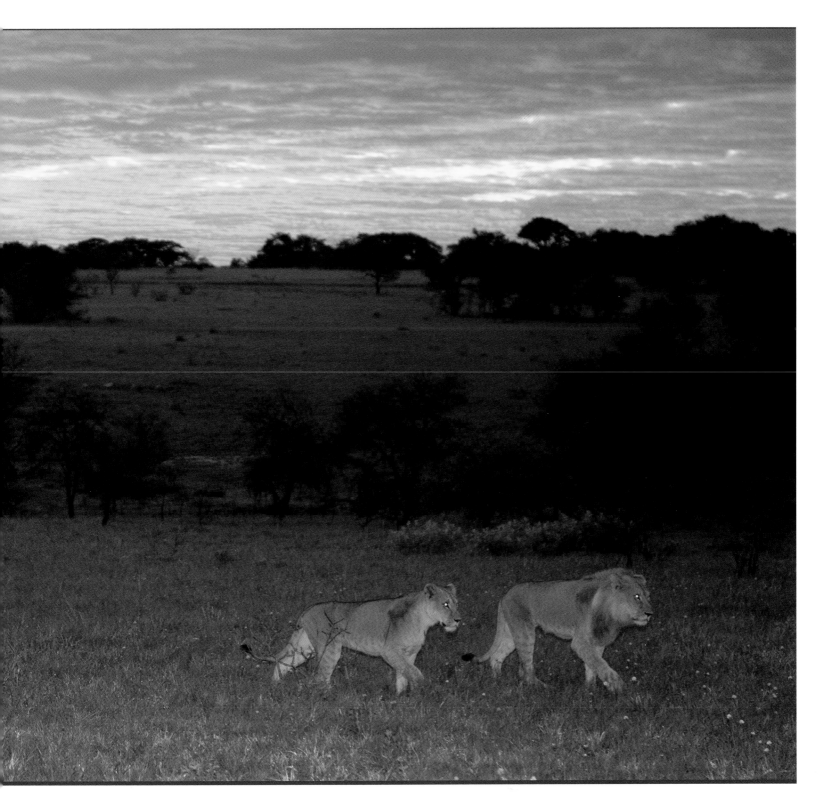

Stage 1 Developing hunting instincts

Lion cubs born in the LRRW breeding centre are removed from their mothers at the age of three weeks. This is normal practice for most captive carnivore-breeding programmes and increases the cubs' chances of survival. Experienced lion handlers take the place of the dominant members of the pride and, as we shall see in more detail later in this chapter, train the cubs up to the point where they are habituated to people. From here, the cubs are given every opportunity to build their confidence within a natural environment, both during the day and at night.

As their experience grows and they start to take an interest in the game species they encounter, their hunting opportunities are increased and skills developed so that, by the age of 18 months, they are able to stalk and bring down many of the smaller and young antelope within the park. By the time they are two years old the lions are seasoned hunters.

Stage 2 Developing a social structure

Lions are social creatures living in structured prides and it is vital that the programme mimic this prior to any wild release. That is the purpose of Stage 2. During this period, the lions develop a natural pride system within an enclosure of at least 200 hectares. These micro-ecosystems contain sufficient game for the newly formed pride to hunt. The lions are radio-collared and micro-chipped but, although their progress is monitored closely, all human contact is removed. The lions remain in Stage 2 until the pride is seen to be stable and self-sustaining.

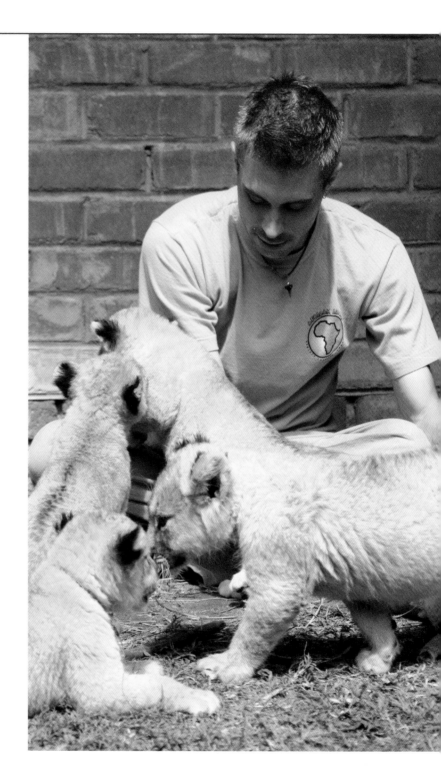

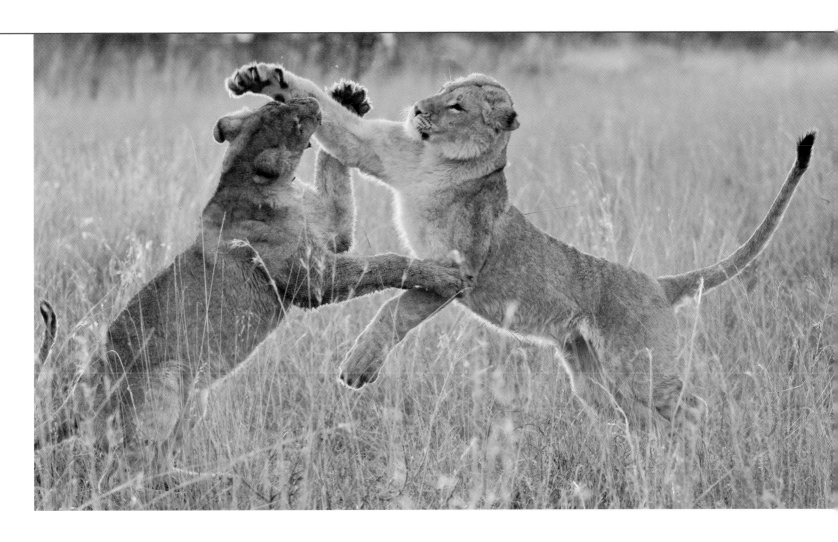

<< Cubs are removed from the breeding pride
when they are three weeks old.
< Radio collars are fitted to all Stage 2 lions.
^ During daily walks the cubs develop
their hunting skills.

Stage 3 **Translocation**

In Stage 3, Stage 2 prides are translocated to much larger, managed ecosystems of a minimum of 3,850 hectares. These release areas have no resident humans and differ from the Stage 2 sites in that competitive species, such as hyenas, are introduced. Stage 3 lions are entirely self-sufficient and have formed a natural pride. Cubs born to these lions are raised by the pride; because their habitat closely resembles a truly wild environment, they develop the human-avoidance behaviour apparent in wild lions and the full complement of skills they need to survive in the wild, including competitiveness and the ability to interact with other species. At this stage, they are ready for...

Stage 4 **Reintroduction to the wild**

This four-stage programme will enable ALERT to release lions into national parks and approved wildlife conservancies as either fully formed mixed-gender prides, female-only groups that can integrate with existing wild prides, or male-only coalitions that can increase gene pools, depending on the needs of the country or region into which they are released.

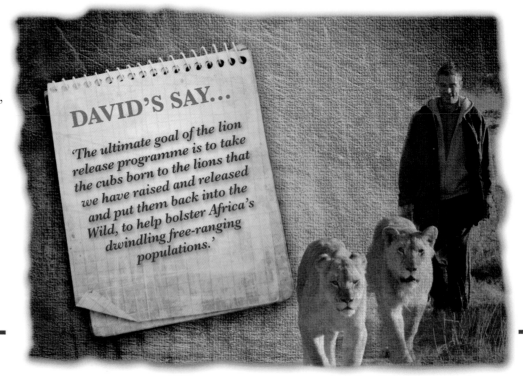

DAVID'S SAY...

'The ultimate goal of the lion release programme is to take the cubs born to the lions that we have raised and released and put them back into the Wild, to help bolster Africa's dwindling free-ranging populations.'

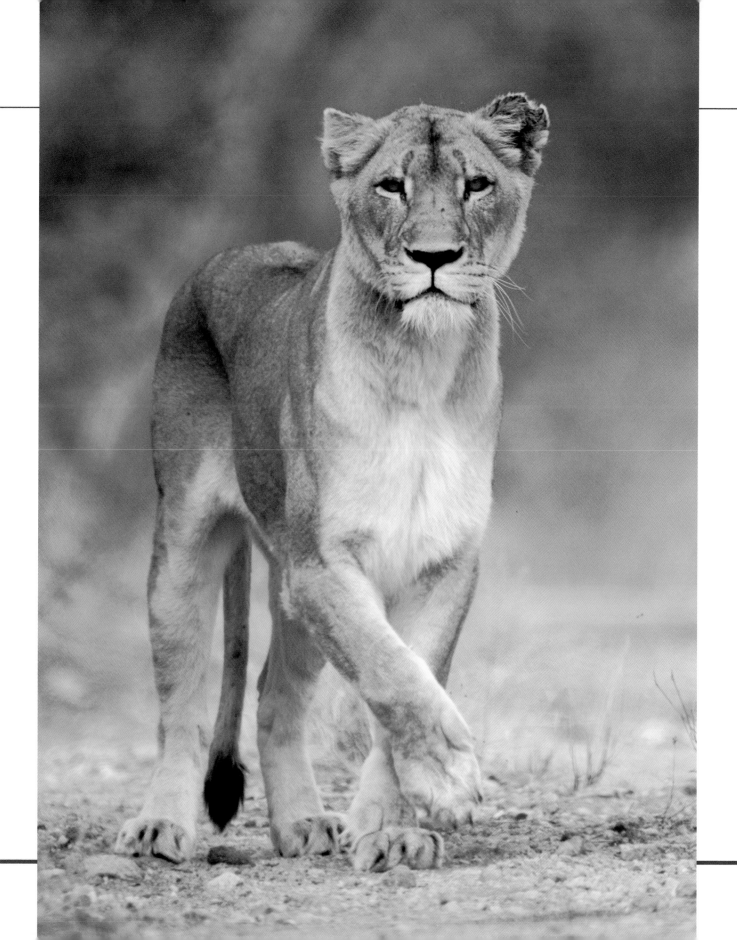

Bringing the idea to life

Once Conolly had given substance to his vision, he needed to make a plan to bring the whole idea to life. He knew he couldn't do it alone. First he had to garner the support of established experts in the fields of conservation and lion ecology. It was here that he first met with resistance from those who believed he was approaching the problem from the wrong angle or who simply thought that his plan would never work.

A chance encounter at an airport between one of his key staff, Greg Bows, and the eminent ecologist Dr Pieter Kat changed all that. Like Conolly himself, Kat is considered among his peers as a bit of a maverick and is renowned for his sometimes controversial and outspoken views. In each other the two men found kindred spirits and, more importantly, Conolly found a believer in his programme. Having witnessed the lethargic approach of the mainstream conservation bodies and organisations to the plight of the African lion, Kat concluded that:

'The future for lions is in African hands. If the international community does not offer considered support, I suggest we come up with our own solutions. If governments continue to seek income from trophy hunting at the expense of wildlife resources, it is up to us to prevent such greed. If numbers are going to be disputed by different groups, let governments step in and ask dispassionate experts to determine how many lions remain in their countries, and then justify off-take on a sustainable basis. Let these same governments decide where they want lions and, once that decision is taken, vigorously protect these populations.

'It is also up to us to come up with positive solutions to reverse the loss of lions. I believe we can do this by promoting directed research on disease threats and wild lion reproduction. In addition, we can begin programmes of lion reintroduction in a wide variety of depopulated areas. Such programmes will not only be immediately positive, but will also place lions squarely in the category of animals like rhinoceroses, whose plight seems to be better appreciated

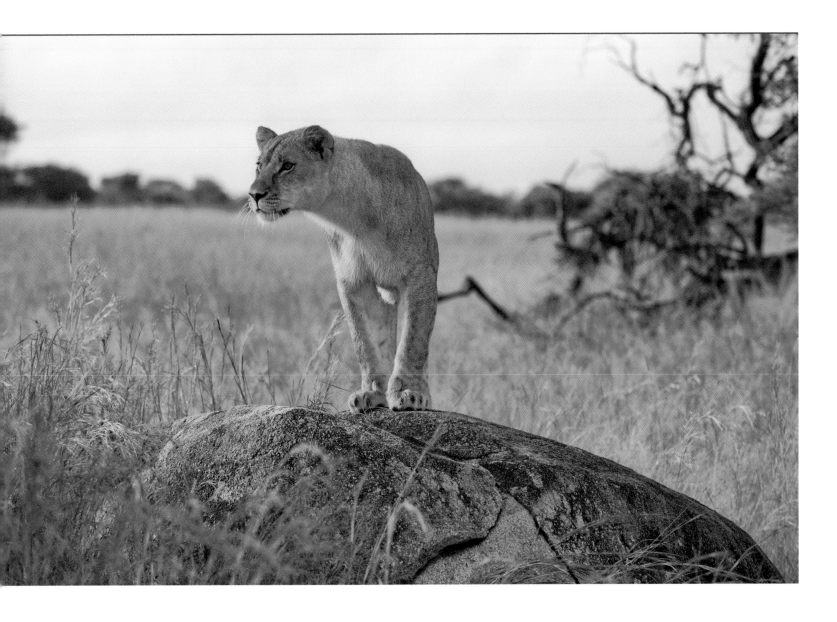

by the international conservation community.

'This is why I am appreciative and excited by the initiatives taken by Andrew and Wendy Conolly. Through years of self-funded and determined effort, they have developed a programme of reintroduction that has a very good chance of success.

Predators of any description are notoriously difficult to reintroduce, but now at least we have a workable plan. As I said, the future of African lions is in African hands. Let us salute those who have been steadfast to ensure this future, and recognise that any action is better than no action if we are to prevent the extinction of an African icon.'

With Kat on board, others soon followed, including Professor Peter Mundy of Zimbabwe's National University of Science and Technology (NUST). Mundy – a winner of the 1994 Rutherford Conservation Award and co-founder of the Biodiversity Foundation for Africa – was scientific officer for the Endangered Wildlife Trust in Zimbabwe and, later, in South Africa; he also worked as Principal Ecologist with the Zimbabwean Department of National Parks and Wildlife Management. Another early supporter was Dr Don Heath, who worked as a consultant ecologist with the Conservation Centre for Wild Africa and is a former senior ecologist for Zimbabwe's National Parks and Wildlife Management Authority.

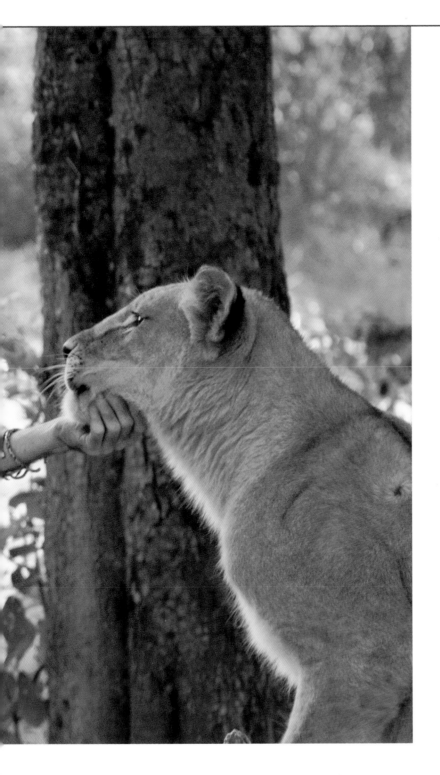

Another key person

Having gained the scientific support he needed, Conolly turned his attention to the practicalities of the programme and to the people he needed to make it happen. An early recruit was a young, disillusioned travel agent from the UK. David Youldon is fanatical about wildlife but having failed to excel in academic science at school, he fell into a career in travel logistics.

To many, travelling the world for a living may seem an ideal job but Youldon quickly became restless and began to consider his future. Whichever direction his mind turned, it always came back to his first love – wildlife conservation.

With no formal qualifications, Youldon looked for ways he could gain vocational experience and discovered volunteering. His first assignment involved assisting a cheetah research project in Namibia. As much as anything, Youldon wanted to know whether the practicalities of living and working in Africa matched his expectations. What he discovered exceeded his wildest dreams and his future path was sealed. All he needed now was for someone with a job on offer to believe in him.

< David Youldon's fascination with wildlife began at an early age.

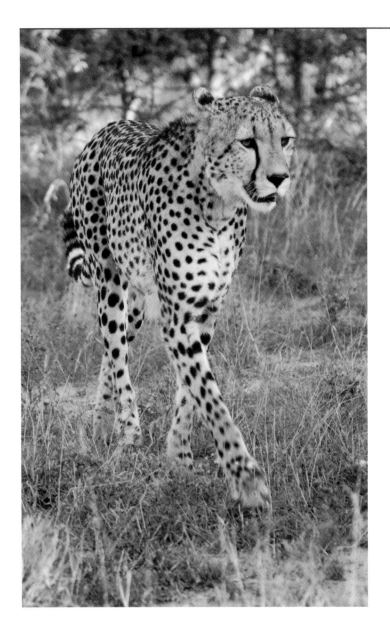

Before joining ALERT, Youldon worked on a cheetah rehabilitation programme in Namibia. After his initial stay at Antelope Park and then a stint back in the UK, he returned in 2005 and has never looked back.

Although he returned to the UK and spent another two years working in travel, the draw of Africa was too strong. He took a course in Conservation Management, joined an elephant research project and then assisted with a game-capture unit. Eventually, his travels took him to Antelope Park, where he stayed for six weeks working on all aspects of the lion programme. It was his first encounter with lions and he was hooked.

After another three months in the UK, studying intensively the ecology and conservation of lions, Youldon returned to Antelope Park early in 2005. This was an opportunity he wasn't going to let slip by and when the chance came he grabbed it.

Andrew Conolly has a saying: energy and perseverance are unconquerable. In David Youldon he saw the vigour, the passion and the commitment that ALERT needed. He also saw a man with skills in research, marketing and promotion, corporate lobbying and deal-making – areas in which Conolly wasn't proficient but which were essential if ALERT was to grow beyond a pipe dream.

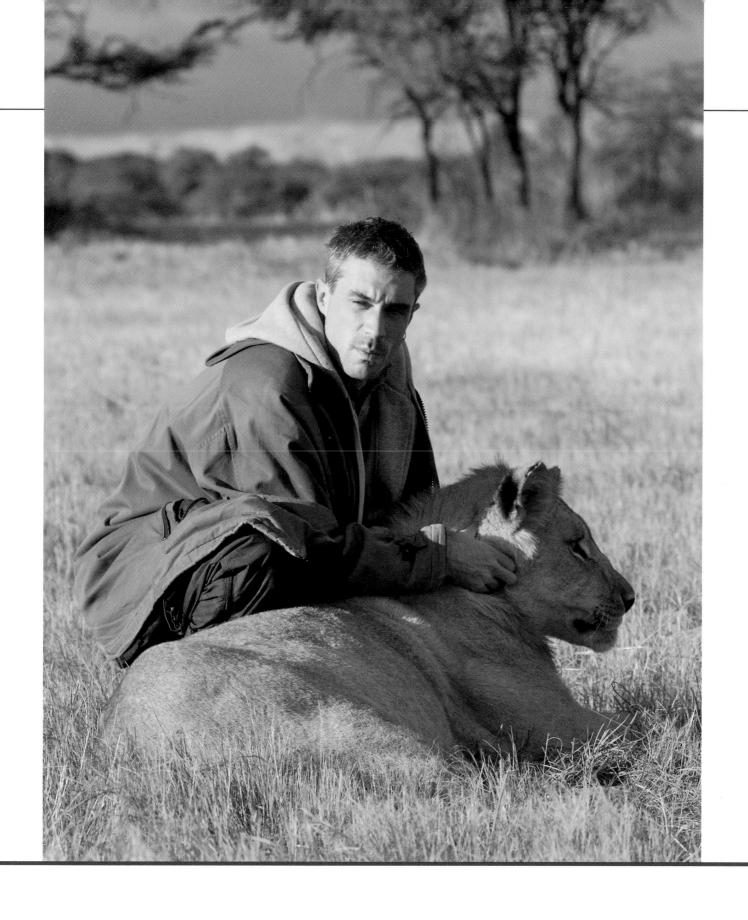

⌄ When the cubs are three weeks old, an experienced handler is assigned to look after them.
› Volunteers help with cub feeding.

The programme begins

The task of raising and caring for lions in captivity brings with it many responsibilities, not least of which is care for the individual lion. To ensure the health and wellbeing of the animals born at Antelope Park the ALERT team drew up a set of husbandry protocols. These were developed from the many years' experience of people involved with the captive breeding of lions and adapted using the Guidelines and Specific Concerns for Hand-Rearing Carnivores produced by the Zoological Society of San Diego and the Ethical Guidelines set down by the African Association of Zoos and Aquaria (PAAZAB), of which ALERT is a member.

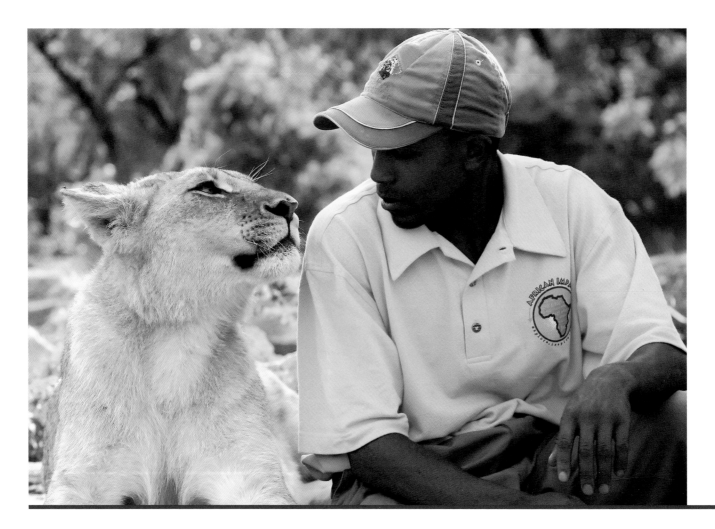

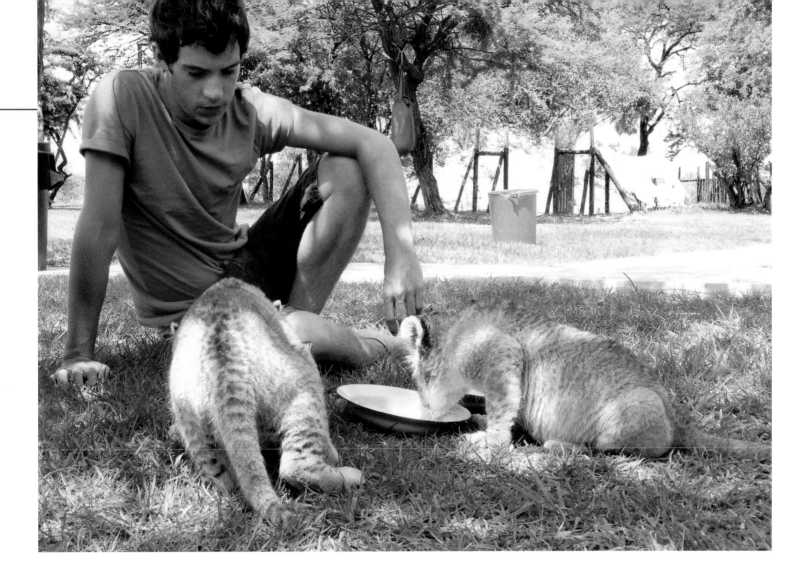

At three weeks old...

...the cubs are removed from their mother. They are picked up by the scruff of the neck, mimicking the mother's action, and placed in a padded crate for transfer to the nursery enclosure. The mother, having been coaxed into an adjacent enclosure, rejoins her original pride.

The nursery enclosure – in a quiet location so as not to scare the cubs – has been thoroughly cleaned and disinfected, removing any traces of previous occupants. There is a den for the cubs to rest in and bedding to keep them comfortable.

An experienced handler is now assigned to act as the cubs' surrogate mother. The handler is responsible for ensuring the cubs are properly cared for and fed during this delicate time, so that they develop the confidence to venture out when they are old enough.

At ten o'clock on their first night away from their mother, they are fed for the first time from a bottle containing a specially formulated milk. They typically drink around 5–10 ml at first and it can take several attempts before they are able to suckle from the bottle.

To eliminate confusion at this early stage, the cubs may be marked with a livestock marker. Eventually, though, their physical and behavioural characteristics will enable the handlers to identify individuals.

Hand-feeding lion cubs may sound like fun, but a great deal of responsibility goes with the role. After they have become used to the bottle, lions are often vigorous when feeding. If the hole in the nipple is too large they can easily suckle too quickly and inhale milk formula into the lungs, resulting in a serious and often fatal condition called aspiration pneumonia.

Before feeding begins, the bottle and equipment are thoroughly cleaned to prevent infection. Any unconsumed milk is discarded; only freshly prepared formula is given.

Like human babies, lion cubs don't necessarily take easily to suckling and often have to be coaxed or trained to attach themselves to the nipple. At first, it is okay for them to chew but when their teeth break through they must be taught through discipline to stop chewing, something the natural mother will do to prevent injury and damage to her teats.

One of the most significant risks is overfeeding. Too much milk can lead to excessive gas, diarrhoea, vomiting, blooded stools, gut stasis and bloat. The handler, then, must be careful not to indulge the cubs and must remove the feed, even against their pleading whines, when they have consumed the correct amount.

Feeding lion cubs also presents some dangers to the handler. The cats may be small but their teeth and claws are still very sharp. To prevent clawing, the cubs must be held in a particular way when feeding – in front of the handler with their head raised. The bottle must then be held firmly at the end, ensuring that the cub stays in one position and doesn't try to move around. After the feed, any excess milk or meat on faces or bodies must be removed by wiping with a moist, clean cloth – again mimicking the mother's natural actions. Leftover food on a cub will cause other cubs to lick it excessively and may result in a loss of fur, as well as attracting biting flies.

CUB FEEDING

Between three and six weeks old...

Initially, the cubs stay close to the den, but they soon begin to explore the whole enclosure. It's vital during this time that their surrogate mother sit with them so that they feel safe and gain in confidence while with the handler.

The cubs are fed every four hours between ten in the morning and ten at night. It's not long before they are drinking much more milk and they grow rapidly. By the time they are six weeks old, their intake has increased to around 150 ml per feed.

It is noticeable how the cubs' feeding patterns mirror those they would develop in the wild. For the first week, they feed very slowly: it can take up to an hour to drink 75 ml of milk. They take small amounts at a time, rest and then come back for more. As they get older, they speed up and what they have not finished after around 20 minutes is taken away to ensure that feeding doesn't become laborious.

In their first week, the cubs need to be stimulated to go to the toilet, which is done by rubbing a clean finger or a warm, damp cloth around the anus and the bladder opening. It can take up to 15 minutes to get the desired response.

In winter, it can be very cold at night. In the wild, lion cubs snuggle close to their mother for warmth. In the den, a covered hot-water bottle replaces the mother's body heat. To simulate the mother's licking, the handler will wipe the cubs regularly with a warm, damp cloth.

‹ It's not long before the inquisitive cubs are exploring their new surroundings.

Between six and ten weeks, meat is introduced to the cubs' diet to supplement the milk. At this age they are also ready for their first walks.

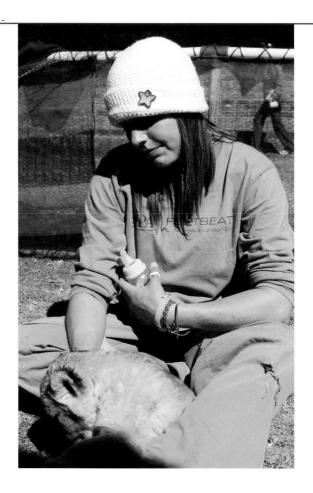

Between six and ten weeks old...

...the cubs continue to grow quickly. They also become increasingly social and start to follow their surrogate mother around the nursery enclosure as they gain confidence. At this point, they are ready for their first walks. They are easily frightened, so the handler mimics their own calls to put them at ease, in addition to encouraging them with the command 'Come, cubs'. It is around now that other guides and handlers are introduced, simulating the cubs being familiarised with other members of the pride.

At this age, the cubs' teeth erupt and minced meat is introduced to their diet. Milk continues to be given at four-hourly intervals during the day and mince is added to the 6 p.m. feed. The 10 p.m. feed is dropped. By nine weeks of age, the cubs are drinking around 200 ml at a time.

After a while, the cubs stop sleeping in the den and it is removed from the enclosure.

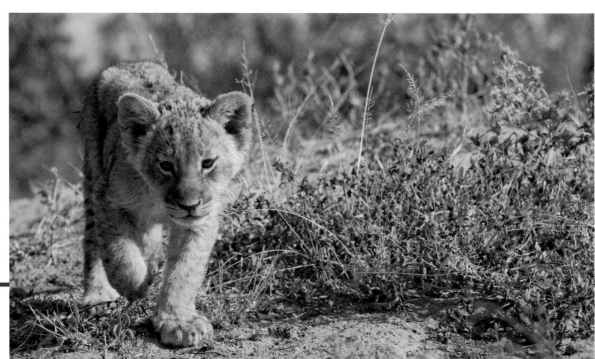

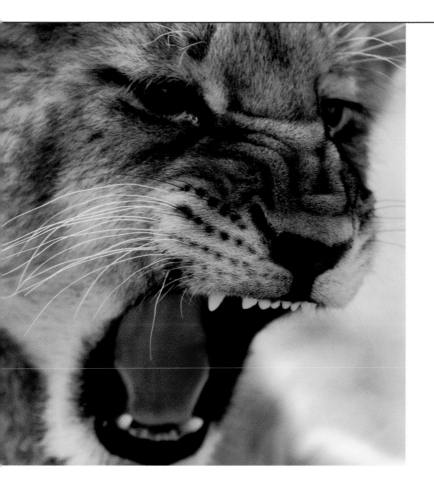

Between ten and 16 weeks...

As the cubs become more active and inquisitive, and more confident in their surroundings, they start to go on a bush walk each day with their handler. The aim is to build their ability to interact with other lions and to familiarise them with the habitat outside the nursery enclosure.

Their feeding pattern also changes, as they take less milk and more meat. Milk feeds are reduced to three a day, at 6 a.m., 10 a.m. and 6 p.m., supplemented with meat. When the cubs' back teeth break through, mince is replaced with shin meat, initially cut into small chunks that they can swallow whole. Once they learn to chew and use their dew claws, larger chunks are provided. When this first happens, there is a risk that the cubs may try to swallow chunks that are too large. The handlers are trained in how to remove food blockages to prevent a cub from choking to death.

⌐ Cubs' canines and front teeth develop first.
‹ The cubs' fulfilling days leave them ready for an afternoon nap.

From 16–28 weeks the cubs display all the behaviours of wild lions. At this time they move out of their nursery enclosure into a more natural environment.

Cubs on a daily excursion with a volunteer at Antelope Park.

Between 16 and 28 weeks...

...the cubs grow significantly and, with size, become increasingly bold. Daily excursions of increasing duration into the bush are vital as the cubs begin to display their hunting instincts. It is important that their handler maintains discipline within the group, mimicking the role of the natural mother. It is a fine balancing act, allowing the cubs to mature while maintaining the social structure.

At six months the cubs are fully weaned. Their feeding pattern also changes to mirror how it would be in the wild. Daily feeds are dropped and meat is fed, initially, every other day. Towards the end of this period, this is reduced to every third day and the quantity is increased accordingly.

The cubs are also moved permanently out of the nursery enclosure into a larger, more natural home, where there is mental enrichment to stimulate them when they are not out walking in the bush. At around eight months the cubs are displaying all the behaviours of wild lions and may be making their own kills – a sign they are ready to graduate to Stage 2 of the process.

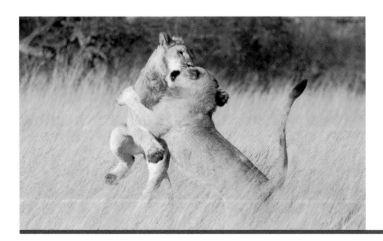

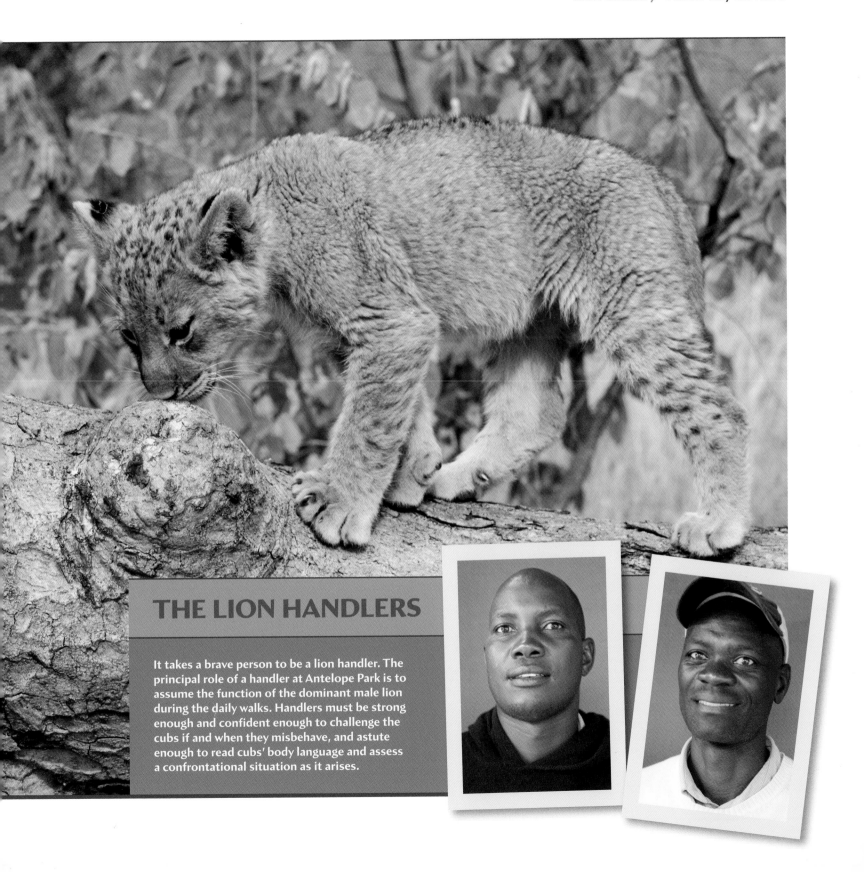

THE LION HANDLERS

It takes a brave person to be a lion handler. The principal role of a handler at Antelope Park is to assume the function of the dominant male lion during the daily walks. Handlers must be strong enough and confident enough to challenge the cubs if and when they misbehave, and astute enough to read cubs' body language and assess a confrontational situation as it arises.

Health care

ALERT takes the wellbeing of its lions seriously. Every cub born into the programme is micro-chipped and veterinary and health records are maintained on all the animals using a standard format; these are kept for a minimum of five years after death or transfer.

Routine treatments for all lions in the programme include vaccination against numerous diseases, including rabies. This is especially important, as disease is one of the greatest threats to wild lion populations. Acaricide (a pesticide that kills ticks and mites) is applied regularly and every four months the lions are de-wormed. To ensure they receive essential vitamins, the diet is supplemented with a special carnivore mix.

Lions that are destined for release are genetically sampled and screened to prevent inbreeding and to strengthen bloodlines. Depending on the requirements of the region in which they are to be released, blood screens and specific disease testing may be carried out. The lions may also have to go into quarantine for a month.

A qualified vet is always on hand to deal with more serious problems that arise. During filming of the first series of *Lion Country*, Dhakiya, a 13-month-old lioness, sustained a facial injury during a play fight with her brother Damisi. The wound was infected and refusing to heal; lion manager Leigh-ann Marnoch had to call in wildlife vet Dr Keith Dutlow. After examining the wound, the vet was concerned that the infection

‹ All of Antelope Park's lions are routinely vaccinated and micro-chipped.

might lead to the sometimes-fatal disease septicaemia and decided to operate. Damisi, who was becoming agitated, was moved into a holding area before Dhakiya was sedated.

Once the tranquilliser had taken effect, a cloth was placed over Dhakiya's eyes to protect them and the team worked quickly to clean the wound and inject the infected area with iodine. Once the procedure was complete, Dhakiya was injected with antibiotic, a painkiller and a reversal drug to bring her round.

The vet and handlers left the enclosure and readmitted Damisi, who immediately went to his sister's side, nuzzling and licking her. Soon the two lions were back at play and, two weeks later, the wound fully healed, they resumed their adventures on the plains of Antelope Park.

THE LIONS' DEN

The enclosures where the lions live when not out walking are specially designed to ensure the animals' wellbeing. They are at least two and a half times larger than the Zoological Society of London's standards and provide the lions with plenty of stimulation: there are trees to climb and use as scratching posts; artificial ramps and climbing areas; and heavy-duty toys that will withstand the attention of a large, active lion. At regular intervals, additional stimuli are introduced, such as meat frozen in ice blocks and the dung from other species that is retrieved from the park.

Volunteering

The involvement of volunteers in the LRRW programme is critical to its success. Volunteers help management and the team of guides, handlers and scouts in all aspects of caring for the lions at each stage of the programme. This includes feeding, cleaning and occasionally assisting in veterinary care.

Collecting data on the lions' development also forms a significant part of a volunteer's role. During morning and afternoon walks in the bush, the lions are assessed in how they are adapting to their environment, awareness of their environment, behaviour in relation to each other and towards the game they encounter, and hunting skills. Data collected during these excursions is used by ALERT when assessing each lion's welfare and potential for future release.

Away from the breeding centres, volunteers may work with local schools to garner support for conservation through education. The syllabus of this programme was originally devised under the Worldwide Fund for Nature (WWF) 'We Care!' project, with lesson plans designed to offer children a full understanding of their environment and to build an appreciation of the need to conserve what remains of the wild areas of Africa. Such education is vital if the problem of lion/human conflict is ever to be resolved.

The involvement of volunteers in the programme is critical to its success. Among other duties, they help collect data that is an important part of ALERT's research.

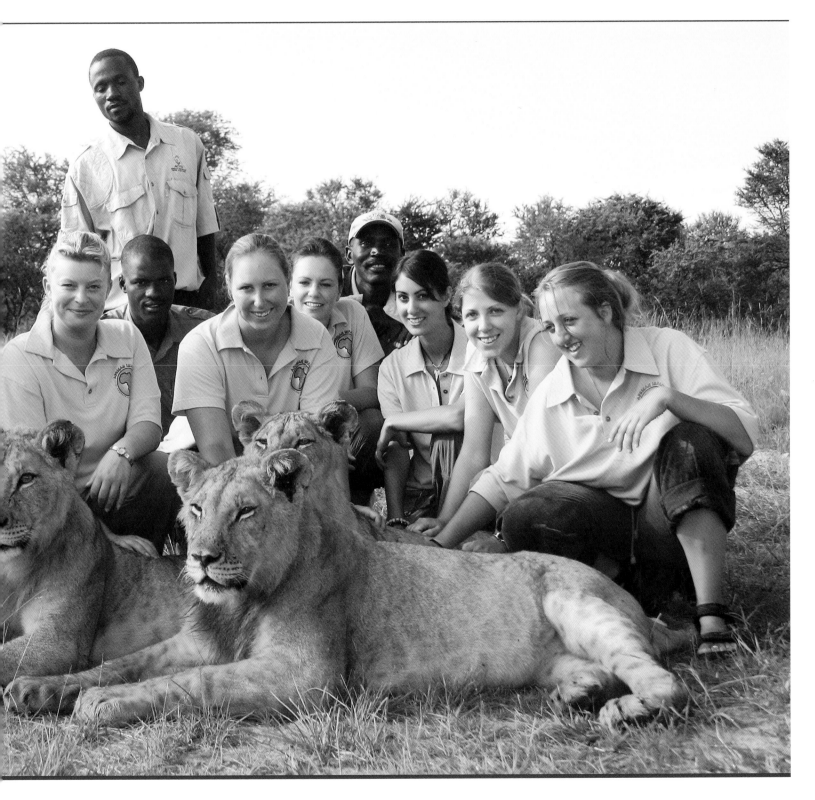

SAVING ANTELOPE PARK

Zimbabwe (then Rhodesia) declared independence in 1980 after successful negotiations led to the Lancaster House Agreement. The agreement saw the beginning of much-needed land reform in Zimbabwe.

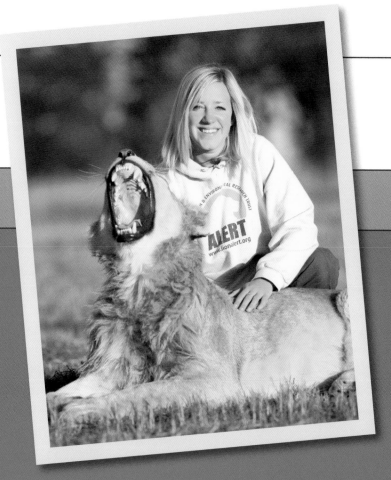

The history of land issues in Zimbabwe goes back to the 1890s, when European and South African farmers first started immigrating to what was then Southern Rhodesia. In 1918 the British government declared that the land of Southern Rhodesia was owned by the Crown and, after self-government was granted in 1923, the Southern Rhodesian House of Assembly passed the Land Apportionment Act in 1930.

One effect of the act was that many families of the native Shona and Ndebele tribes were ejected from land they had held for generations. Additionally, the more fertile, productive land was designated to white farmers; government policy on farming typically favoured the white minority. At the time of the Lancaster House Agreement, white Zimbabweans, although forming just 1 per cent of the country's population, owned 70 per cent of its arable land. Then, between 1979 and 2000, land was repatriated under a principle of willing buyer/willing seller, with economic help from Great Britain. However, progress was hampered by a lack of funds and by resistance to reform. After ten years – when the willing buyer/willing seller clause lapsed – only 40 per cent of targeted land had been reclaimed and less than half of families resettled.

Falling aid and increased resistance meant that little changed in the years that followed. In February 2000 the ruling ZANU-PF party was defeated in a referendum to instigate a new constitution that would have empowered the state to acquire land compulsorily and without compensation. A few days later, the War Veterans Association, an organisation ostensibly comprising veterans of the 1970s bush war and having a close alliance with ZANU-PF, organised a march on white-owned farms. This began with drums, song and dance but quickly degenerated into the chaotic, often violent and sustained actions in the name of land reform that prevailed throughout the first decade of the twenty-first century.

Soon after the first marches began, a large gang of veterans arrived at the gates of Antelope Park demanding they each be given three hectares of land. Fearful of the consequences to the lions and the whole ALERT programme, a loyal member of the park's staff telephoned the province's governor to seek assistance. That governor was Cephas Msipa.

Governor Msipa had been closely involved in the movement for independence and was present during the Lancaster House negotiations. He is a man who believes in justice and had been appointed Provincial Governor of the Zimbabwean Midlands in 2000,

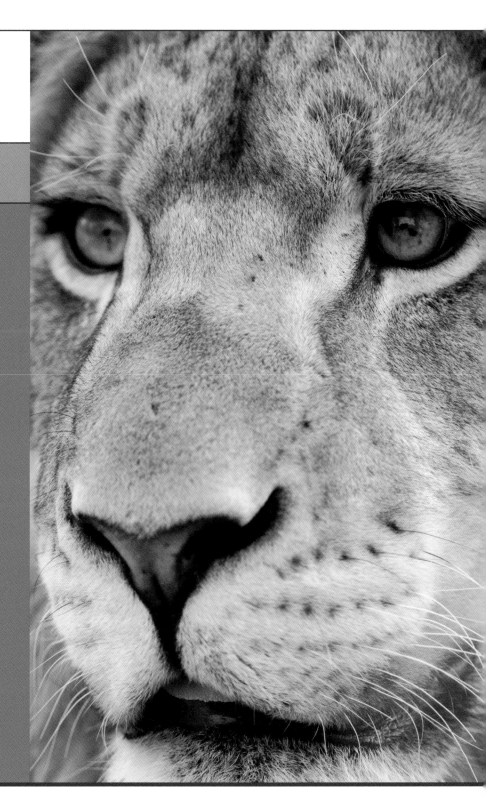

‹ Governor Msipa's intervention intervention made it possible for others to continue to experience the work being done at Antelope Park.

just as the fast-track reform programme started. Although he had been tasked with carrying out the government's new land policy – on his second day in office he had met all the local district administrators to assess current land claims – he also understood the implications for the country's long-term future of any misappropriation of land.

Being mindful of the financial contribution Antelope Park was making to the economy of Zimbabwe and, more importantly, its contribution to wildlife conservation, the governor intervened in the incident there. He immediately drove to the park and explained to the crowd that had gathered that the land was not for resettlement. He told them to leave, which they did, peacefully. Later, the Provincial Lands Committee and the government endorsed the governor's position.

For those who know Cephas Msipa, his unfaltering intervention on behalf of Antelope Park comes as no surprise. During his tenure as Provincial Governor he saved many of the region's farms from being unfairly claimed and he is renowned for having worked tirelessly and co-operatively with the mayor, Sesil Zvidzai, on behalf of the region. These two politically opposed men are revered throughout the Midlands for their unquestioned legacies of political maturity and defiance of partisan interests in developing the region's economy and social amenities.

Now retired, having voluntarily passed his political power on to 'a younger man', the former governor is still involved in politics and uses his knowledge and vast experience to promote the causes of his other great passion – wildlife. He remains a fervent supporter of Antelope Park's conservation goals and is a regular visitor; like Andrew Conolly, he believes that the way forward is through private/public sector partnerships involving local, national and international governments. At the age of 80, while many of his peers would be happy to rest, the now Doctor Msipa continues to lobby tirelessly on behalf of Africa's wilderness and for the return of its king.

The lions
of Antelope Park

LION COUNTRY

The lions of Antelope Park

A new generation is reared for release

It's first light on a chill morning in the Zimbabwe Midlands. The sky is turning red and a soft mist lingers above the dam. Nothing stirs. Suddenly, the tranquil silence is broken by a booming *humphf* – the unmistakable call of the king of beasts. Soon a cacophony fills the air as one by one others join the dawn chorus and a new day begins for the lions of Antelope Park.

To some people all lions look alike. But to Lion Manager Leigh-ann Marnoch every one of the lions in her charge is an individual. Each has a unique personality that she knows intimately and all, she believes, will one day be stamping their characteristics, either directly or indirectly, across Africa's wild plains. These are the pioneers and, maybe, the future of all Africa's lions.

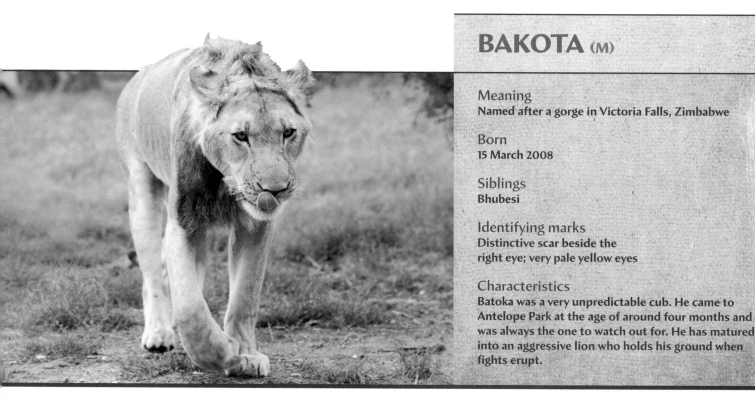

BAKOTA (M)

Meaning
Named after a gorge in Victoria Falls, Zimbabwe

Born
15 March 2008

Siblings
Bhubesi

Identifying marks
Distinctive scar beside the
right eye; very pale yellow eyes

Characteristics
Batoka was a very unpredictable cub. He came to
Antelope Park at the age of around four months and
was always the one to watch out for. He has matured
into an aggressive lion who holds his ground when
fights erupt.

BHUBESI (F)

Meaning
Lion

Born
15 March 2008

Siblings
Batoka

Identifying marks
Dark scar on the forehead

Characteristics
Unlike her brother, Bhubesi was very nervous when she arrived at AP. On walks people rarely handled her; she preferred to keep herself to herself. She was given the nickname 'Motorbike' because, when walking, she used to make a distinctive growl that sounded just like a motorbike engine.

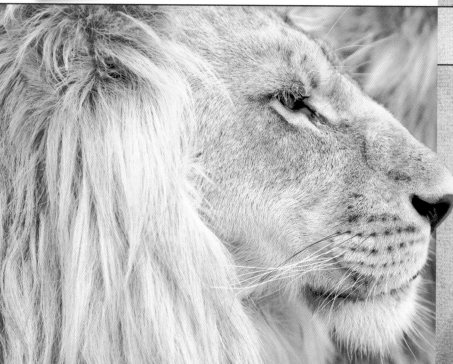

DAMISI (M)

Meaning
Happy

Born
15 August 2008

Siblings
Dhakiya, Kosey and Kanu

Identifying marks
A beautiful mane that marks him out from the rest of the lions

Characteristics
Damisi and his siblings came to AP at four months. As his name suggests, he was a happy cub, always the one to instigate play when out on a walk. He hunted actively during walks and has since proved an effective hunter.

DHAKIYA (F)

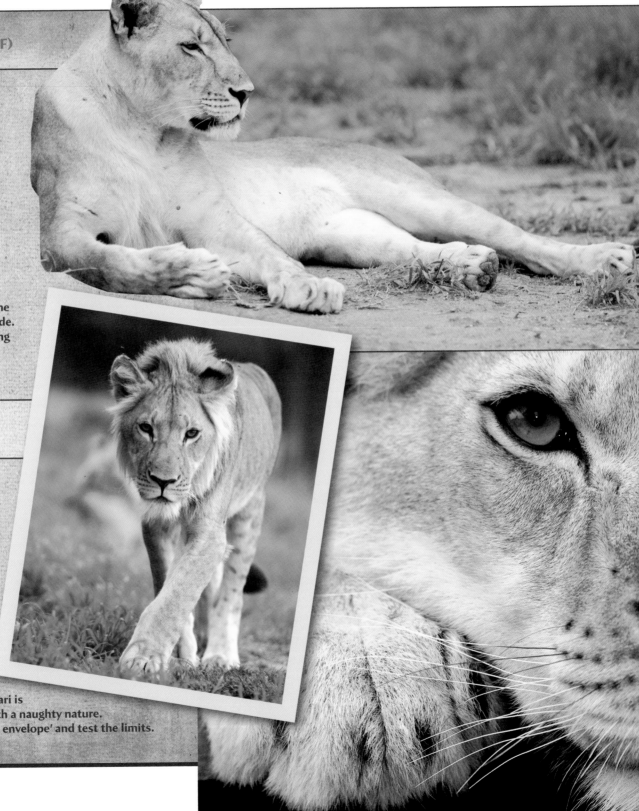

Meaning
Smart

Born
15 August 2008

Siblings
Damisi, Kosey and Kanu

Identifying marks
Short tassel
(the black tip of the tail)

Characteristics
A superb hunter, often the
leader of the hunting pride.
She has brought a straying
Damisi under control
many times.

JABARI (M)

Meaning
Fearless

Born
15 April 2009

Siblings
Jelani

Identifying marks
Very dark coat

Characteristics
Despite being the
smallest in his litter Jabari is
a very confident lion with a naughty nature.
He will always 'push the envelope' and test the limits.

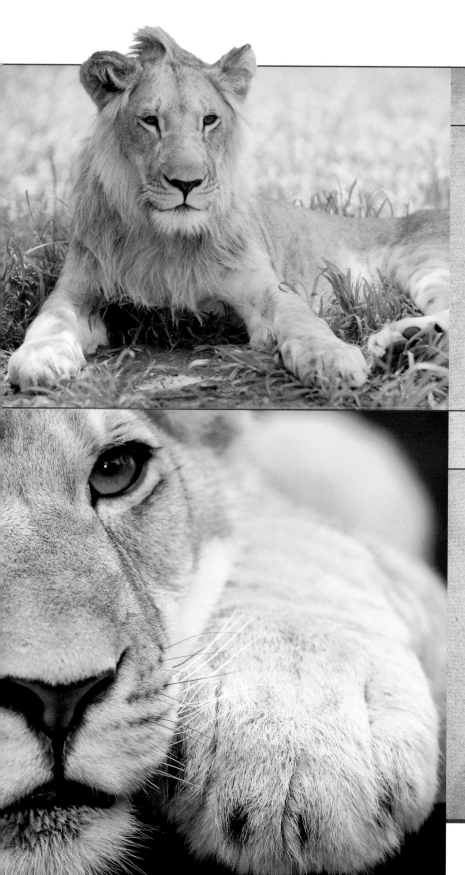

JELANI (M)

Meaning
Mighty

Born
15 April 2009

Siblings
Jabari

Identifying marks
Very pale coat and blonde mane

Characteristics
Although confident like his brother, Jelani gets nervous and is easily spooked; when this happens he seeks the comfort of Jabari's presence.

KALI (F)

Meaning
Energetic

Born
26 November 2009

Parents
Kenge (mother) and Milo

Identifying marks
Short and stumpy with a very wide face

Characteristics
At double the normal weight at three weeks, Kali was the heaviest cub ever to be born at AP. She is shy and prefers her own company – one of several traits she shares with her mother.

KANU (F)

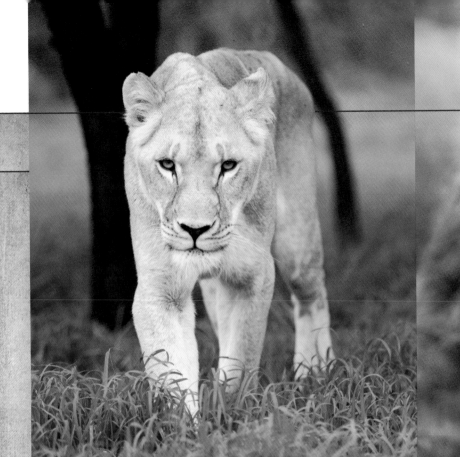

Meaning
Wise

Born
15 August 2008

Siblings
Damisi, Dakhiya and Kosey

Identifying marks
Pale coat

Characteristics
Came to AP with her siblings at the age of four months.
A skittish cub who dislikes human contact. Despite her
nervousness, she is successful on walks into the bush.

KOSEY (M)

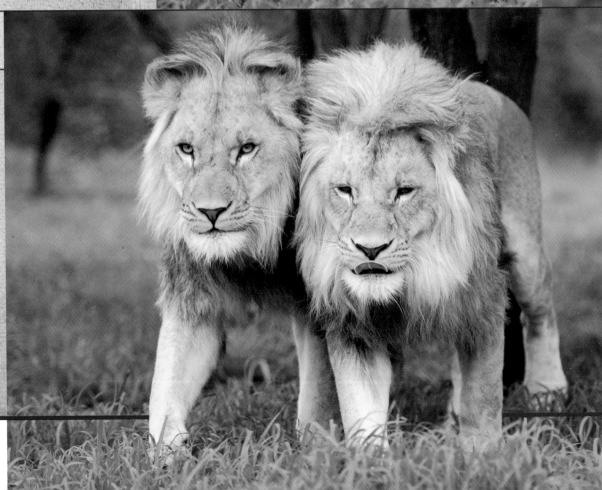

Meaning
Lion

Born
15 August 2008

Siblings
Damisi, Dakhiya and Kanu

Identifying marks
Majestic face and dark mane

Characteristics
Like his sister Kanu, Kosey
is a nervous lion who offers
affection only when it suits
him. After successful walks,
his hunting prowess came
to the fore during night
encounters at AP.

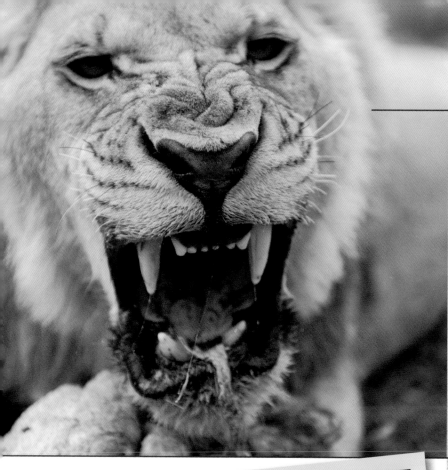

LUKE (M)

Born
10 December 2003

Parents
Lucy (mother) and Mara

Siblings
Lucky and Leo

Identifying marks
Has a very blonde mane and is quite small for a male

Characteristics
Can be aggressive and is choosy when making friends. Unusually for male lions, he enjoys climbing, which is why he is now in an electrified enclosure.

MEEKA (F)

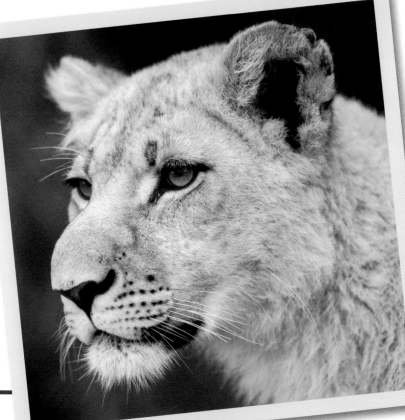

Meaning
Strong-hearted and brave

Born
29 November 2009

Parents
Mafuta (mother) and Slwane

Identifying marks
Pronounced eyes and a long face

Characteristics
Meeka's mother rejected her and she was hand-raised from birth. Although healthy, she lost her spirit when she broke her leg: the lion team thought she wouldn't survive. Then one day she got up and decided to walk – and that was it. She is now the leader of her pride, which includes Kali and Moyo. This is one lion who has touched a lot of hearts with her warm and friendly greetings.

MEGGIE (F)

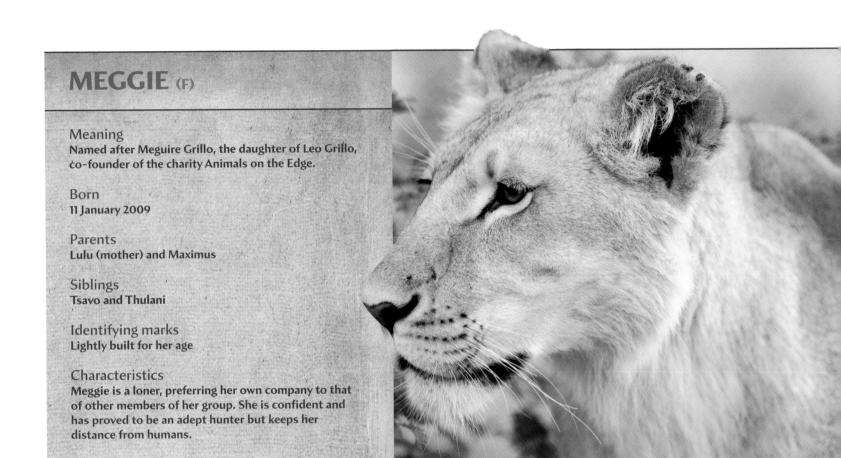

Meaning
Named after Meguire Grillo, the daughter of Leo Grillo, co-founder of the charity Animals on the Edge.

Born
11 January 2009

Parents
Lulu (mother) and Maximus

Siblings
Tsavo and Thulani

Identifying marks
Lightly built for her age

Characteristics
Meggie is a loner, preferring her own company to that of other members of her group. She is confident and has proved to be an adept hunter but keeps her distance from humans.

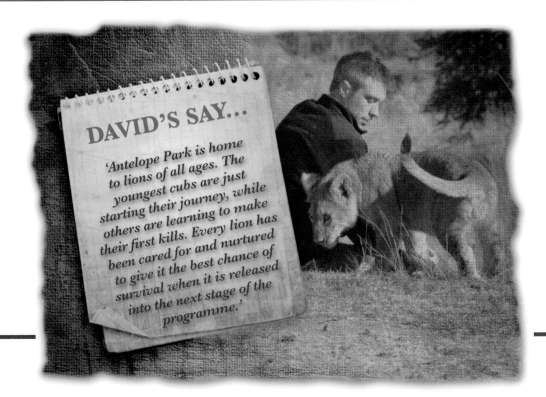

DAVID'S SAY...

'Antelope Park is home to lions of all ages. The youngest cubs are just starting their journey, while others are learning to make their first kills. Every lion has been cared for and nurtured to give it the best chance of survival when it is released into the next stage of the programme.'

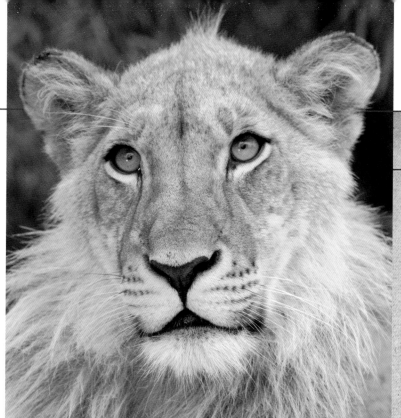

MOYO (M)

Meaning
Heart

Born
2 December 2009

Identifying marks
Long nose and a mark on the right ear

Characteristics
Rescued by AP at a young age, he had been hand-reared but had little contact with humans. Perhaps because of this, he is skittish and rarely walks with his group, instead staying in the long grass close by.

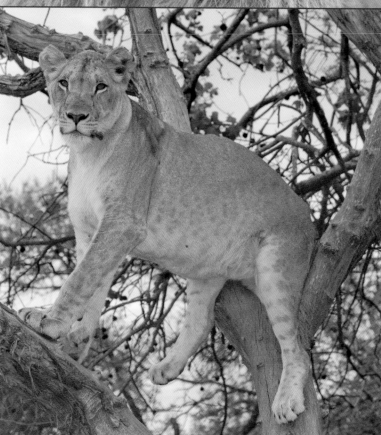

SAHARA (F)

Meaning
Named after the Sahara Desert

Born
8 October 2007

Parents
Sandy (mother) and Big Boy

Siblings
Sango (deceased) and Swahili

Identifying marks
Numerous spots on the forehead

Characteristics
From a quiet beginning and despite her affectionate nature, Sahara is AP's most proficient hunter, making the most kills during both day and night hunts.

SORIAH (F)

Meaning
Princess

Born
15 November 2007

Identifying marks
Very long face

Characteristics
From a young age, Soriah was confident and playful, with a mischievous streak that enabled her to fit in well with other lions. She has matured into a beautiful lioness and was a member of the most successful hunting pride AP has ever had.

SWAHILI (F)

Meaning
Named after the widely spoken African language

Born
8 October 2007

Parents
Sandy (mother) and Big Boy

Siblings
Sango (deceased) and Sahara

Identifying marks
Dark scar on the bridge of her nose

Characteristics
Unlike her siblings, Swahili is a skittish lion who likes to wander alone. Despite that, with Soriah and her sister Sahara, she has proved to be a very successful hunter.

THULANI (M)

Meaning
Be still

Born
11 January 2009

Parents
Lulu (mother) and Maximus

Siblings
Tsavo and Meggie

Identifying marks
Dark brown eyes

Characteristics
The most playful and mischievous of his three siblings, Thulani is a natural hunter.

TSAVO (M)

Meaning
Named after a Kenyan national park

Born
11 January 2009

Parents
Lulu (mother) and Maximus

Siblings
Thulani and Meggie

Identifying marks
Distinctive blonde mane

Characteristics
The largest of his litter, Tsavo is a born leader and was confident in the bush from a young age. His affectionate nature won him many friends at AP.

Born
to be free

The release pride

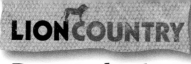

Born to be free

The release pride

August 29 2007 is a historic date for all those involved in ALERT. With great fanfare, Sir Ranulph Fiennes – the world's greatest living explorer – cut the tape on a newly built enclosure and a pride of seven lions, consisting of two males (Maxwell and Luke) and five females (Mampara, Muti, Kenge, Ashanti and Phyre) was set free in the African Lion Rehabilitation and Release into the Wild Program's first-ever Stage 2 release. It was the first opportunity for Andrew Conolly, David Youldon and the whole lion team to discover whether all the hard work on the pre-release training of Antelope Park's lions had paid off.

The release site was a 200-hectare enclosure in the centre of the game-rich Dollar Block reserve. Dollar Block, located between Bulawayo and Gweru, around 250 km from Antelope Park, covers almost 25,000 hectares in the Zimbabwean Midlands. As this was the programme's first Stage 2 release, the lions' progress was monitored closely but remotely, using radio collars. As per standard Stage 2 protocol, all human contact was removed.

Within four days, the lions had made their first kill, an eland (Africa's largest antelope). Confirmation of their ability to hunt came when they successfully preyed on a warthog and an impala. Soon after, however, the programme suffered its first setback.

Two months after the release, in October 2007, the research team discovered Muti's body. Maxwell and Luke were in the area and it was believed that the lioness's death was the result of an aggressive encounter with one or both of them. A week later, the two males were observed attacking Mampara. She appeared to suffer only a superficial wound but later died, most likely from internal injuries.

In an attempt to understand the males' behaviour, the ALERT team called in a team of expert consultants. In the end, however, it was impossible to draw any firm conclusions from the available information. To protect the remaining members of the pride, Maxwell and Luke were removed from Dollar Block and returned to Antelope Park.

^ The world's greatest living explorer, Sir Ranulph Fiennes OBE, patron of ALERT.

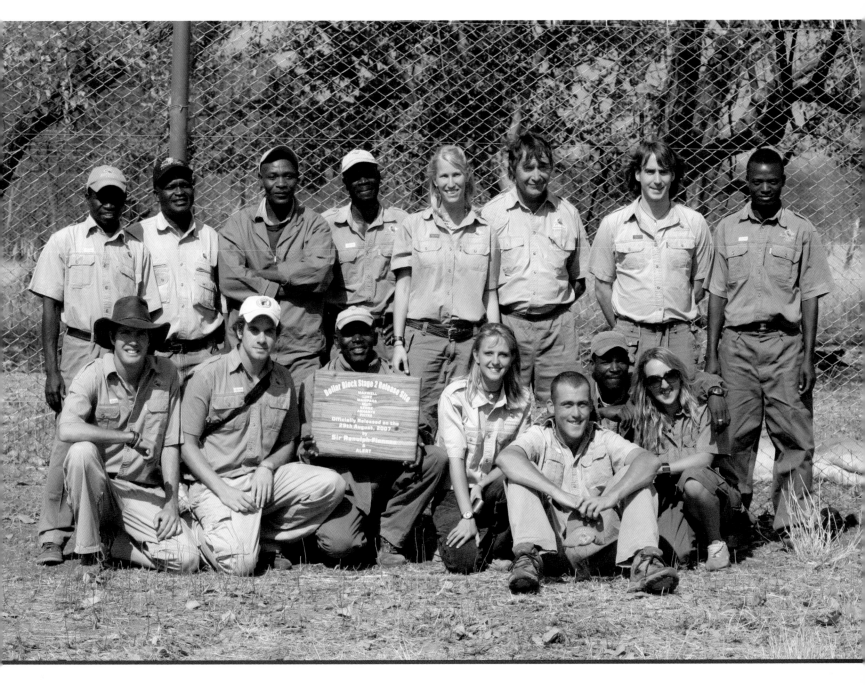

^ Members of the ALERT team at the first Stage 2 release in Dollar Block.

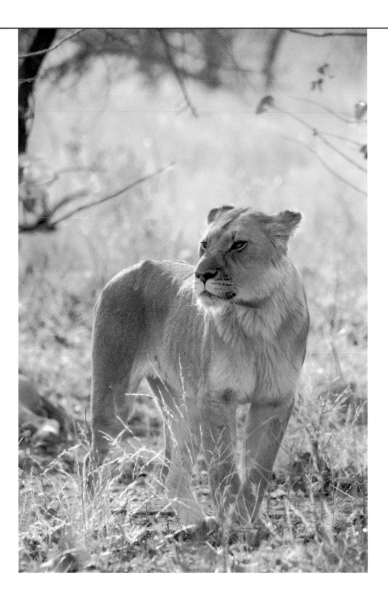

The surviving females, Phyre, Ashanti and Kenge, stayed in the release site and immediately began rebuilding the pride, hunting successfully, even bringing down an adult giraffe. In April 2008, following a careful bonding process, they were joined by three new females, Athena, Nala and Narnia.

Initially there were concerns that two sub-groups were emerging (the original pride and the introduced lions) but it became evident that Athena, Nala and Narnia were simply exploring their new surroundings and soon rejoined the other three. Eventually the six lions spent around 90 per cent of their time together, separating only occasionally – a natural behaviour within wild lion prides.

With the females now stable and hunting successfully and regularly, the plan was to introduce a male to the group – a newly formed protocol drawn up after the earlier Dollar Block experience, which persists to this day. However, a new challenge lurked that was beyond the team's control. By now, the economic situation in Zimbabwe had deteriorated significantly, making it hard to maintain the Dollar Block site and the research programme. After much soul-searching and with a great deal of regret, in December 2008 a decision was taken to return the six lionesses to Antelope Park.

Despite the obvious heartache, many lessons had been learned from the Dollar Block experiment, not least of which was that a Stage 2 release could be successful. And so, undeterred, the team made plans for a second attempt.

It was to be almost two years before they secured the necessary land and rebuilt the fence on a new Stage 2 release area. The new site – named Ngamo – was much closer to Antelope

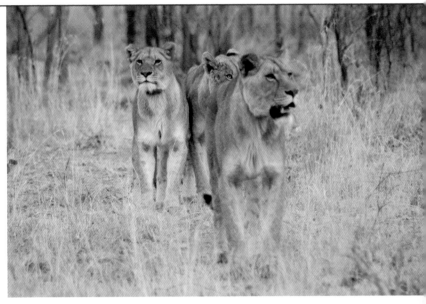

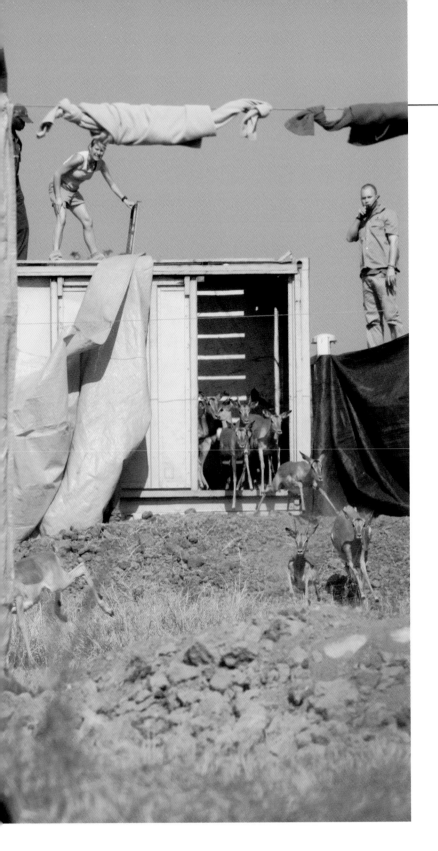

Park and, having taken on board the lessons learned from the Dollar Block release, the team was confident of success. But before the lions (the Dollar Block pride, plus a new female, Kwali) could be introduced to their new home, one small but critical obstacle needed to be overcome.

The land acquired for the release had previously been used for agriculture and was devoid of game. For the release to have any chance of success the lions needed prey to hunt and so, in August 2010, a major stocking programme began. A professional game-capture team was called in and, using a light helicopter, zebra, wildebeest and impala were rounded up from Antelope Park and translocated to Ngamo.

The capture took two days and the help of practically every volunteer on site but, ultimately, was successful. Once it was completed, around 100 animals were roaming the expanse of Ngamo's grasslands and the site was ready for the lions. One of the most important lessons from Dollar Block was that the pride needed to be released in two stages: the females first, followed sometime later by any males. The date for the lionesses' release was set at 1 September 2010.

ASHANTI (F)

Meaning
Named after a region of Ghana

Born
8 November 2004

Siblings
Achilles, Apollo, Ariel and Athena

Identifying marks
Long face and prominent eyes

Characteristics
Ashanti is a confident and sometimes mischievous lion. She has grown to be a great leader and is the dominant female within the Ngamo Stage 2 pride. She is clever and uses different strategies when hunting. She's a team player and works well with the other members of the pride.

ATHENA (F)

Meaning
Named after the Greek goddess of wisdom

Born
8 November 2004

Siblings
Achilles, Apollo, Ariel and Ashanti

Identifying marks
A very muscular lioness with a wide-looking face

Characteristics
Athena has always been confident when hunting but was shy around people, preferring to stay to the side of the pride. She is working well within the release pride and is an active participant in hunts.

NARNIA (F)

Meaning
Named after the magical kingdom in the children's books,
The Chronicles of Narnia

Born
26 November 2005

Siblings
Nala

Identifying marks
A long, old-looking face

Characteristics
Narnia and her sister Nala were AP's second best hunters
after Sahara. Narnia was especially successful at night and
is one of the best hunters in the Ngamo pride.

NALA (F)

Meaning
Successful

Born
26 November 2005

Siblings
Narnia

Identifying marks
A very light coat and small head

Characteristics
A superb hunter, one of the
best in the Ngamo pride.
Very skittish around
people and avoids
any contact.

KENGE (F)

Meaning
Everything is all right

Born
31 October 2004

Siblings
Kwezi and Kwali

Identifying marks
A very short and muscular lioness with dark eyes

Characteristics
Kenge was a very skittish cub who would sometimes growl if people came too close. She has grown into a mature lioness, a good hunter with the potential to be a good mother.

KWALI (F)

Meaning
Francolin

Born
31 October 2004

Siblings
Kwezi and Kenge

Identifying marks
Her face is slightly deformed

Characteristics
Kwali is a friendly lion but suffered Horner's syndrome (a stroke) when she was just 11 months old. She was spayed so that she would not breed. She is an exceptional hunter and has carried that on in Ngamo.

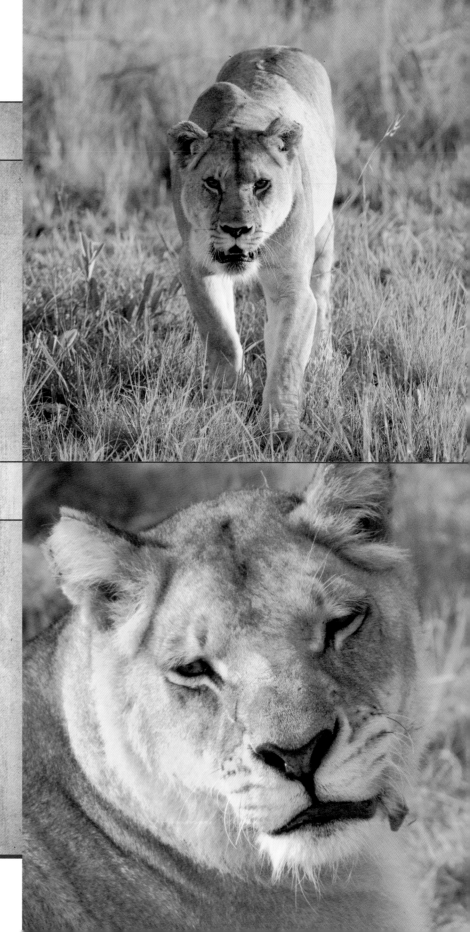

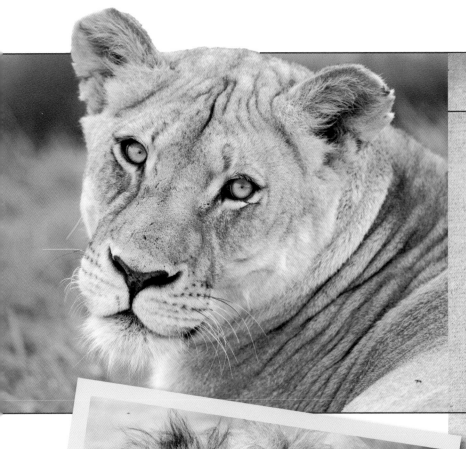

PHYRE (F)

Meaning
Burning bright

Born
4 July 2005

Siblings
Praise and Paka

Identifying marks
Long face and pale eyes

Characteristics
Phyre is confident and was always the mischievous one on walks. She is a good hunter and has done well since being released into Ngamo, but we suspect her greatest strength will be as a mother figure to the rest of the pride.

MILO (M)

Meaning
Named after a guide at AP

Born
7 December 2002

Siblings
Mickey and Marcus

Identifying marks
Very dark mane

Characteristics
Milo is an aggressive lion. He is leading the Ngamo pride well and, although he can sometimes be a loner, never lets his pride of females stray too far.

For a first-hand account of events leading up to and following the release, let us turn to David Youldon's big cat diary for September 2010...

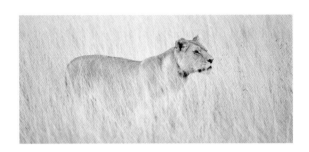

1 September (morning)

The day starts yesterday really. Due to bureaucratic issues with getting the necessary drugs into the country to dart and collar the lions, we are left with no option but to start the process after dark – 10.15 p.m. to be precise. Narnia, Kenge and Kwali are placed in a management pen and quickly darted. However, the remaining four lions catch on to what is happening and some hours later we have to abandon attempts to dart Nala and Athena. At around 2.15 a.m. we successfully dart Ashanti and Phyre and, once they have come round at about 3.30 a.m., we call it a night.

By 6 a.m. we are up again; this time Nala and Athena play ball and receive their collars. During the collaring process we also take the opportunity to take blood samples and body measurements for future analysis. The pride is then moved into a large passage adjacent to the release site and allowed to chill out until the time of release.

1 September (afternoon)

Our honoured guests arrive and are treated to a game drive around the release site. This project is a joint public/private sector initiative and guests include His Honour Francis Nhema, Minister for Environment and Natural Resources, the Director General of the Zimbabwe Parks and Wildlife Authority, the regional governor and representatives from a host of public organizations from all facets of government and public life, as well as the Zimbabwean press.

Andrew Conolly, founder of the programme, gives a speech, followed by a speech from Minister Nhema (reproduced at the front of the book, page 8). After the speeches, the gates to Ngamo are opened. Kwali is the first to investigate, approaching the gate, but when the others refuse to follow she retreats to their company. But then, as one pride, they move forward, led by Phyre. Together, they move along the fence for a few metres before disappearing into the long grass. The adventure begins.

Trained volunteers help with radio-collaring the lions. With the collars on, the lionesses are ready to go and guests arrive to watch the release into the Ngamo reserve.

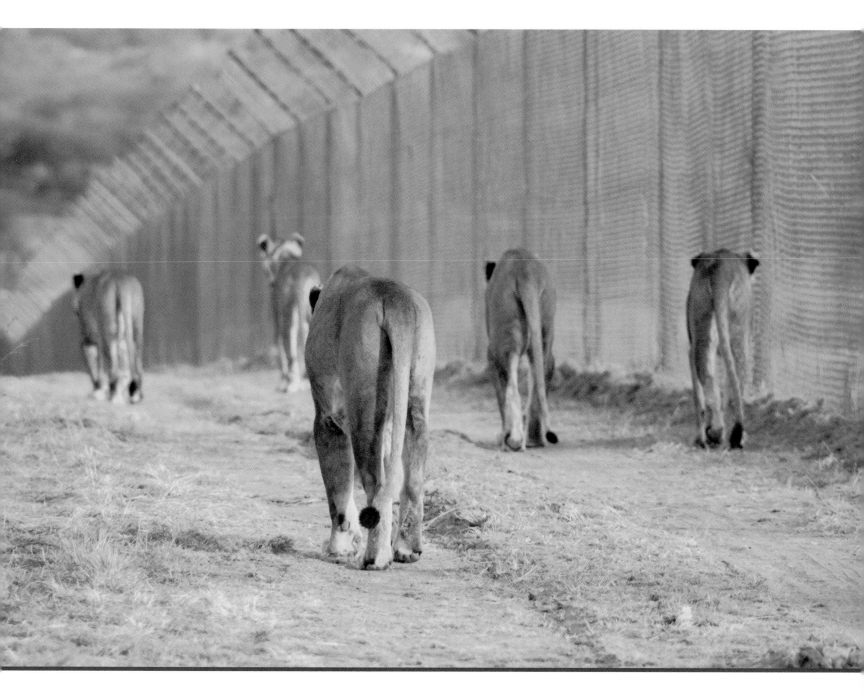

^ Five of the seven lionesses, immediately after their release.

The last we see of the girls is some tails disappearing into the long grass, heading south into the area called Amboseli. Shortly afterwards, some keen observers spot them a few hundred metres into the site, resting under a tree with a good view of the surrounding land. Later, while clearing away the chairs at the release gate, the staff see the lions back in the area, climbing trees, jumping over anthills and generally having a good sniff around.

At 4.30 p.m. a small team drive into the site to make sure all is well. The telemetry helps us find the pride, still in Amboseli, just off the road known as Route 66. They are spread out around a patch of long grass surrounding an anthill. There is no sign of Athena but her collar tells us she is in the long grass somewhere. The girls are extremely calm, lounging around in the sun and barely raising an eye when we approach.

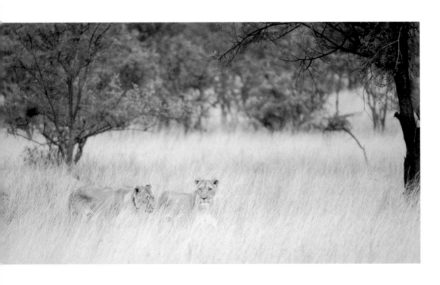

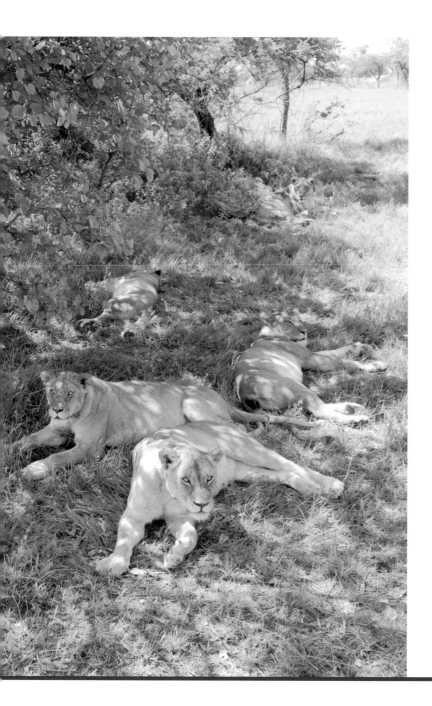

Narnia moves first, suddenly standing and walking off along the boundary towards the Ngamo Road Gate. The others follow, but as they disappear over the brow of the hill there is still no sign of Athena. On closer inspection, we find her asleep and when she wakes she looks genuinely confused as to where the rest of the pride has gone.

Leaving her, we decide to follow the others. With Narnia leading and Kwali bringing up the rear, they march off at a steady pace along the boundary. They stop to play in the grass a couple of times and have an unsuccessful stalk on a duiker that is just minding its own business. Before long, having covered a kilometre, they have made it to fence point NR4 and show no signs of stopping. Seeing that they are all OK, we decide to leave them be and return to Athena, who has moved back to her spot in the grass and gone back to sleep. We are not surprised to see her on her own, as she is the most independent lion within the pride and is often seen apart from the others.

So where will they explore tonight? Will they encounter more game? Will Athena rejoin the other girls? Have they found the waterholes? They are out there, right now.

< Members of the new pride rest in the shade in their new home.
<< The girls disappear into the long grass.

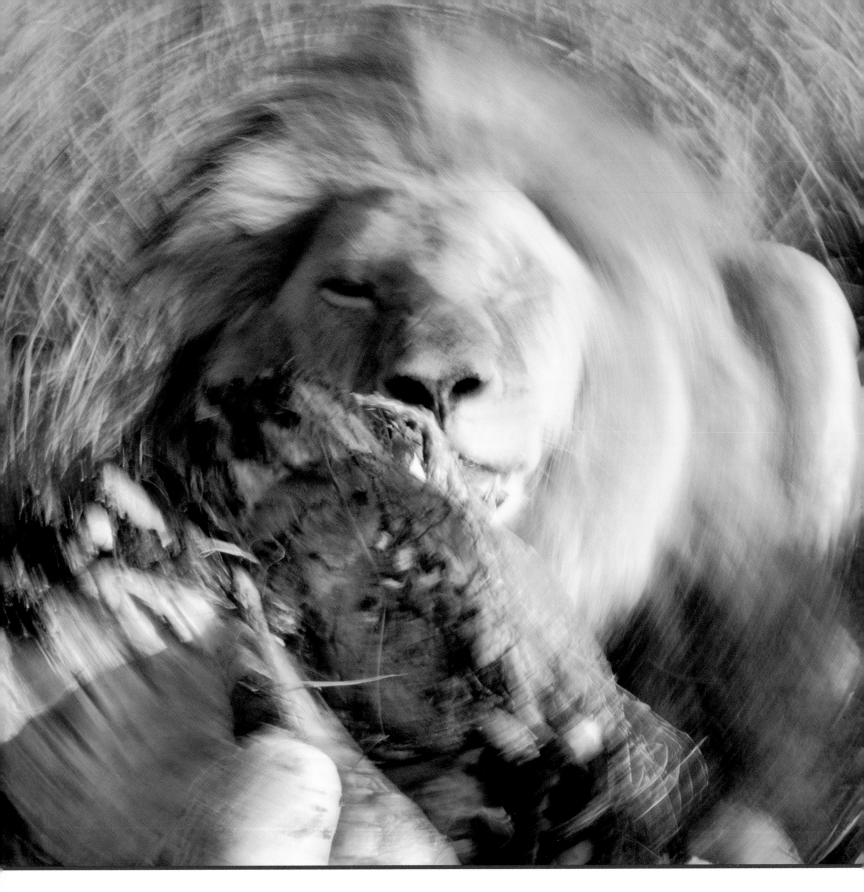

2 September

This morning we find Athena in the area around Amboseli, using the long grass around an open vlei full of game to stalk for a possible meal. Unsuccessful, she skulks back to rest under a tree, where she remains for the rest of the day.

Meanwhile we set off to find the others. We get a signal for all but Kwali at the far end of the site near the River East Gate, but cannot get a visual. So we go in search of Kwali, who turns up in the area named Kruger. We notice drag marks in the grass and follow them to discover the carcass of a juvenile wildebeest, its entrails already consumed.

When we see Nala we realise that things are not quite as they seem. On closer inspection, we can see that the pride is resting after a meal of juvenile zebra, although Kenge is still munching on the leftovers. Both kills are small and, based on the expected average daily intake of a lioness, they will need to make another kill within 48 hours.

< Milo tears into a zebra.
˅ In the first few days, the lionesses explore their new territory.

3 September

A quiet day. Phyre, Ashanti and Kenge are choosing to sleep off their meal from yesterday. We can't get a visual, but we know they are along Route 66, somewhere between the fence and Leopard Tree. Nala and Narnia (the Ns) have decided to do a bit of exploring. We saw them this morning, moving across Serengeti East before finding a tree under which they slept. Later, we spot them again close to Crossroads, just off Route 66, quite possibly heading back to Ashanti, Kenge and Phyre.

As for Kwali and Athena, they were last seen alone in different parts of the reserve. We drive to where Kwali's kill was and find her happily finishing it off. She gets up from the kill and lies down to rest some metres away. Only then do we spot the familiar shape of Athena appearing to take what is left of the wildebeest. The two remain together all day.

The initial signs are good. The pride is splitting into kin groups of two or three animals that are exploring the reserve, then joining up again later. This is natural behaviour and what we'd expect within a wild pride.

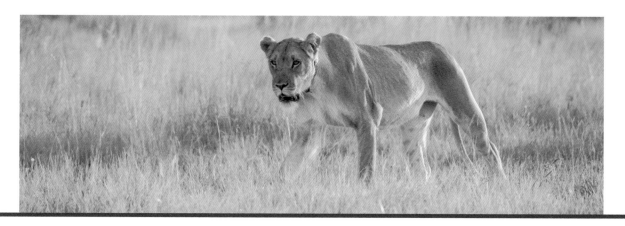

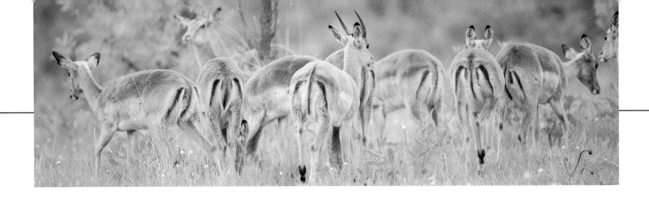

^ Impala graze in the Ngamo reserve.
∨ Milo takes exception to Kwali's unsolicited approach and chases her off the kill.

4 September

This morning, Ashanti, Athena, Kenge, Phyre, Nala and Narnia make their way to Waterhole 1. There is no sign of Kwali. We head to where we last saw her with Athena. As soon as we drive up, Kwali comes out of the grass, calling and looking a little lost. We go back to the others and see Kenge chase after a murder of crows. As we draw nearer we realise that she is protecting a kill. When we saw the lionesses earlier, they must have just left the kill to drink. Twenty minutes after we arrive Kwali turns up, looking decidedly sheepish. She stops 30 m from the kill and watches. The six girls watch back – a stand-off.

As Kwali is the newest member of the pride, this behaviour may be a sign that the core group isn't ready to fully accept her, even though she has been bonded to them over a long period.

Phyre gets up and approaches Kwali. We are unsure if this is about to erupt into a fight, as Phyre has a menacing look about her. When she approaches she gives Kwali a head rub. Kwali responds by dropping into a submissive position, then lies there looking uncomfortable while Phyre eyes her closely. Seemingly satisfied that Kwali isn't an intruder, Phyre returns to the kill.

5 September

The lions seemed to have settled into their new home. Having gorged themselves on wildebeest and zebra, our gang spend the whole day sitting by Waterhole 1. The only thing of note is that Kwali and Athena lie together on one side, while the remaining five lie in what can best be described as a pile, in a thicket on the other.

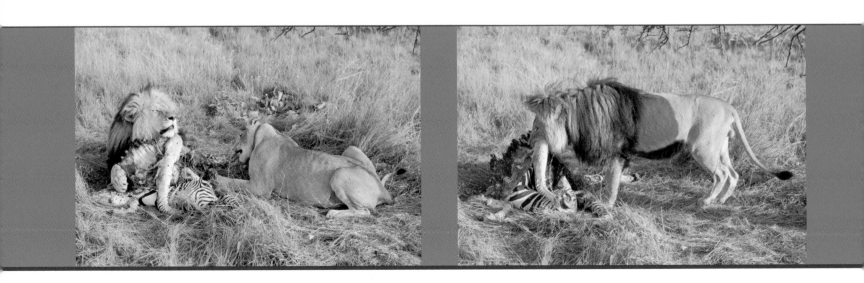

> Just four months after the release, only one of the original wildebeest released into Ngamo had survived, the rest having fallen victim to the lions.

6 September

Little to report today, although we do discover some new group dynamics. We pick up Athena, Nala, Narnia and Kenge (who is usually never far from Ashanti's side) moving from Serengeti East to Kruger. Their march, clearly led by Athena, takes them all the way to The Valley, where they remain near Leopard Tree, although Athena leaves at some point in the afternoon.

Phyre, Ashanti and Kwali are not seen at all today, although their collars put them somewhere around Crossroads. A brief sighting at the end of the day suggests that at least some of the lions are back near Waterhole 1. The first night patrol is out right now and should be able to verify this.

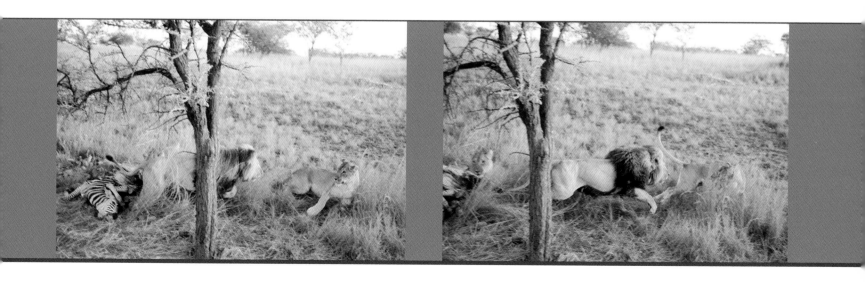

^A thirst-quenching drink on a hot summer day.

7 September (morning)

The girls are fit, fat and flourishing this morning when we find them on yet another wildebeest kill in the Tree Tops area. All seven are present, with just the two youngest, Nala and Narnia, still eating while the rest lounge around. Kwali has made several attempts to approach the kill but has been rebuffed on each occasion either by the Ns or by Ashanti.

7 September (evening)

As day turns to evening the pride become restless. On several occasions Narnia and Kenge walk off up the road, only to return when no one else follows. All the lions look as if they are ready to leave, but Phyre is still asleep. Finally, she wakes, grooms herself for a while and then goes to greet Ashanti before the two of them play.

When Phyre starts to walk off, the others follow. It's as if they have been waiting for her to take the lead. Ashanti brings up the rear. From this observation, plus the gathering evidence from our social interaction study that Phyre continues to be the lioness most others want to greet, it appears that Phyre has taken over the role of alpha female.

8–9 September

A pattern is beginning to form. On both days we see the gang enjoying some wildebeest before spending the rest of the day lounging in one of their favourite spots – the area around Leopard Tree. What is becoming apparent is that either Ashanti or Phyre is taking the alpha female role.

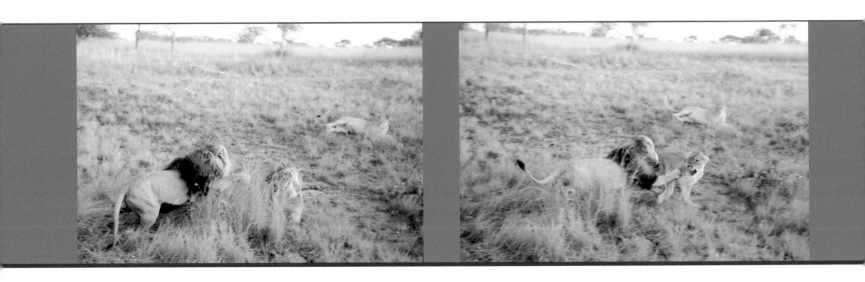

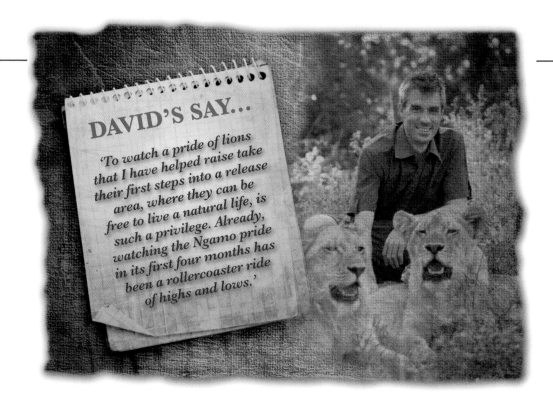

DAVID'S SAY...

'To watch a pride of lions that I have helped raise take their first steps into a release area, where they can be free to live a natural life, is such a privilege. Already, watching the Ngamo pride in its first four months has been a rollercoaster ride of highs and lows.'

11 September

From our initial research, we are beginning to see how the members of the pride are interacting. Of the first 86 observations, 28 different groupings have been observed, the most common (28 times) being all seven lions together. Ashanti has never been in a group of fewer than three lions, Phyre only once. Athena is most likely to be seen on her own (five times) and Athena and Kwali are most likely to be part of an observed group of two. The second most common grouping (eight times) is Ashanti, Athena, Kenge and Kwali.

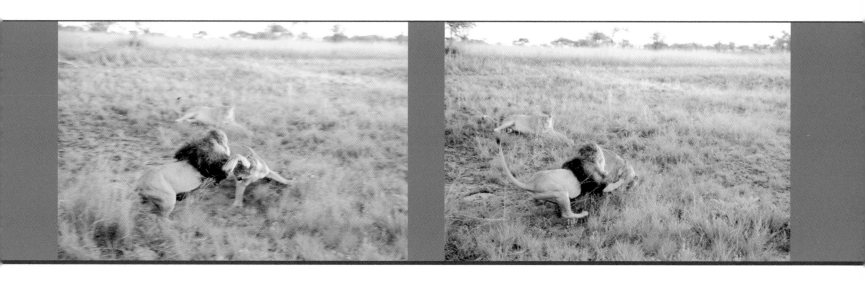

12 September

It's been very quiet in the pride these last few days. The girls have spent most of the time chilling near Waterhole 1. Ashanti is on heat and is presenting to most of the other lionesses, especially Phyre. Which brings me on to Milo – the male lion. This has been one of those frustrating times unique to Africa, involving drug availability, licences, supervisory requirements, the legal system and bloody-mindedness. We are hoping that Milo will finally get his collar tomorrow and be released late Wednesday or early Thursday, but I am not prepared to commit to anything until he's been released.

Within Ngamo, the pride has had to deal with the pesky pied crows for a while now, but something bigger arrives from the skies today, and they come in numbers – white-backed vultures. Ngamo will be an important food source to these scavengers.

^ Skulking away after an unsuccessful hunt.

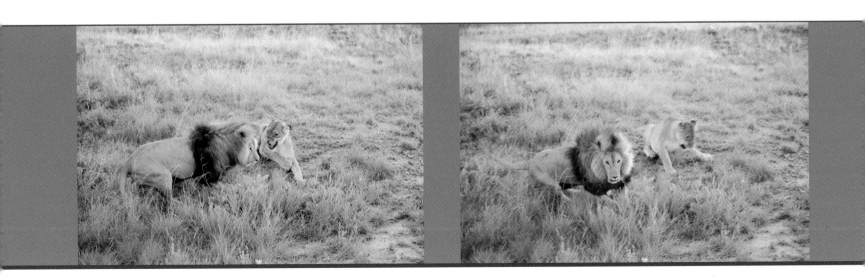

13 September

The lions are in an active and playful mood this morning. After sunrise we watch Ashanti, Narnia, Kwali, Nala and Kenge stalk eight zebras in a failed hunt. When the chase is over, the prey don't go far: they stop to look back from the relative safety of the short grass. Nala and Kenge are following Kwali, who charges suddenly. Kenge and Nala are taken by surprise and stop in their tracks. Meanwhile, Kwali's tail is seen heading over the hill in pursuit of the fleeing herd. She is back 15 minutes later with nothing to show for her efforts. On her return she spends some time playing in the morning sun with her sister Kenge. Then the five lions regroup and pass by the waterhole for a drink before rejoining Athena and Phyre, who are warming themselves on an open vlei, surveying their territory.

˅ Lions spend much of the day resting, sleeping for up to 18 hours.

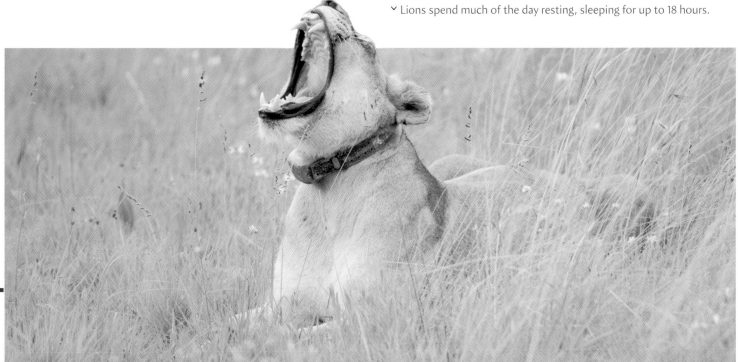

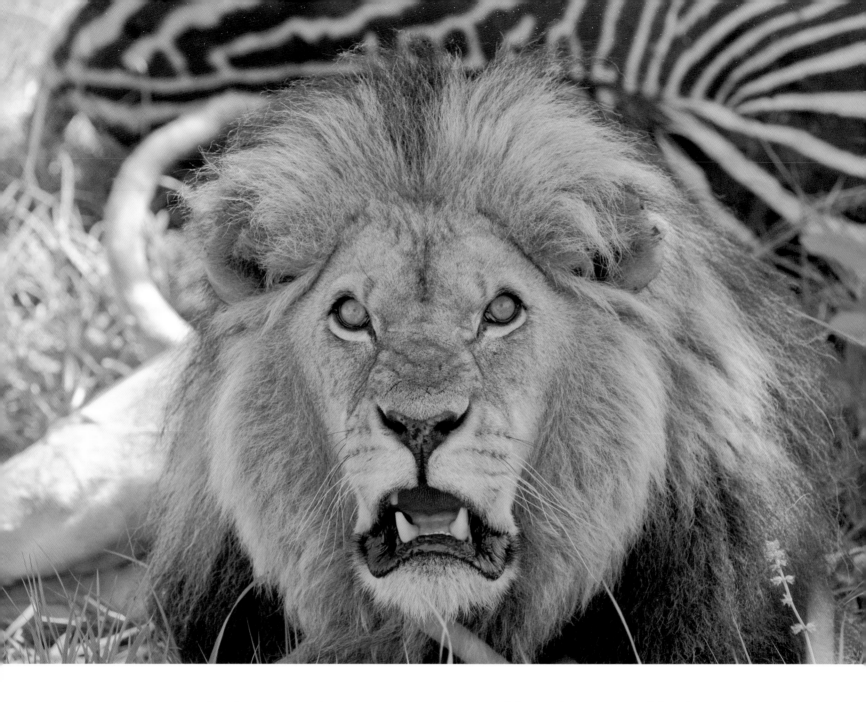

15 September (early morning)

At first light we find Ashanti, Nala and Narnia making their way along Grasslands towards Waterhole 1. As they go, they stalk, then run at each other before rolling around in the grass. Before long playtime is over and Ashanti lifts her head, sending a deep resonant roar across the savanna. Moments later a response is heard, maybe a kilometre away. Seemingly satisfied as to where the rest of the pride are, she sets off in their direction with the Ns in tow. After much greeting and more playing, during which Narnia decides to climb a tree while Ashanti watches at its base, the pride settles in for what I am sure they think is just another lazy day in the bush.

< Milo doesn't share his food with anyone – at least not until he's full.
˅ The lionesses stalk a small herd of impala.

15 September (mid-morning)

Strangely (coincidentally?) the pride has decided to sleep very close to Milo's holding enclosure and the commotion from that direction gets their attention. As we bring Milo from the holding pen into the passageway the girls move towards the release gate. Two in particular, Phyre and Kwali, sit on either side of the gate, waiting. The rest of the lionesses are in the long grass. At 10.14 a.m. precisely, Milo comes through the release gate and heads straight to the waiting girls. We watch to see whether they'll run, greet him affectionately, or whether a fight will break out. There are so many unknowns: are Athena and Phyre on heat? What does Ashanti think of all this? How are the young Ns going to deal with it? Is Kenge going to remain Milo's first-choice girlfriend? And what next for Kwali? I believe in the trade this is what they call a cliffhanger!

From previous experience we know that Phyre does not submit easily and yesterday she started to show signs of being on heat. This morning we think Athena might be too. So it is a great relief to note that the first thing to happen is Phyre starting flirting, while Kwali tries to greet the new boss. Milo takes both interactions in his stride and simply prowls off down the fence, the girls in tow. Ashanti is definitely the most hesitant, staring at Milo, perhaps not quite sure what to make of the situation.

15 September (afternoon)

The girls are fascinated! Phyre and Athena constantly approach Milo, wiggling their bottoms at him, tails flicking in his face (so I guess they probably are on heat, then!) The others trail along behind, trying to get a look in, maybe to gain his attention. There are a couple of small growls in the long grass. I can't be sure but I think they are directed towards Phyre – maybe she has come on a bit too strong. Either way, before long Milo has had enough of the attention and starts making his way from the Amboseli area towards Serengeti East, covering over a kilometre in quick time.

15 September (evening)

Milo certainly isn't pestering the girls, who are happily snoozing around the waterhole. Phyre is also sleeping, but she's woken by the not inconsiderable weight of Athena sitting on her. The action has the desired effect as both girls get up and march off determinedly in the direction of a roaring. As they approach their target Milo rises to meet them. So it turns out that our girls, Phyre and Athena, are … how do you say? Gagging for it. They flirt for all they're worth before rolling around in front of Milo, trying to look alluring. Milo simply steps to the side and urinates on his own feet. Then he finds a spot in which to settle down. Phyre and Athena literally run after him and begin a pretty unsubtle routine. With the girls' oestrus cycles expected to last another three to four days, I wonder … will Milo finally give in and make honest women of them?

17 September

Life in the pride has settled down once again. There are a lot of vultures around, which hasn't escaped the notice of Kenge. She isn't happy and, at full speed, she charges into a large group on the ground, sending them flying in all directions. That's about the only action we get today.

21 September (morning)

We find the girls, minus Athena, in Amboseli, engaged in a bout of prolonged play. As usual, though, someone has to go and ruin things and, after being the focus of one too many initiations, Phyre and Narnia have had enough and move off to sit alone. Some 30 minutes later Milo joins the group and sits 30 m away. Then, shortly after, we see Athena arriving along Route 66. Seemingly content with being able to see the pride, she stops short and rests, still hampered by her limp.

Within minutes of Milo's arrival the six females set off with some purpose back towards Southern Cross and their favourite anthill. Reaching the crest of the hill, a duiker shoots out in front of them. Only Kwali reacts and gives chase, although it is half-hearted at best. We check back in with Milo and Athena at Amboseli. Milo is exactly where we left him earlier; Athena is giving a strong signal on the telemetry but has obviously found somewhere out of sight to rest.

21 September (afternoon)

We find Athena by Waterhole 1 and she's calling from the top of the hill. We leave her after a few minutes and head towards the pride's favoured resting spot, passing a herd of impala. Still some 200 m away, we can see some of the pride

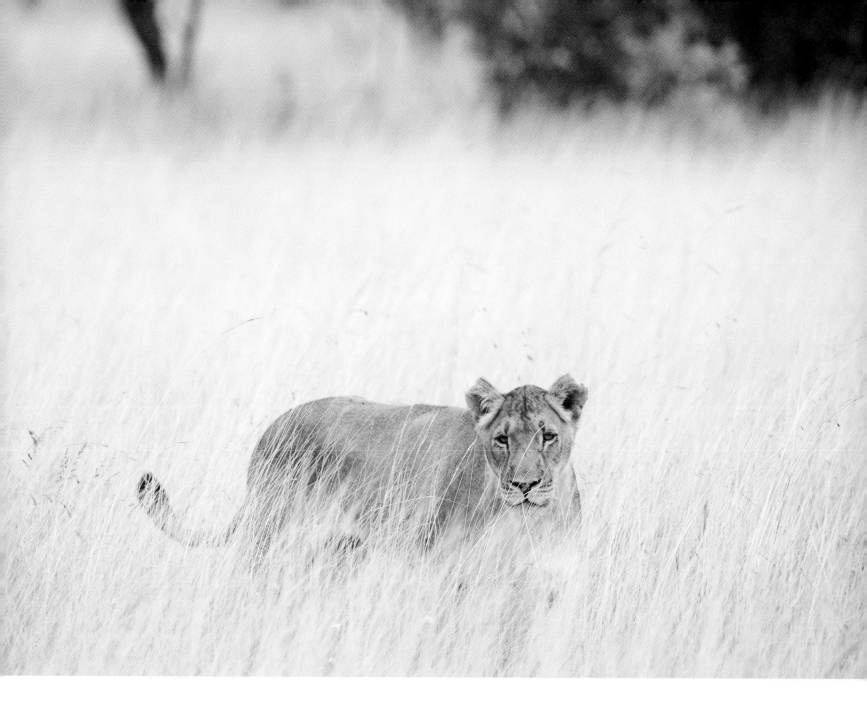

around the anthill but Narnia, Nala and Kenge are walking down the road towards us before veering off across Southern Cross. They may be responding to Athena's calls, as the four meet up soon after.

Phyre is making her way up towards the pride and drops into a stalk. About 30 m away she begins chasing a herd of impala, which dart in all directions. We lose sight of her momentarily until the impala race past about 20 m in front of our truck. Phyre's still hot on the tail of one of them, but not close enough. At this point, Kwali comes trotting past the right-hand side of the vehicle and picks up the chase.

22 September

We find Milo first. The females are all lying just on the other side of the tree they were resting under before. Some very interesting behaviour is being displayed. Milo moves to within about 40 m of the girls. Nala soon approaches him and smacks him around the head, which he accepts. She sits down a few metres away. Narnia joins them and begins to do exactly the same thing, to which, again, Milo shows no reaction. Soon after, Phyre approaches Athena and greets her; the pair engage in a very long grooming session. Narnia joins them after about 10 minutes, followed by Athena and then Kenge.

^ Milo shelters under a tree with the pride's latest kill.
< The lionesses greet each other.
> Tucking into a well-earned dinner.

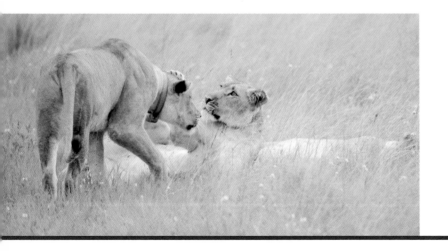

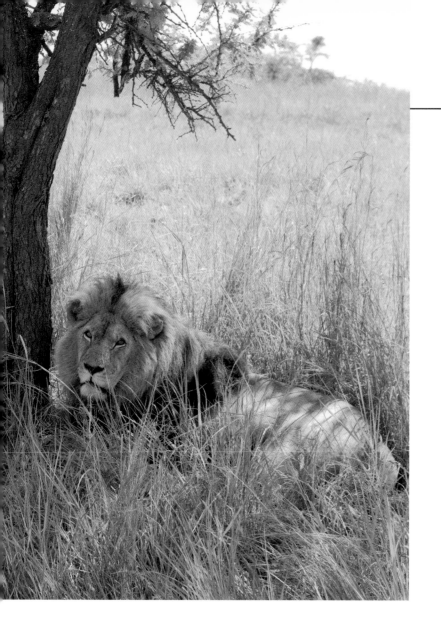

26 September

The first thing we see this morning as we enter through Ngamo Gate is a herd of zebra. We count them and then count three times more to confirm that two are definitely missing. As soon as we reach the top of the hill by Waterhole 1 we begin picking up a signal on the telemetry. We make our way across the top of Southern Cross and sight the unmistakable form of Milo, away down the road; several of the females are dotted around the area. We can see a shape a little way past Milo that is definitely not a lion.

Still some way off, we use the binoculars to confirm that there's a zebra carcass about 20 m beyond Milo. But something doesn't make sense. The stomach of the carcass is open but it has barely been touched. And all the lions in sight (everyone except Athena and Phyre) are fat, with blood on their faces. Almost immediately, Milo gets up and begins feeding on the offal of the little-touched zebra, before dragging it to a shady spot some 30 m away. While Milo is eating, we find a second carcass close by. Two kills!

27 September (morning)

It's just before 7 a.m. and Phyre seems agitated, walking up and down and roaring. None of the pride responds vocally but Nala, Kenge, Ashanti and Kwali all come to sit with her. She isn't having any of it, though, and snarls at all but Kenge as they approach. However, the tantrum doesn't last long and soon all five lionesses are resting in a pile. Later, Athena and Narnia move onto the carcass vacated by Ashanti, but aside from a bit of grooming between Ashanti and Phyre it's a very quiet morning. We leave the girls at 8 a.m. after an activity budget on Nala has been completed, and go to find Milo before we leave the site for the morning. Looking completely relaxed, resting in the tall grass around Waterhole 1, His Lordship briefly lifts his head as our truck pulls up alongside the waterhole, before slumping back down with a weary sigh.

27 September (afternoon)

Milo is still at Waterhole 1, sleeping. Ashanti, Kwali and Nala are all sleeping around the half-eaten second carcass. The others are resting under a tree a couple of hundred metres away. While they could be thought of as technically in the vicinity of the other females, it is decided to class them as a new grouping, as there is no line of sight between the two groups: when Narnia initiates a move shortly afterwards, Ashanti, Nala and Kwali are unable to see it and respond, whereas Athena, then Kenge and finally Phyre follow Narnia's move.

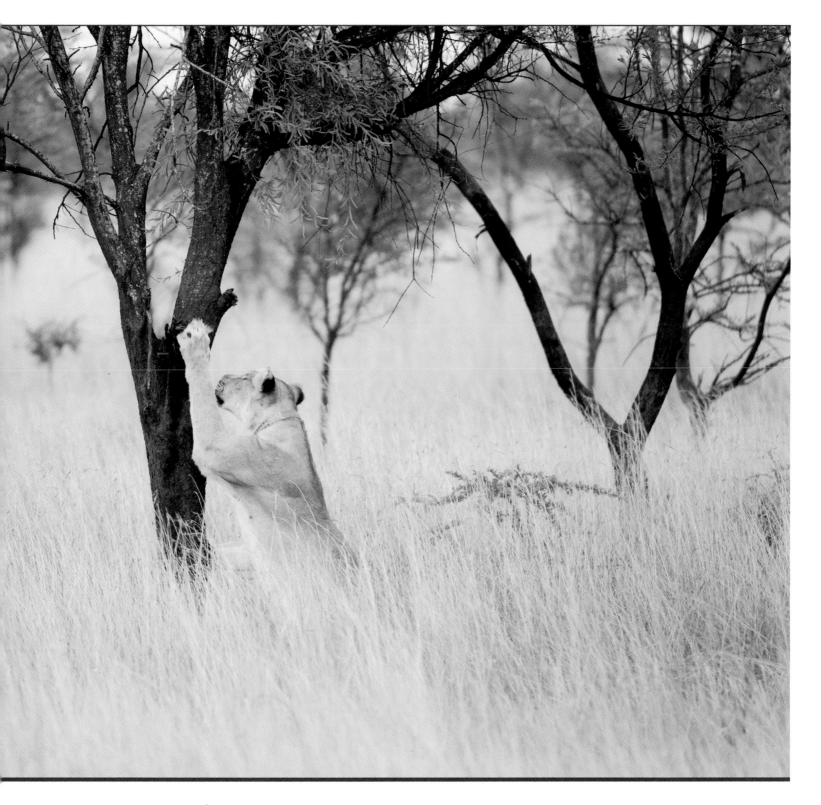

29 September (morning)

This morning we thought we'd found the entire pride back together, having spotted a smattering of lion-shaped forms dotted around the area. But on closer inspection, we find that Milo and Ashanti are absent. We stay with the six girls long enough to complete the 'nearest neighbour' research, but are curious as to where Ashanti might be, as we are receiving no signal for either her or Milo. We head down towards Waterhole 3 to see if they are resting up there, but find nothing. Our last sighting of any of the females was at Waterhole 2 last night, so we decide that should be our next port of call. And we're right. First we spot Milo lying just ahead of the pan. Ashanti is about 5 m away, drinking. As we pull to a stop, Ashanti ambles over to Milo, tail aloft, and greets him. He instantly stands and follows her before mounting her briefly. He follows her throughout the morning, although she never strays too far.

29 September (afternoon)

We head straight for the honeymoon suite, as Waterhole 2 is now known, and pick up a reasonable signal for both Ashanti and Milo even though we can't see them. Heading across the cut area, behind the pan that leads towards Route 66, we find them lying close together and looking, for want of a more finessed phrase, shagged out. Immediately we begin an activity budget on Ashanti. Unfortunately none of our minute marks coincide with the 'action'.

However, at 16.52 Milo approaches Ashanti, sniffs and exhibits flehmen. She rolls over on her back and begins pawing at his face and chest. He then sits down beside her and we don't have to wait long before he stands and sniffs again. She rolls over into position and Milo jumps on top. They repeat the ritual and mating at 17.25. After both matings, the pair roll over and rest. A third mating occurs towards the end of the hour, this time initiated by Ashanti, who stands and greets Milo. He, in turn, stands and leans into her before mounting her. It looks as if it won't be long before we have the first cubs ever to be born into a release pride.

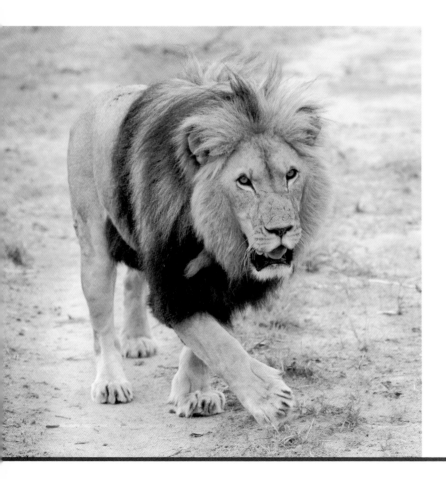

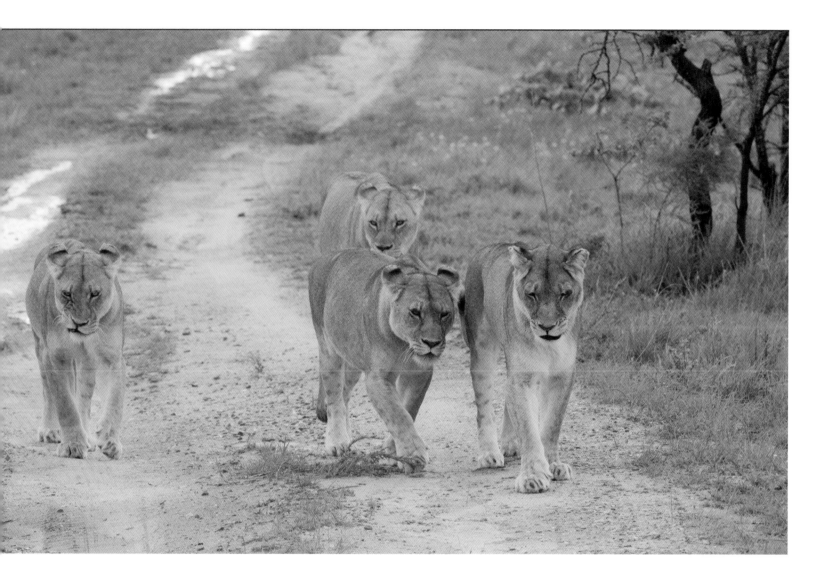

The release pride, including Milo (opposite page),
on patrol in the Ngamo reserve.

What the future holds

the

future

holds

The outlook for lion conservation

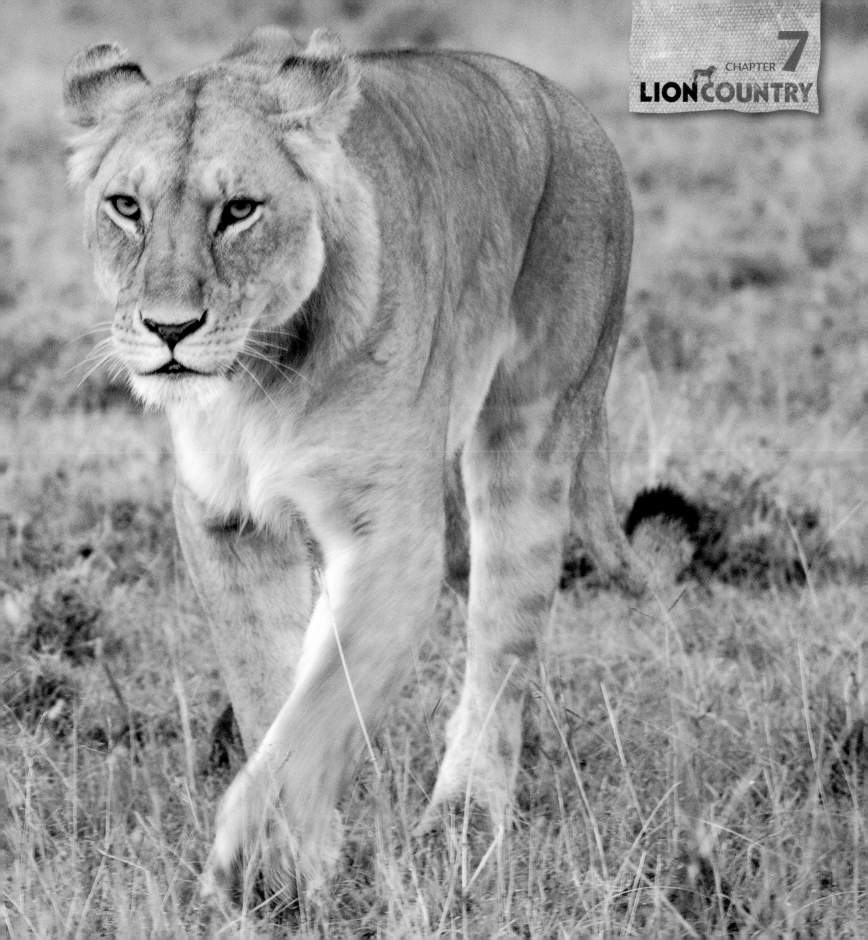

What the future holds

The outlook for lion conservation

While the IUCN categorises the lion as Vulnerable, this classification is generalised across all populations. In reality, national populations of lions differ widely in their true conservation status: some are extinct in the wild, some are critically endangered, others endangered and so on.

The level of protection afforded to lions also differs greatly between nations. In some countries (e.g. Namibia, South Africa and Zimbabwe) trophy hunting is legal; in others, such as Uganda and Malawi, it is not. In Sudan, hunting licences are reported as being issued by the government in the north but, in practice, aren't recognised in rebel-controlled areas in the south, which issue their own licences. Similarly, some nations allow trade in lions and lion products, while others ban it.

Below government level too there are divergent perceptions of lion conservation. In the developed world, lions are widely seen as a flagship species around which conservation efforts should be focused. For rural African communities, however, the perception of the king of beasts is often very different: to many who live side by side with wildlife, lions represent loss of livelihood, threat to life and suffering.

Varying densities of lions in different regions also cause potential conflict between conservation priorities. For

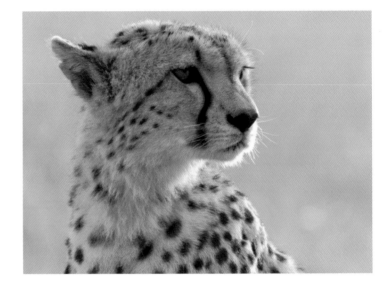

example, the Kenya Wildlife Service has culled around 30 lions in the Aberdares National Park because their over-abundance was threatening the already critically endangered bongo population. In neighbouring Tanzania, cheetahs living in the Serengeti ecosystem are threatened with extinction because of the density of lions there. In this example, the question is, do you cull lions to

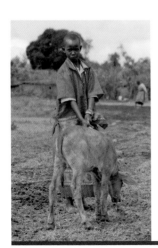

‹ For rural communities lions are often seen as a threat to livestock and livelihoods.
꜓ Density of lions in the Serengeti has a direct impact on cheetah populations.

< Like Andrew Conolly,
David Youlden has
never been afraid of the
challenges that lie ahead.

protect the cheetah, or let nature take its course?

On top of these issues, our planet's changing climate is also having a dramatic effect. In the past 17 years, droughts and downpours exacerbated by climate change have enabled two diseases – canine distemper virus (CDV) and infestations by a tick-borne blood parasite called *Babesia* – to wipe out large numbers of African lions. Lions regularly survive outbreaks of both these diseases, when they occur, as they normally do, in isolation. In 1994 and 2001, however, a 'perfect storm' of extreme drought followed by heavy seasonal rains set up the conditions for the two diseases to converge. The effect was lethal. The synchronised infections wiped out about a third of the Serengeti lion population in 1994 and a similar percentage in the nearby Ngorongoro Crater in 2001.

Changing weather patterns also have an indirect impact on lions. Droughts weaken lion prey, including the Cape buffalo. Then, when the rains resume, *Babesia*-carrying ticks emerge en masse and proliferate in their buffalo hosts, killing many of them. Lions feasting on sickly, parasite-infested buffalo and infected carrion are left with unusually high concentrations of *Babesia*. Again, the subsequent CDV outbreak can prove lethal.

As a result of all these factors, every lion conservationist tends to have his or her own opinion on where time, effort and money should be focused. Perhaps because of this lack of agreement,

little has been done in practical terms to protect the lion. Andrew Conolly and David Youldon are under no illusions that ALERT is a panacea. They see it as a part of the solution. Importantly, however, while others talk at multi-million dollar conferences and then do nothing, these two men, along with their team and supporters, are in the field making something happen.

And their efforts are being rewarded. Interest has been expressed by governments and private reserves across Africa – from Niger and Benin, Malawi and Uganda to Zambia, Zimbabwe and Mozambique – in introducing the ALERT programme and help restore lions in those lion-impoverished countries. The need for such a programme is increasingly acknowledged in terms of boosting lion numbers as well as in promoting sustainable conservation practices.

'The time for talking is over, the time for action is now. The lion needs the African people and Africa needs the lion. Together we can secure the future of this most noble beast.'

Andrew Conolly

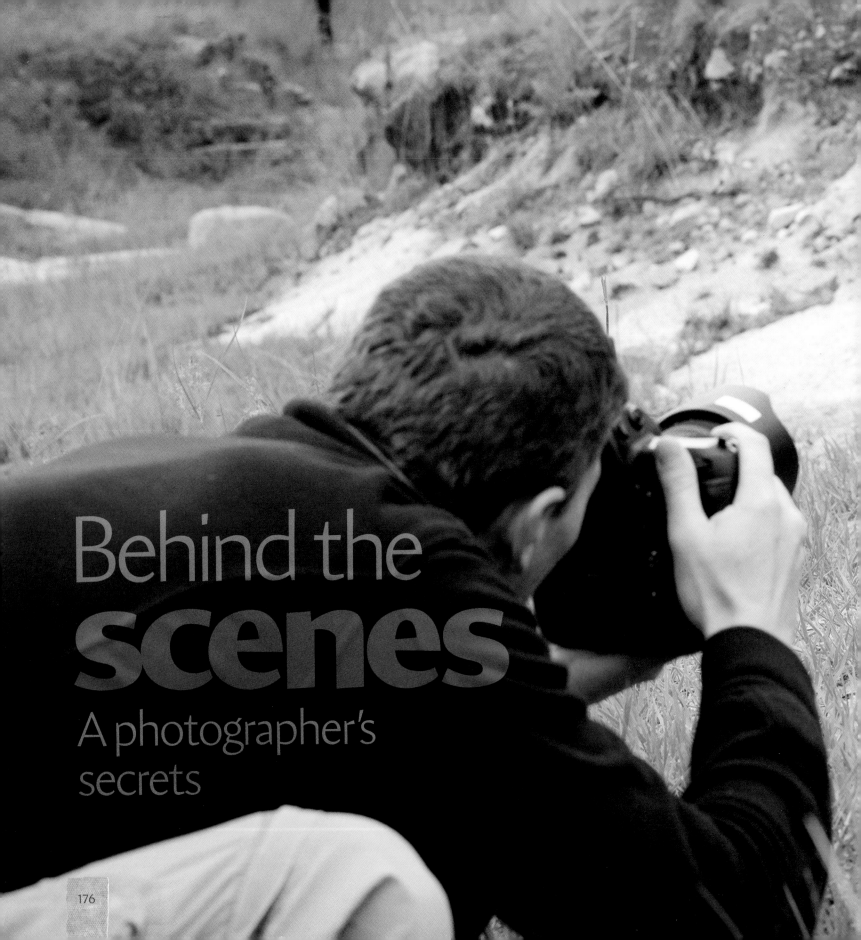

Behind the
scenes

A photographer's
secrets

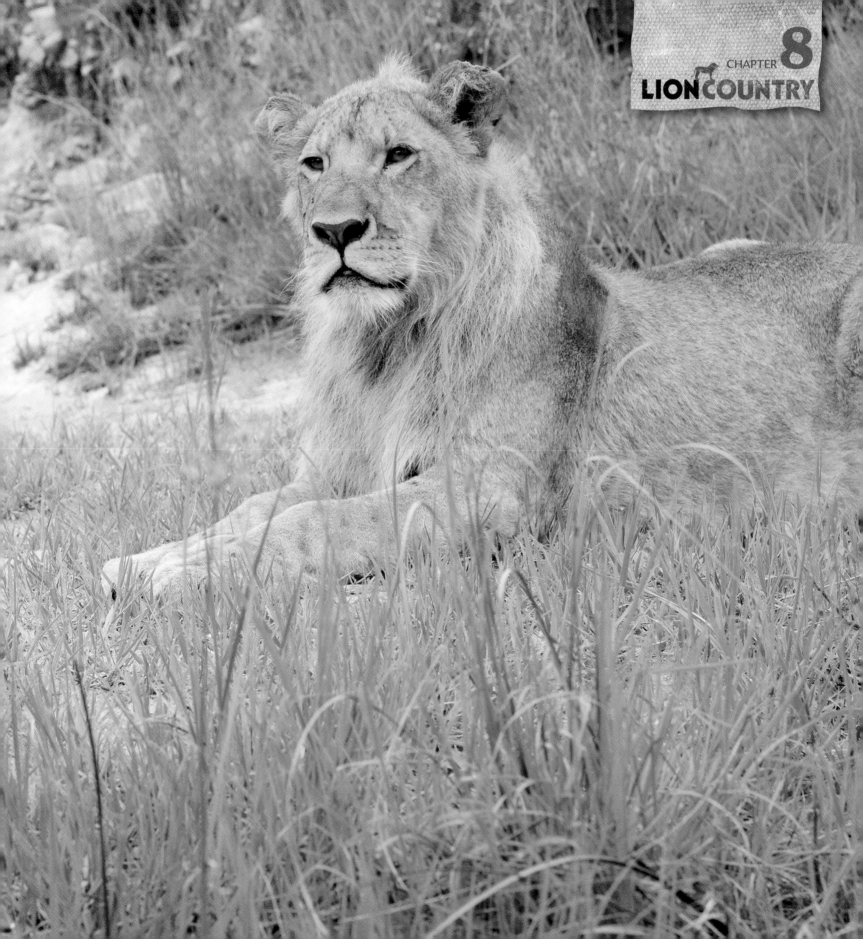

Behind the scenes

A photographer's secrets

It's fair to say that I have never had an assignment quite like *Lion Country*. My last major book project, *Animals on the Edge: Reporting from the Frontline of Extinction*, was longer and more far-reaching but it involved many different species and continents. There was a lot of variety, which helped make each image unique. For *Lion Country*, however, I had just one subject – the lion – and that provided me with a testing challenge: how to photograph the same subject over and over again and still make each image compelling?

For me, a photograph starts in my mind. I spend a lot of time thinking about what I want each image to 'say'. Typically, I sit at my desk and write captions for images I have yet to make. Once I have the caption, I begin visualising the image to match and, when I have a mental picture, I often draw it on paper. This is known in the trade as visualisation and for me it is key to ensuring that every trip I make is productive in terms of its photographic return.

The next step in the process is working out the practicalities of capturing the images. *Lion Country* gave me the opportunity to try some new ideas and techniques. Like people, lions have unique characters, strengths and likes and dislikes. It was these characteristics I wanted to capture and reveal – like the pride that specialised in swimming and the tree-climbing cubs. Such images take forethought and often require specialist equipment. It's a lot of up-front work but the effort is rewarded when the images are 'in the bag'.

Climbing trees

One of my aims with photography is to reveal aspects of the world people will never experience in their own lives. So when I was

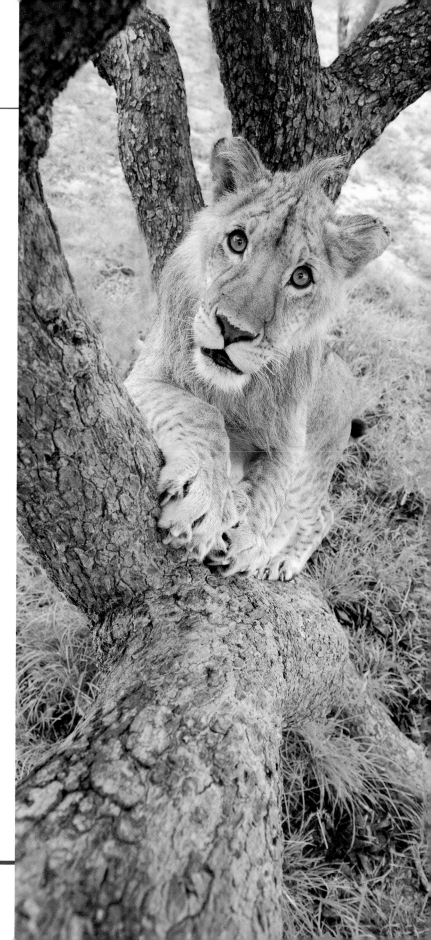

told about a favourite tree that the lions at Antelope Park loved to climb, I wanted to capture this behaviour from a perspective that no one had seen before.

The visual idea was to photograph the lions as they climbed up the tree. But I wanted to shoot not from the ground looking up, which has been done many times before, but from the tree looking down. If I sat in the tree with the camera, the lions would never climb it, so I was going to have to do it remotely.

I made an assessment of which route up the tree the lions were most likely to take and decided where to position the camera. I attached it to the tree with a flexible tripod known as a Gorilla Pod and secured the whole set-up with gaffer tape. I set the focus and exposure manually and then waited for the lions. When they came, they were nervous at first and seemed unsure about the camera – a foreign object in a familiar place. But their curiosity got the better of them as first one then both lions started to climb.

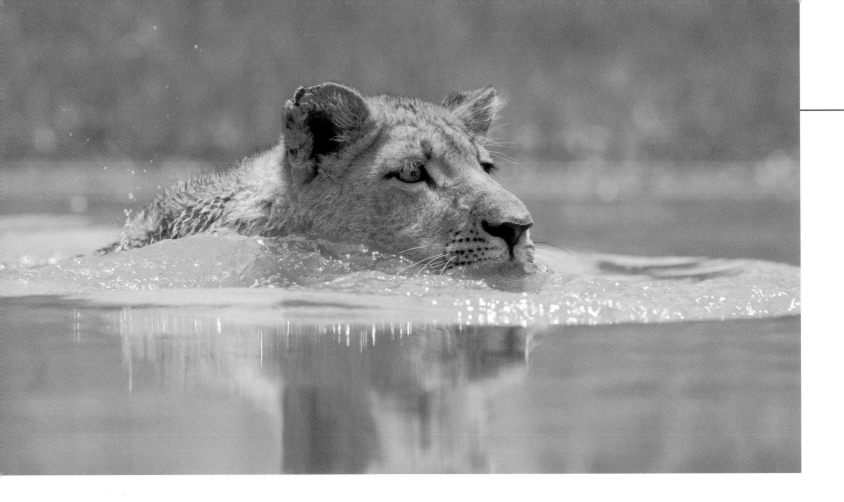

Swimming with lions

Lions are accomplished swimmers, although they are less likely to enter the water than tigers, which spend a lot of time cooling off in waterholes. However, one group of lions at Antelope Park loves to swim, which made for a fascinating story.

Wildlife is generally best photographed at eye level, so I needed to get the camera low down and that meant one thing: I had to be in the water swimming with the lions.

Water and digital cameras don't mix, so I placed the camera in an underwater housing that enabled me to immerse the bottom part of the camera, leaving the lens just above the surface. I also had to think about my own safety. It wasn't just the lions – who are far more agile in water than me – but there was the hidden threat of crocodiles.

In reality, there was little I could do about either if I was to get the shot I wanted. I entered the water and waited. Eventually the lions came and played on the riverbank for a while. Then one of them approached the water. It hissed, an instinctive behaviour aimed at warding off crocodiles, and slowly entered.

As it passed me, it gave me a look that I'll never forget and made me think that there were safer places from which to photograph lions, but it turned out to be just a warning – the lion continued on its path to the bank on the opposite side. In the end, neither the lions nor crocodiles posed a threat, but I did emerge from the water covered in leeches.

Stuck in a hole

I've photographed the wildebeest migration in Kenya and Tanzania several times, but for this shot I wanted to involve the viewer in the experience, creating a sense of what it's like to be right there at the head of the stampede. One option was to use remote cameras, but this created two problems. First, I had no way of knowing exactly where the animals were going to be, so it was hard to predict where to position the camera. Second, there was a distinct likelihood that the camera wouldn't survive the experience. In the end, there was nothing else for it: I was going to have to be there, camera in hand.

I devised a plan that involved digging a pit roughly in line with the anticipated path of the animals as they were herded towards the new reserve. The pit was a bit over a metre deep and about the same square. I climbed in and it was covered over, first with railway sleepers (for my protection) and then with earth to camouflage it. At the front there was a small hole through which I positioned the camera. It was cramped and dirty and, once I was inside it, there was no escape until someone came to free me.

It was then a question of waiting…until a large herd of wildebeest charged past above me. The sound was booming and the experience exhilarating as stampeding hooves passed centimetres from the camera. Dust and debris flew everywhere – including straight down through the hole into the pit: once the herd had passed it was almost a minute before I was able to breathe again. On top of all that, from my low position, I couldn't see the animals until they were almost on top of me, so framing, focusing and exposure were all split-second decisions.

I was in the hole for several hours over the course of two days and, as well as photographing the wildebeest, managed to capture similar images of zebra and impala. So it was worth it!

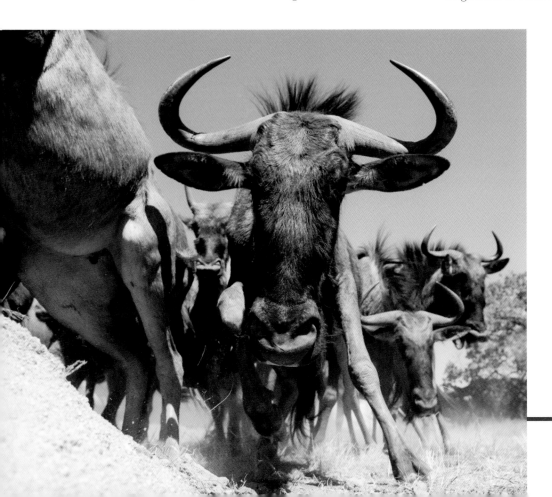

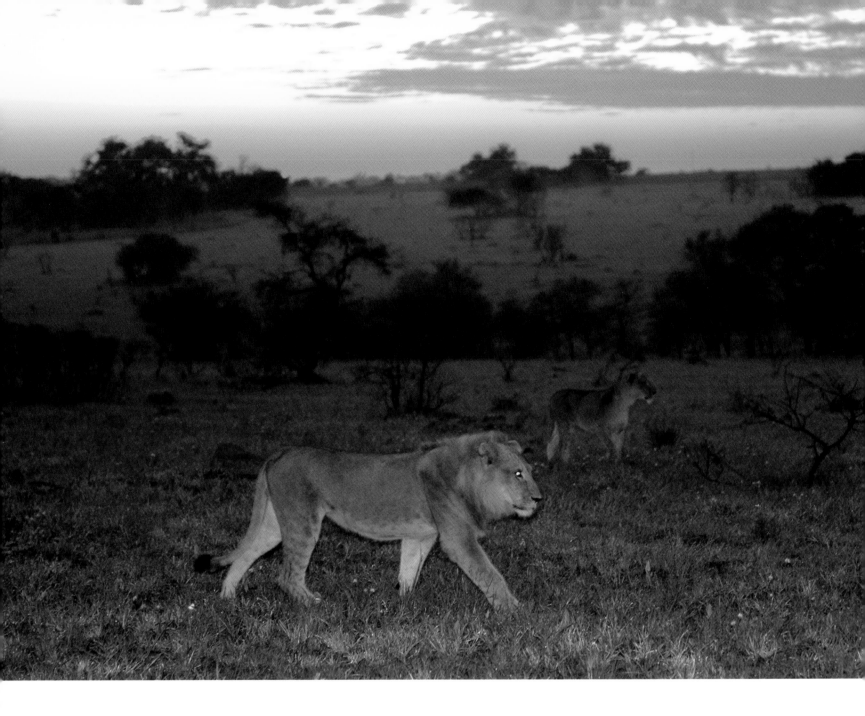

Dawn raiders

Lions are most active at dawn and dusk and through the night, which meant, to get images of them hunting, I had to work in very low light conditions – a challenge for any camera and wildlife photographer.

My main difficulty was setting a shutter speed fast enough to freeze the movement of the lions as they traversed the grassy plains of Antelope Park. As well, I had to balance the very dark foreground light with the brighter sky, which was lit by the rising sun.

To overcome both challenges, I elected to

DAVID'S SAY...

'Almost monthly, we hear that another population has been lost and those that remain are struggling. But there is hope, there are programs, such as ours, that can ensure Africa's most iconic species will always be a part of a wild Africa.'

use two flash units, one operating off the other. I could set a shutter speed that captured the lions and provided enough light on the foreground to create the composition I envisaged.

To soften the light from the flash, making it appear more natural, I used two large soft boxes (one per unit), a bit of kit designed to spread the light over a wider area.

The bright spot in the lion's eyes is a result of the flash reflecting off the retina. While I could have removed this spot using Photoshop, I felt it made the image more realistic, providing the viewer with a greater sense of what it was like to be there in the moment.

Acknowledgements

Perhaps the most important person in the creation of this book has been Andrew Conolly. Without his vision, his energy and his perseverance I would have nothing to write about or photograph. Over the years, I have come to know Andrew well and I am privileged and honoured to class him among my good friends. David Youldon, too, has played a large part in the ALERT programme and his help with this project has been significant and unyielding.

I would also like to thank the many staff at Antelope Park, including but not limited to Leigh-ann Marnoch, Nathan Webb and Roy Steffen. Also, Greg Bows, Marleen Lammers and Sarah Graham – the only person I know outside the UK who knows how to make a proper cup of tea.

Special thanks must also go to my able, if sometimes unwilling, assistant on the project, Marc Chapman; and to Leo Grillo, for his continued support and dedication to wildlife.

Thank you, too, to the *Lion Country* production team and crew, including Series Producers Jenny Williams and Chris Barker; Location Producers Karen Partridge, Susan Houghton and Alison Quirk, and Executive Producers Petra Regent and Marie Thomas.

In the production of the book, thanks to Kevin Morgan, Bev Bulcock and Pui-Man Li (ITV), Caroline Minshell (Evans Mitchell Books), Caroline Taggart and Darren Westlake. And finally, my sincere thanks go to Sir Ranulph Fiennes and his wife, Louise.

About Animals on the Edge

My work on this project has been supported by the wildlife conservation non-government organisation (NGO) Animals on the Edge (AOTE). Animals on the Edge is a Public Charity registered under section 501(c)(3) in the United States and, in the UK, a Companies House-registered not-for-profit company limited by guarantee (reg. no. 06994155). Operationally, the organisation is engaged in researching new and innovative methods of conserving wildlife and works with wildlife-centric NGO partners around the world.

For more information, visit the AOTE website: **www.animalsontheedge.org**

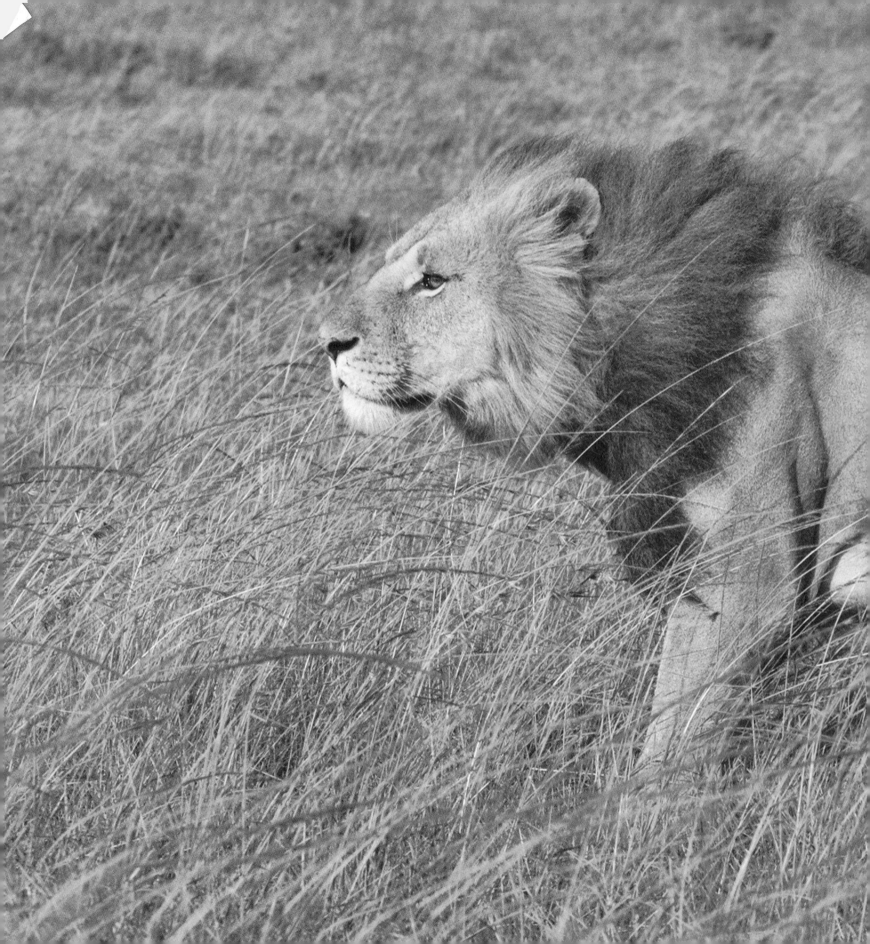